Urban C. Perea
10269 Sharp Drive
El Paso, Texas
79924

Ph. No. 755-7348

The Quattrocento

THE
QUATTROCENTO

A Study of the Principles of Art and a Chronological Biography of the Italian 1400's

Alfonz Lengyel

Wayne State University

KTH

KENDALL/HUNT PUBLISHING COMPANY
DUBUQUE, IOWA

Copyright ©1971 by Alfonz Lengyel

Library of Congress Catalog Card Number: 79-167841

ISBN 0-8403-0470-6

Printed in the United States of America

"Scholars are responsible not only to their own age, but to future generations as well."

A. Lengyel
(Excerpt from a Commencement Address, Ohio Dominican College, Columbus, Ohio 1968)

Contents

Acknowledgements

I am indebted to Mrs. Louisa Curtis-Brantigan, my former student, friend and colleague, who has helped me in editing my text and to Mr. Joseph Pulcini, who took the time to proofread my material and index it.

Introduction

My purpose in this book is to give the reader something which could help him in understanding the principles of 15th century art in Italy, rather than a pictoral account of the art of the Quattrocento. Today's fashionable art book is usually a collection of photographs with little or no text, a presentation which leads the reader to look but not necessarily to understand. I strongly believe that the right presentation, if it is followed by meditation, is the best way to realize visual appreciation. The importance of such an approach is especially evident in the understanding of today's art. Heizer's *Earth Sculpture* has failed in Detroit. Robert Rodgers, Director of Public Relations for the Detroit Institute of Arts, has described the source of this failure as a "public relations disaster" because the Institute, prior to the "exhibition," did not educate the public to the ideas behind Heizer's unique attempt at art.

For the understanding of the art of the Quattrocento we have no such problems and we do not need a heavy publicity bombardment to educate the spectators. However, certain principles of the Quattrocento should be known before one can approach an understanding of the masterpieces of the 15th century.

It is true that the artists of the Quattrocento were not aware of the fact that they were the representatives of the Early Renaissance. With their innovations and new methods of expression, they only opposed former tendencies in art. They developed a certain self-consciousness which they filtered through the contemporary idea of growing humanism. The generation of the Quattrocento initiated a modern spirit which is still developing today.

Whether or not the Quattrocento was just an episode or a real period in the development of modern humanistic ideas is a secondary

question. Its principle merit is that the classical idea of the recognition of man was reborn, which opened a new horizon for artistic expression.

The humanists and artists who interpreted the Greek and Roman ideas were the children of the Quattrocento and not reincarnated "Ancient Men." Consequently, the nature of understanding those ancient ideas was permeated with a contemporary Quattrocento flavor. The artists sublimated those ancient traditions with their own imagination and did not copy from ancient art directly.

This transformation is the point that is so important to note. In addition, through Greek and Roman studies, one may recognize the basic principles of the Italian Renaissance as expressed by the masters of the Quattrocento.

Alfonz Lengyel

CHAPTER 1

The Concept of the Renaissance

The term Renaissance expresses "rebirth" or "revival." Burckhardt in his *Die Kultur der Renaissance in Italien: ein Versuch* (Basel, 1860) intended to create an image of contrast between the scholastic Medieval period and the Humanistic age of the Renaissance.

The Renaissance was not a revolutionary movement achieved overnight; rather the roots of the Renaissance are traceable to the intellectual and artistic innovations of the previous centuries. Historians from Burckhardt to the present have tried to describe the basic meaning of the Renaissance and in their point of departure and national origins, have raised unresolved controversies about the subject.

The traditional point of view toward the Renaissance came from the thesis of Jakob Burckhardt. Among other factors, he underlines the importance of the revival of Classical Antiquity, naturalism, learning, and the discovery of Man. This thesis was widely criticized, supplemented, partly corrected, and interpreted. As for those who attempted to replace it, their arguments were annulled by the sophistic quality of their approach.

Heinrich Thode, in his *Franz von Assisi und die Anfange der Kunst der Renaissance* (Berlin, 1885) derived the origin of the Renaissance entirely from the Franciscan mystical love of nature. It is evident that the idea of the revival of naturalism through the discovery of "natural beauty" in Italy was part of Burckhardt's thesis. In this regard, Thode's point of view could be considered as supplementary information to the thesis spelled out by Burckhardt, and not an antithesis. However, in regard to naturalism; not only the Franciscan

idea, but 13th century French naturalism and the naturalism of the Paleologues could be considered as precursors for the naturalism of the Quattrocento in Italy. A Frenchman, Louis Courajod, in his article "Les veritables origines de la Renaissance" in *Gazetta des Beaux Arts* (XXXVII, 1888, pp.21-35), has overemphasized the naturalism of the Renaissance. He mentioned that an accentuated naturalism was evident in Franco-Flemish art long before the Quattrocento. Consequently, he entirely denied the Italian origin of the Renaissance. According to him, naturalism is the key issue in the existence of the Renaissance.

It is evident that the men of the Quattrocento in Italy had no idea that they were the champions of the Renaissance. The new modern ideas, which in their time were opposed to Medieval practice, only gradually became part of the new artistic experience. Some artists were sensitive toward naturalism, others toward the love of antiquity. One erected a pedestal to the recognition of man as the center of the universe; others were more or less involved with the demonstrations of new scientific learning, such as anatomy, botany, mathematics, geometry, etc. These explanations developed according to the individual interests of the artist during the Quattrocento in Italy. It is extremely difficult and unnecessary to make a strict classification of the Renaissance because it was the result of individual thinking, denying Scholasticism and approaching a new aesthic. The Renaissance in Italy culminated in the Quattrocento and the first decades of the Cinquecento. This new way of thinking in the earlier period drew reprisals, but the subsequent statement of "truth" became accepted when the time was ripe for receiving it as the respectable Humanistic view of the Quattrocento.

During the 12th and 13th centuries, the Christian West had already started to translate and comment on scientific and astrological works, as well as works on alchemy by Greek and Arabic writers. Latin was adopted as the major language and therefore knowledge of pagan Latin literature was required. The universities were the centers of this Christianized "pagan spirit." Soon there developed great conflicts between original and interpreted texts. During the course of Renaissance Humanism, the interpreted texts were also revised.

Burckhardt, in his thesis, searched for the roots of pagan classicism and naturalism in the Medieval past. The work of Huizinga, *The Waning of the Middle Ages* (English translation, London, 1924), also

supports the idea of the survival of the classical elements during Medieval times. As an antithesis, Burdach, in his *Reformation, Renaissance, Humanismus* (Berlin), attempted to derive a concept of the Renaissance entirely from religious or mystical traditions. Schramm went so far in his extreme ideas in his *Kaiser, Rome und Renovation* (Leipsig, 1929) that he exaggerated the political aspect of the Renaissance.

The statement of Burckhardt on the revival of Classical Antiquity during the Renaissance was severely challenged by Anton Springer in his *Das Nachleben der Antike im Mittelalter* (Bonn, 1867). The joint publication of Panofsky and Saxl also followed the Springer idea. They published in the *Metropolitan Museum of Art Studies* (volume 1932/33) an article which proved the use of classical mythology in Medieval art. They recognized and pointed out the classical elements used but they admitted that the form was rather distorted rather than an exact adoption of classical aesthetics. Panofsky, in his "Renaissance and Renascences" *Kenyon Review* (vol. VI, 1944, pp. 201-236), attempted to differentiate between the actual classical representations of Antiquity in the Renaissance and the earlier use of its degenerated form. The Springer thesis was quite strongly supported by Jonathan Nordstrom in *Moyen Age et Renaissance* (Paris, 1933).

Burckhardt, in his thesis, treated the Carolingian and the 12th century as a continuation of the classical tradition within the Medieval period. However, his short introductory statement about the revival of antiquity, and especially his statement about the reproduction of antiquity, needed some clarification. Arnold von Salis, who published a book in 1947 in Switzerland, *Antike und Renaissance,* pointed out that the antique forms were not copies of Antiquity but a rational reuse of the antique theme and motifs absorbed through the contemporary spirit of the Italian Quattrocento and Cinquecento.

Burckhardt's ideas concerning the revival of Classical Antiquity was supplemented and elaborated by George Voight in his *Die Wiederbelebung des Classischen Altertums* (Berlin, 1859). This problem was also treated by Bolgar, Curtius, Sabbadini, Toffani and finally summed up by Kristeller in *The Classics and Renaissance Thought* (Cambridge, Mass., 1955).

In addition to those critics, who just supplemented or revamped the thesis of Burckhardt, there were some who wanted to replace it

entirely. Lynn Thorndike, for example, in the *Journal of the History of Ideas* (January 1943, vol. IV, no. 1, pp.63-74), published an article "Renaissance or Prenaissance" in which he completely denied the originality and distinctiveness of the Renaissance. Recently, Wallace Ferguson referred to the Renaissance as "Europe in transition," which culminated in Modern Civilization. With this classification, the role of the Renaissance is minimized into a historical episode. If we accept this theory, we could merely register the whole cultural history of western civilization as a great perpetual transition—a dialectic movement from the beginning to the end of the world.

Despite the inaccuracy and vagueness of Burckhardt's thesis, his concept of Renaissance civilization stands to date at the center of the pro and con observations and disputes. His recognition of the cultural period called the Renaissance inspired historians, philosophers, social scientists, economists, etc., to create a framework for a movement which became the vehicle toward our present civilization.

Sources

Baron, H., *The Crisis of the Early Italian Renaissance*, Princeton, 1955.

Burckhardt, J., *The Civilization of the Renaissance*, I-II, N.Y., 1958.

Ferguson, W., *The Renaissance in Historical Thought*, Cambridge, Mass., 1948.

Garin, E., *L'Umanesimo Italiano*, Bari, 1952.

Gilmore, M., *The World of Humanism*, N.Y., 1952.

Haskins, C.H., *The Renaissance of the Twelfth Century*, Meridian Books, 1957.

Kristeller, O., "Humanism and Scholasticism and the Italian Renaissance," *Studies in Renaissance Thought and Letters*, Rome, 1956, pp.553-583.

Potter, G.R., *The New Cambridge Modern History*, vol. 1, Cambridge, 1958.

Toffanin, G., *Storia dell'Umanesimo*, Naples, 1933.

Wackernagl, M., *Der Lebensraum des Kunstlers in der florentinischen Renaissance*, Leipsig, 1938.

CHAPTER 2

Sources for
Renaissance Art Studies

One can roughly divide the main sources of the Renaissance as follows: official records, private documents, and treatises.

In order to find background material for artists' lives and their artistic activities from birth to death, certain officials records are very helpful. Unfortunately, wars, fire and other disasters have destroyed a good many of these valuable documents, therefore we cannot find any continuous record of the life of an artist in many cases. Thus, we have only fragmentary documentation. For example, Pietro Cavallini, whose date of birth and death are unknown, is only recorded as being active between 1273 and 1308. Cennino Cennini, who wrote the *Libro dell'Arte,* was a pupil of Agnolo Gaddi, but no documentation remains of his works of art.

Tax statements, wills and account books can also give some valuable information about the artists. In a tax statement of 1469, Uccello states, "I am old, infirm, and unemployed, and my wife is ill."

We know through documentation that the family of Duccio refused to accept his inheritance because of his enormous debts. The account books give information about when and how much an artist received for some work of art and sometimes give an entire description of the iconography. Contracts also give in detail a description of what the patron wanted from the artist, at times including what the materials were to be. Frequently artists offered an iconographic program for their works. This gives us an extremely useful source of documentation, especially for lost pieces of art or in the detection of fakes. Publicly printed letters which announced interesting aquisitions are equally helpful in research on the life and art of a specific

artist. In journals, like the *Landucci Journal,* articles appeared describing public festivals including their artistic decoration. The growing public interest in collecting soon produced the art dealer and critics. Books published in the 16th century on collections give fairly good information about masterpieces which were produced during the Quattrocento and which became part of a private collection. From the book of Sabba di Castiglione, *Ricordi* (1546) we receive information about the level of collecting. Castiglione mentioned that since good antique works are rare and expensive, one should decorate his house with the inexpensive works of Donatello. Through these statements we can easily formulate our knowledge about the art market. One can also find mistakes in the descriptions Castiglione gives. For example, he mentioned that he, as a poor gentleman, has a small head of S. John the Baptist by Donatello in Carrara marble. Janson identified this piece, which is now in the Pinacoteca of Faenza, as one which came from the workshop of Rossellino.

Sometimes Castiglione, and others, misused names also. Castiglione mentioned an artist named Alfonso da Ferrara, who was certainly Alfonso da Cittadella, called Lombardo da Ferrara, a friend of Castiglione. Through him, we have some information about several intarsia makers, including the highly praised Fra Giovanni da Monte Olivetto, Fra Rafaello da Brescia, who specialized in perspective views, and Fra Daminao da Bergamo, whose intarsia landscapes were made with great naturalistic feeling.

Marcantonio Michiel left unpublished notes which were later published by Morelli under the title *Anonimo Morelliano.* Michiel visited and described the collections of Pietro Bembo, Antonio Pasqualino, etc. In those collections, he described and evaluated artistically some works of art of the Quattrocento.

Records of penal or ecclesiastical law suits are also another source of information concerning the lives of artists. For example, we learn through documents that Duccio was fined several times. He refused to pay allegiance to the Capitano dell Popolo, and failed to appear for military duty. Several times he created public disturbances and he was also under suspicion of practicing magic.

Several private and official letters mention artists or some sort of aesthetic evaluation on a work of art and on the artist himself. A great part of the work on artists, written by Marcantonio Michiel, was the gathering of these types of letters. These letters were written

directly to him or were gathered from other sources. Leonico Tomeo gave him the letters of Campagnola on Paduan artists, and Pietro Summone sent him letters which included reports on the works of the artists of Naples.

In addition to these documents, a great many sketches and models remain which give us information about the preparation for some works which were executed or abandoned by artists.

The Quattrocento artists introduced themselves by signing their paintings or writing about themselves in diary form. Later, this became a sort of autobiography combined with an analysis of their studies and work. The first autobiography of this type is the *Commentarii* of Lorenzo Ghiberti, who made his fame with his bronze doors for the Baptistery of the Cathedral of Florence. He trained Donatello, Michelozzo, Paolo Uccello, and Benozzo Gozzoli. Toward the end of his artistic career, he wrote his autobiography. This was partly an account of ancient art which he learned from Vitruvius and Pliny. He gave a cross section of the works of the Trecento artists in Italy and explained other things he had learned during his lifetime. At the end of his *Commentarii,* he added a theoretical discussion which was largely taken from Roman writers and Arabian scholars, especially the scientific and anatomical works of Alhazen (Ibn-al-Hartam) and Avicenna (Ibn Sina). His aesthetic conviction coincided with the Vitruvian idea of "Beauty depending on proportion."

In addition to the autobiography of Ghiberti, individual and collective biographies have appeared, in contrast to the biographies of the saints in the *Aurea Legenda* of the Middle Ages. One such biography was written by Antonio Manetti just a few years after the death of Brunelleschi, entitled *Vita di Filippo di Ser Brunellesco.* The most eminent compilation of collective biographies was published in Vespasiano Bisticci's *Vite di Uomini Illustri del Secolo XV.* Bisticci was a learned bookdealer in Florence and his shop was an internationally known meeting place for scholars in Europe. He supplied books to the great patrons of art and culture in Italy, England, and Hungary.

The scientific approach of the artists resulted in a growing number of art theories. Prior to the Quattrocento, the first but still medieval type of craftsman's handbook *(Libro dell'Arte)* was published by Cennino Cennini. He, as a Giottesque artist, stands between medieval times and the already awakening modern times. Despite this positive

fact, his book should be considered not as a scientific treatise, but more as a commentary. However, it is mentionable that in this book the proportion of man was treated for the first time, which later became the key issue in the treatises on art of the Quattrocento and Cinquecento in Italy.

The scientific analysis of art and architecture started with the literary works of Leon Battista Alberti, who was an illegitimate son of a wealthy exiled Florentine nobleman. He first received a degree of Canon Law at the University of Bologna, and later turned to an interest in art and architecture. Through self-education he developed into a "Vitruvian" architect.

Alberti, through his contact with artists, developed an art theory of painting which was based upon reality and which was controlled by the scientific study of vision. In his treatise on sculpture, he demonstrated an interest in developing a system of proportion. In addition, he discussed the various techniques of sculpting. His book on architecture, which was circulated from 1452 to 1485 in manuscript form, was written after the ideas of Vitruvius. He also wrote poems, theatrical plays, and moral and philosophic essays.

Alberti demonstrated his concept of beauty in architecture in addition to his technical descriptions. This concept was influenced by that of Vitruvius, which was based upon a rational and proportioned integration of all parts of the building. He gave a detailed guide for the proportions of the ideal building. His law of proportion reflects a musical harmony which by mathematical technique produces the perfect harmonized plan and interrelationship between the building and its surroundings.

The treatise of Alberti was presented in a traditional style of exposition. However, other treatises on architecture appeared in a dialogue form, such as Antonio Averlino's (Il Filarete) *Il trattato d'Architectura* and Fra Francesco Colonna's *Hyperomacchia Poliphili* which was a charming discussion between two Platonic lovers, Poliphilus and Polia.

Filarete, as the architect of Francesco Sforza of Milan, wrote a book on an imaginary city, Sforzinda. He dedicated the manuscript to his former patron Piero de' Medici, but left it without a formal ending.

Francesco di Giorgio's book on architecture is an excellent source for city planning and military architecture. He anticipates some of

the architectural theories of the High Renaissance. After the treatises of Alberti, Filarete and Francesco di Giorgio, several other architects wrote books on architecture, but their theoretical and practical activities took place primarily during the Cinquecento.

In order to fulfill one of the basic ideas of the Renaissance, the return to natural representation, certain scientific studies were required to present nature in depth. More and more landscapes appeared in the middle and far distances in paintings, even as backgrounds for portraits.

Alberti had already, in *Della Pittura,* explained a system for perspective. His friend Filippo Brunelleschi, who was inspired by Alberti, continued his studies on perspective and made a series of perspective drawings. Brunelleschi soon discovered the mathematical law of perspective which had already been used by Masaccio. Soon Paolo Uccello (1397-1475) compiled all the material on perspective in a book and demonstrated his new knowledge in his equestrian portrait of Giovanni Acuto on the wall of the Cathedral of Florence. The importance of this compilation was long overestimated by art historians, and the discovery of the laws of perspective were wrongly accredited to him. It is true that Uccello's study on perspective modified his style, but he never reached the truly naturalistic style of Masaccio or the followers of Masaccio.

Another artist who scientifically studied the question of perspective was Piero della Francesca (1410/20-1492), who demonstrated his skill in theory and practice as well. Near the end of his life, when he became partially blind, he wrote a book on perspective, *De Prospectiva pingendi,* and another book on proportion, *De cinque corporibus regularibus.* The idea of proportion set forth by Piero della Francesca was used later by Luca Pacioli, a mathematician who wrote *Divina Proportione.*

Another artist who was involved in this study of perspective was Leonardo da Vinci. Through his vast number of sketches, he developed a system of mechanical drawings. With Leonardo ends the history of theoretical writing in Italy in the Quattrocento and the gate opens for the Cinquecento. His famous treatise on painting was composed from his unedited notes, which were rearranged and published for the first time in 1651. Leonardo, through his writings, tried to create a new dignity for the artist by advancing the idea which made them equal in status to a philosopher. He advocated the idea that

painting is a selective mental process and most important, created the criteria for a good painting, that the painter must know what he wants to paint. He compared painting with one type of Humanist activity, writing poetry. By philosophizing on the comparison between painting and poetry, he accepted poetry as superior to painting in the presentation of words, but he underlined the superiority of painting over poetry in terms of facts. Therefore, Leonardo concluded that painting was superior to poetry. Leonardo wrote notes about anatomy, embryology, physiology, mechanics, water pressure, and the flight of birds. In addition, he wrote studies on the expression of human attitudes and the functions of eyes and ears. He also left illustrated notes on geometry, mineralogy, botany, bronze casting, city planning, fortifications, and bestiarii. It is quite noticeable that the scientific studies of Leonardo reflect on his artistic creative activities. For example, his studies on the force and the circulation of water are reflected in his composition of the *Deluge*. In contrast to this, we find Uccello who codified artistic theory which could have been a special reinforcement of his skill in painting, but he never entirely put his scientific knowledge to practice. This fact might lead us to conclude that Uccello's compilation was only a written testimony of the already existing theories, but that Leonardo invented most of them himself, which made him thus an independent genius.

Sources

Bottari, Tricozzi, *Racolta di lettere sulla pittura, scultura ed architettura*, vol.I-VIII, Milan, 1922-1925.

Holt, E., *A Documentary History of Art*, vol. I, N.Y., 1957.

Oettingen, *Filarete tractat uber die Baukunst*, Quellenschriften fur Kunstgeschichte, Vienna, 1890.

Olschki, *Geshcichte der neusprachlichen Wissenschriften litteratur*, Heidelberg, 1919.

Richter, *The Literary Work of Leonardo da Vinci*, V. I-II, 1939.

Schlosser, *Kunstliteratur*, Vienna, 1924.

Venturi, *History of Art Criticism*, N.Y., 1936.

The Social Position of the Artist during the Quattrocento in Italy

At the beginning of the Quattrocento in Italy, artists were subject to the guild system. Most of the artists came from the lower sector or from the petty-bourgeoise sector of society—sons of barbers, butchers or peasants. Some of them were illegitimate sons of clerks or well-to-do businessmen, like Leonardo and Alberti. Hauser mentioned in his *Social History of Art* that artists were sometimes named after the occupation of their father, their birthplace, or their master, and were treated as familiarly as domestics. They were trained at the beginning of the century in a more or less practical and not theoretical education.

Many artists, at the beginning of the Quattrocento were registered in a craft which was the closest to their artistic production, since guilds for artists per se did not exist. The sculptor Donatello, the genius of the Quattrocento, was registered as a goldsmith and a stonemason.

Soon, as a part of the struggle for social recognition of the artist, leading shops, the so-called *botteghes,* introduced certain aspects of theoretical method in the artists' education, rather than continuing the guild tradition. These workshops included carpenters, gilders, woodcarvers, and marquetry makers. Chastel describes those shops as small factories which were led by directors and assistants. Well known among these was Verrocchio's shop, in which the master regularly gave lectures in mathematics and geometry. It is documented that Giuliano da Sangallo worked as a woodcarver in the shop of Botticelli before he became famous as an architect.

In Florence, in addition to the workshop of Verrocchio, the leading shops were those of the Pollaiuolo Brothers, Ghirlandaio, and the Robbia family. Soon the workshop idea influenced the artists in other Italian cities where they built rival *botteghes*. Those workshops soon entered into serious aesthetic and economic rivalry. Later, certain workshops, as a further development, established international contacts for securing commissions from far away, or established filial workshops abroad.

It is documented that Chimenti Camicia, a Florentine architect, worked for the King of Hungary, Matthias Corvinus, and that he employed several Florentine woodworkers *(legnaiuoli)* in his workshop in Buda. The ceiling of the building which Camicia made in Buda was decorated with wood coffers made by the uncle of Benvenuto Cellini, Baccio Cellini.

The artists Benedetto da Maiano and Ercole dei Roberti also worked in Hungary. Although Bode doubted that Benedetto da Maiano worked in Hungary, Budinis stated directly that Maiano worked in Hungary for King Matthias Corvinus for several years.

Certain artists, in order to share the expenses of the workshops, joined together; Donatello joined with Michelozzo, Fra Bartelomeo with Albertinelli, and Andrea del Sarto with Franciabiagio. Certain artists sublet commissions or employed artists as did Da Predis in Milan, who for a time also employed Leonardo.

Sometimes artists accepted commissions which fell into the category of handicraft rather than art. Ghirlandaio and Botticelli, for example, painted shop signs. In addition, Botticelli drew patterns for embroidery. Lucca della Robbia manufactured majolica tiles for floors and fireplaces. It was only during the Cinquecento that a clear distinction was made between artistic and artisan work.

As far as artistic education is concerned, the Renaissance brought about great changes. During the fourteenth century, the artists already had begun to leave the medieval "loges" which were organized around an ecclesiastical building project. In Florence the painters attached themselves to the pharmacy guild because they made their paint from powder in the same way that pharmacists made medicine from powder. Membership was compulsory.

The Florentine Compagnia di San Luca in the middle of the fourteenth century was organized just as a religious group of artists with a charitable aim. S. Luke was chosen as the patron saint of painters

because, according to legend, he painted the portrait of the Virgin while he had a vision of her. The greatest change in the artist's education occurred when Lorenzo the Magnificent founded the Garden School in 1490 at Florence; it became the prototype for future art academies. However, the establishment of formal academies took place only in the second half of the Cinquecento. With this new education system, the social status of the apprentice changed. He became a pupil, and along with his changed social status, the master became a teacher. The first academy, as such, was also established in Florence (1563) under the name *Academia Disegno*. Leonardo da Vinci also established a so-called academy at the end of the Quattrocento, but its only function was as a place for social gathering, where amateurs discussed the theory and practice of art.

As far as the economic situation of the artists in the Quattrocento is concerned, one can establish a fairly clear picture from the artists' tax statements. Vasari stated that Filippo Lippi was destitute, that he could not buy himself a pair of stockings in his old age. The independent artists were very much subject to competitions, but those who were engaged by a great patron, or who became court artists enjoyed higher and more stable economic and social statuses. However, several court artists did have financial difficulties. Leonardo and Michelangelo several times complained about not having received their fees from their patrons. Generally speaking, the artist during the Quattrocento received a decent income which placed him in the middle-class income bracket. Only during the Cinquecento did some artists reach the level of the upper class. Raphael and Titian attained high honor and a considerable income, which secured a lordly life for them.

The years between 1400 and 1500 witnessed enormous changes in the social lives of the artists. At the beginning of the 1400's artists were often treated as servants. One hundred years later, Titian was appointed by Emperor Charles V as Count of the Lateran Palace, member of the Imperial Court, and Knight of the Golden Spur. Michelangelo received the honorary title of "Divine." The hand of the niece of Cardinal Bibiena was offered to Raphael, but he refused to accept it.

Sources

Drey, P., *Die Wirtschaftlichen Grundlagen der Mahlkunst,* 1910.

Hauser, A., *The Social History of Art,* vol. II, pp. 52-84, 1951.

Lucki, E., *History of the Renaissance, Economy and Society,* University of Utah Press, 1963.

Martin, A., *Sociology of the Renaissance,* 1944.

Wackernagel, M., *Der Lebensraum des Kunstlers.*

The Rediscovery of Man

Aided by Greek philosophy, the recognition of man was already practiced in Grecian art. Genesis also placed an emphasis on man as the most important creation of God, which raised man above all others in the Christian world. The position of man, from time to time, was re-interpreted—to be de-emphasized or over-emphasized.

At the middle of the Quattrocento, Gianozzo Manetti wrote a treatise *On the Excellency and Dignity of Man* as an antithesis to the medieval concept as expressed in *On the Misery of Man* written by Pope Innocent III.

Boccaccio wrote *De claris mulieribus* which is a collection of biographies of famous women, and was written with the intention of supplementing Petrarch's *De Viris Illustribus.* Moreover he also wrote a book on illustrious men entitled *De casibus virorum illustriorum.* These collective biographies were the precursors of the publication of Vespasiano Bisticci on *De vite di uomini illustri del secolo XV.* Bisticci felt that the revival of learning which resulted in Humanism began with Dante, Petrarch, Boccaccio and Salutati. It was they who started and developed, along with other Humanists, the new aspects of learning which reached its peak in the Neoplatonic Academy. The idea to write a book on popes, prelates, rulers, statesmen and writers in itself demonstrated a rebirth of the ancient biographical tradition.

During the Quattrocento, Platonism and Aristotelianism, as complementary to each other, were the focal point of Humanistic observations in Italy. Pietro Pomponazzi (1462-1525) was one of the leading representatives of Aristotelianism. His philosophical activities started at Padua. During the last decades of the Quattrocento he

remained in Padua. At the beginning of the Cinquecento he moved to Ferrara and Bologna. He advocated that the moral virtues constitute the peculiar dignity of man on earth and not his reward after death.

Marsilio Ficino (1433-1499), who studied Aristotelian philosophy and medicine, also studied Epicurus, Plato, the Neoplatonists, S. Augustine and S. Thomas Aquinas. He translated the Greek and Latin originals, and made his interpretation of them. In 1462 Ficino became the head of the Florentine Platonic Academy. He became extremely influential with his philosophical work, *Theologia Platonica,* published in 1482.

In this work, Ficino gave special emphasis to man and his dignity. Ficino, like Pomponazzi, placed man in the center of the universe. Pico della Mirandola prepared to defend in a public disputation in Rome in 1486, 900 theses of Greek, Arabic, Hebrew and Latin thinkers. For this he made an introductory essay "Oration on the dignity of Man." The public defense of these theses never took place because several of them were considered heretical. Consequently, Mirandola was forced into exile. Later, at the invitation of Lorenzo de' Medici, he became a member of the Florentine Platonic Academy. In his "Oration" he denied the central position of man in the universe, but he underlined the more important fact, that man determined his place and nature through his own free choice.

The concept of the position of man as discovered by antique philosophers was not entirely forgotten during medieval times, only de-emphasized in importance. Kristeller pointed out the fact that "since the beginning of Renaissance Humanism, the emphasis on man becomes more persistent, more systematic and more exclusive."

Most of the so-called medieval portraits depict the donors of an altarpiece kneeling in a position of adoration. The Renaissance concept of the glorification of man, especially the famous man, not only inspired the self-made biographers but the painters and sculptors as well. For example, the artists from Giotto on had already paid tribute to the contemporary and ancient great poets. From Giotto's primitive portrait of Dante, to the sculpture representations of Dante, Petrarch, and Boccaccio by Andrea del Castagno, portrait technique developed to a high degree. Portraiture went in a new direction with the theory of Leonardo at the end of the Quattrocento. This also influenced portraiture for the entire High and Late Renaissance. Leonardo advocated that it is not merely necessary to

copy everything that the artist could visually perceive. A portrait should reflect, rather, the character and the soul of the model. As far as the use of light was concerned, he suggested a dimmed light which created the necessary shadows to give grace to the face.

It is possible that the complex of the dignity of man which governed the philosophical life of the Renaissance was largely responsible for the self-consciousness of the artists and the society. The artists tried to introduce themselves by signing their artistic creations. Some of them signed their name on the *cartolino*. The earliest example of this is found in Fra Filippo Lippi's *Madonna* in the Palazzo Barberini. This practice is also found in Padua among the artists who worked around Squarcione. At times, as Pintoriccio did on his wall painting in the Piccolimi Library in Siena, the artist painted a small copy of his well-known earlier painting within a new large composition. Professor Chastel pointed out the importance of self-identification for the artist. A painting within another painting was used quite often. However, sometimes the artist would copy a small painting within his work which was different in style from his own work and which was simply a copy from someone else's painting.

Finally, as another method of self-identification, the artists sometimes painted their own self-portraits within a large composition which culminated in an independent self-portrait. In addition, we often notice that the artist would paint himself as a spectator in a religious story along with his fellow artists.

Giotto already included a few portraits in his frescoes. In his portrait of Dante and that of Boniface VIII in S. John of Lateran in Rome, Giotto demonstrated a slight tendency toward individual physiognomy. The portraits of the kneeling donors as a carry-over from medieval portrait practice were soon abandoned and portrait paintings were introduced in their many variations.

At times portraits also appeared in large religious compositions and the artist would include himself in the portrait of others. Benozzo Gozzoli painted the fresco depicting the *Journey of the Magi* around the wall of the chapel in the Palazzo Medici in Florence from 1459 to 1461. Frederick Hartt said that Cosimo de' Medici belonged to the "Company of the Magi" which was one of the religious organizations in the city of Florence. It is possible that this was the reason why Gozzoli painted the Medici family on horseback among the

entourage of the procession of the three Magi. Gozzoli also painted his own portrait among the crowd of the procession by inscribing on his hat, "Opus Benotii."

Another painter, Botticelli, went further in the glorification of the Medici family. He painted Piero il Gottoso, Cosimo and Giovanni de' Medici as Magi in the altarpiece, now in the Uffizi Gallery, Florence, which was commissioned by Giovanni Lami for the Church of S. Maria Novella. In this painting, Botticelli grouped the Holy Family in the middle distance in a little elevated ruined stable. In the crowd which entered with the adoring Magi are Lorenzo and Giuliano de' Medici and others from the Medici court. Botticelli painted himself also, at the extreme right of the painting, looking toward the spectator.

Ghirlandaio painted a fresco in the Capella Maggiore of S. Maria Novella between 1485-90, in which Ludovica, the daughter of Giovanni Tornabuoni, is observing, with four ladies, the birth of the Virgin. Perhaps the delicate nature of the subject is why he did not paint himself among the observers.

The great master of nudes, Luca Signorelli (1441-1523) in the chapel of S. Brixio of the Cathedral of Orvieto, painted the monumental fresco series of the Last Judgment on three walls. On the left of the scene near the image of the Antichrist preaching, the standing portrait of Signorelli appears, together with Fra Angelico's, who painted another part of the same chapel.

In historical painting, one can also observe the use of the introduction of self-portraits on the part of the artist. At the Piccolomini Library in Siena, Pintoricchio decorated the walls with frescoes. In the depiction of Pope Pius II (Aeneas Sylvius Piccolomini) canonizing S. Catherine, he painted his self-portrait, together with the portrait of Raphael, standing among the other spectators of this historical act.

Among sculptors one can find the same tendency. The self-portrait of Ghiberti appears in the medallion decoration of his *Porta Paradiso* of the Baptistery of Florence. Michelangelo was more humble, but went so far in his monumental wall painting, the *Last Judgment,* on the end wall of the Sistine Chapel, to paint his self-portrait in a portion of the resurrection. His body has entirely wasted away. Only his anguished face hangs on the empty skin held by S. Bartholomew.

\On bust portraits, the influence of ancient coins is evident. The work of Uccello, Piero della Francesca and Pisanello, among others, is done in this manner. Pisanello, in addition, was known for his bronze medallion portraits, which was influenced by the growing number of ancient coin collections. This new fashionable portrait on coins served two goals. It became a handy portable portrait, and, on the reverse side, made possible the glorification of the person portrayed by making a design or scene, the subject matter being chosen from the greatest achievement of the individual portrayed.

The Flemish influence is also evident in the portraits done by artists during the Quattrocento in Italy. It is known that Flemish art, with its minute details, created a certain photographically realistic portrait, which was foreign to the Florentine tradition. The Flemish artists were well known in Venice and Southern Italy. The Medici bought some works of Flemish artists, including a work by John of Bruges and Petrus Christus, but only to a certain extent was the Flemish influence traceable in Italian portraits. The Flemish manner was developed mostly when the Florentine influence expired and the shift of the center of the Renaissance bypassed Rome and located in Venice.

The Flemish manner was always popular in Southern Italy and in Northern Italy, especially in Milan. Jean Alazard documented that during the second half of the Quattrocento Zanetto Bugatto was sent by Francesco Sforza to study the Flemish technique from Roger de la Pasture. It is also documented that the Duc of Urbino, Federigo Montefeltre, invited Justus de Gent, who through Giovanni Santi, influenced the great Raphael. The best portrait painter in the Flemish manner was Antonello da Messina, but who had never been in Flanders. He became acquainted with the Flemish style in Sicily indirectly, through Flemish educated Spanish painters. Michelangelo absolutely detested the Flemish manner. Francesco de Hollanda in his *Tractado de Pintura antiqua.* reported a conversation on Flemish art between Vittoria Colonna and Michelangelo in which Michelangelo denounced the Flemish tradition, and only admitted that "there were countries where they paint worse than in Flanders." It is possible that the violent opposition of Michelangelo to the Flemish style was due to the fact that his adversary Raphael often painted his portraits with the Flemish type of minute detail.

It is interesting to notice that during the Quattrocento in Italy many artists painted portraits with an emphasis on demonstrating their skill in perspective, anatomy, and landscape. Signorelli's *Portrait of a Man,* formerly in the Kaiser Friedrich Museum, Berlin, is a demonstration of Signorelli's keen interest in nudes. In the background of the portrait, perfectly foreshortened nudes are witness to his ingenuity. Piero della Francesca, who, among others, codified the law of perspective, demonstrated his great ability to create, behind his portraits, a far reaching bird's-eye view landscape as he did in the *Portrait of Montefeltre and his Wife,* now in the Uffizi.

The sculptors sometimes dressed their busts in toga or Lorica as the ancient Roman sculptors had done. Donatello's *Bust of Nicola Uzzano* was dressed as a Roman senator in a traditional toga and Verrocchio's terracotta *Bust of Giuliano de' Medici,* Mellon Collection Wash. D.C., shows him dressed in a Roman military uniform.

It is noticeable that with the short-lived peaceful coexistence policy with the Turks, there appeared portraits by Italian masters of Turkish dignitaries. Contact with Byzance and an attempt to reconcile Byzantine Eastern and Roman Western Christianity failed at the Councils of Ferrara and Florence. This resulted in portraits in which a strict differentiation of the Eastern or Western origin of a person was portrayed through his dress. Even in ancient Greek philosphers' portraits like that of Aristotle, the artist dressed him as a Byzantine hero with a tall Byzantine hat, similar to the hat which John VIII Paleologus wears on the obverse side of the portrait medallion by Pisanello.

Equestrian portraits, also were produced in Italy during the Quattrocento in Italy, by sculptors and painters as well. Alberti contributed to this subject with his essay in Ferrara on *De Equo Animante.*

The equestrian portrait of Giudoriccio Ricco da Reggio, in the Palazzo Publicco in Siena, painted by Simone Martini, appears almost like a tapestry. In contrast to this fresco, the equestrian portrait of Giovanni Acuto by Uccello, and the equestrian portrait of Niccolo da Tolentino by Castagno, achieve a monumental sculptural appearance.

In addition to the painters, the sculptors also joined in the glorification of military heroes by creating giant size bronze equestrian statues. Since Roman times, no large-size bronze figures had been made. The artists of the Quattrocento who wished to create such monuments, first had to study the technology of bronze material and

develop a system of bronze casting. Formerly, only small size equestrian pieces had been made in wood in Northern and Central Italy. In Verona in the early fifteenth century, riding figures already were made in stucco or cement. In Venice, the Sarelli Monument, a wooden equestrian statue, was known. We have documentation for a wooden equestrian figure made by Jacopo della Quercia. But it was Donatello who made the first giant size equestrian monument in bronze of Gattamelata in Padua in 1443. Baroncelli made a monument in Ferrara for Niccolo III in 1451, which was demolished in 1796. Verrocchio's Colleoni, which was erected in Venice after the death of Verrocchio, was cast by Alessandro Leopardi, and it brought to a close Equestrian Portraits of the Quattrocento.

Antonio Pollaiuolo attempted to make an equestrian statue for Galeazzo Maria Sforza, but the monument was never executed. After the death of the artist, the sketches for this proposed monument were discovered among his papers. It is documented that Pollaiuolo had also offered a similar monument to Virginio Orsini in Rome. It is noticeable that the horses of Donatello and Verrocchio are in an advancing position like the horses on the top of the Cathedral of S. Marco in Venice, or the horse of the equestrian statue of Marcus Aurelius in Rome. In contrast to these two Renaissance horses, Pollaiuolo's suggestion was to create prancing horses instead of advancing ones. At the end of the Quattrocento, Leonardo, in a letter addressed to Sforza, offered his services as a military engineer, sculptor and painter. In 1493 he attempted to make a clay model for a Sforza monument. On his model he also placed his mounted rider on a rearing horse. This position of the horse became well exploited by the sculptors and painters in the Late Renaissance, especially during the Baroque Period.

There are many sketches which Leonardo made for the Sforza and the Trivulsio monuments in the Windsor Collection, which deal with different positions of equestrians. Unfortunately, due to the political situation, Leonardo's suggested monuments were never realized. There is, in the collection of the Hungarian National Museum in Budapest, a small equestrian statuette in bronze attributed to Leonardo which was cast after his death. This small bronze depicts a rearing horse mounted by a nude rider. It is well known that Leonardo had seen the Scaliger Tomb in Verona which might have influenced him in the composition of his horse sketches.

It is possible that the philosophy of man's central position in the universe was one of the major factors in reinstating the use of the central-type church during the Renaissance.

In order to construct a central-type church the architects had to search for previous models for it. During the medieval period, for symbolic reasons, the Baptisteries were built in an octagonal form. A few Early Christian circular churches, like S. Constanza and S. Stephano Rotunda and some ruined ancient Roman Vesta Temples survived as models.

In Northern Italy, the baptisteries of Cremona and Parma seem to be the models for Battagio's church of S. Maria Incoronata, Lodi, c. 1491, which was built on the octagonal plan. In order to support the immense dome, every segment of the wall was reinforced by barrel vaults using the system employed by the Romans at the Baths of Caracalla in Rome. With this method, the formation of arches under the octagonal platform of the dome gave an extra strength for supporting the dome and at the same time allowed extra space for the interior.

Another central church by Battagio, S. Maria della Croce in Crema, was circular. The idea to construct it this way came from the example of a fourth century Early Christian church, S. Lorenzo in Milan, where the dome is framed by four towers. In S. Maria della Croce, 1492, Battagio added four additional pentapyrgion, which allowed for additional space and at the same time acted as buttressing for the enormous central dome. The Portinary Chapel in Milan by Michelozzo is a square with a dome resting on pendentives. This is basically a Brunelleschi type of design in combination with the church of S. Lorenzo in Milan.

Leonardo, during his stay in Milan, made a series of sketches for central types of churches with radial architectural plans. It is possible that Bramante was influenced by one of these when he built the choir for the S. Maria della Grazie in Milan, 1492.

Bramante, at the beginning of the Cinquecento, built his S. Pietro in Montorio, which was basically an imitation of an ancient central type of Vesta Temple. As decoration above the classical Doric entablature, he added a balustrade which disturbed the solemn classical effect of the building.

In Central Italy, Brunelleschi (1377-1446) employed a central plan for the Pazzi Chapel (1430-1433). Brunelleschi's idea was to create a

large circular support for a dome on a square plan. The plan is rather sophisticated. Only with the additional portico does it create a large square. The portico itself is in a stylized classical approach. Six columns support the architrave, frieze and cornice. This motif is repeated above, but with double pilasters.

Brunelleschi also used a radiating central plan for the S. Maria degli Angeli (1434-1437) in Florence. The plan was similar to the ancient temple of Minerva Medica in Rome. Janson stated that Brunelleschi had wanted, with his plan, to recreate the Roman principle of the "sculptured wall."

At the end of the Quattrocento Giuliano da Sangallo (1445-1516) built S. Maria della Carceri in Prato (1485-1492). His floor plan is derived from a Byzantine-Greek cross. Among numerous drawings by Sangallo in the Codex Barberini, Vatican Library, are drawings of Byzantine churches with special interest in Hagia Sophia.

Francesco di Giorgio made numerous sketches for buildings employing the central plan. This central idea also influenced artists and architects in urban planning. It appeared in the plan by Filarete for the city of Sforzinda. During the Cinquecento this central planning continued in the plan by Leonardo for a city.

Sources

Alazard, J., *The Florentine Portraits*, Shocken Books, 1970.

Blunt, A., *Artistic Theory in Italy, 1450-1600,* 1966.

Chastel, A., *The Flowering of the Italian Renaissance*, N.Y., 1965.

De Wald, E., *Italian Painting, 1200-1600*, N.Y., 1961.

Gromort, G., *Italian Renaissance Architecture*, Paris, 1922.

Gundersheimer, W. L., *The Italian Renaissance*, N.J., 1965.

Hartt, F., *Italian Renaissance*, N.Y., 1970.

Kristeller, P.O., *Renaissance Thought*, II, N.Y., 1965.

Lowry, B., *Renaissance Architecture*, N.Y., 1962.

Stegmann, C. and Geymuller, H., *Architecture of the Renaissance in Tuscany,* II vols, N.Y., 1924.

Vasari, G., *Delle vite de'piu eccelenti pittori, scultori e architetti,* I-III, Florence, 1568.

Wittkower, R., *Architectural Principles in the Age of Humanism,* London, 1962.

CHAPTER 5

Paganism in
Renaissance Christianity

It is certainly true that the idea of the rediscovery of man prompted the thinkers of the Renaissance to search for support of their thesis in ancient literature. They turned especially toward Cicero for an understanding of the true nature of man. The new epoch, concerned with the question of the position and behavior of man, was closer to the antique than to S. Thomas Aquinas. The ideology of the early humanists was quite well formulated in the work of Petrarch. The followers of Petrarch, Salutati and Boccaccio, disseminated these ideas. At the beginning of 1400, the humanists had already penetrated the world of education. The new avant-garde, which was considered Petrarchian, was led by Malpaghini and his eminent students, Leonardo Bruni and Carlo Marsuppini.

— In 1404, Vergerio wrote his *De Ingenius Moribus* in which he gave a pattern to be followed by the gentleman who wished to be well informed. He suggested that during leisure time the gentleman should study literature, history and philosophy and train himself as an orator.

The invention of the printing press radically changed the basic conditions of education and research. The works of the antique past in every domain were re-examined, criticized and amended.

The technique of making paper was invented in China and carried to Europe by the Arabs. Since the beginning of the 13th century, the production of paper was known in Italy. In printing the block print was first used, but later independent letters were cut and finally the metal type was used. By the end of the Quattrocento, 73 printing presses were in operation in Italy. Certain presses specialized in

Greek and Roman works like the Aldina Press, operated by Aldo Manuzio in Venice, which was famous for classics. Manutius, aided by Greek refugees, between 1494 and 1515, printed a translation of all the Greek authors. Manutius was the center of an intellectual circle, one of the members being Pietro Bembo, who later became a cardinal, leading humanist and great patron of the arts. He wrote his celebrated essay on love *(Gli Asolani)* at the end of the Quattrocento, which also became popular in French and Spanish translations. This essay expressed a Platonic ideal, in addition to a naturalistic overtone, which fit into the contemporary philosophy of the court.

The development of the printing technique and the mass production of books resulted in a new hobby, book collecting. Several great book collections existed in Italy during the Quattrocento but there is some documentation about book collections outside of Italy too. Notably, the library of the King of Hungary and Poland was equally as large and as important as the collection of the Pope or the Medici family. King Matthias Corvinus of Hungary had his own codex illuminator and binding shop which produced the famous Corvin Codexes. Cardinal Bessarion in 1470, bequeathed his library to the city of Venice. In Rome, the book collection under Pope Eugenius IV contained 340 books in the middle of the 15th century; and, after the death of Nicholas V, the library contained 1200 books. In the collection about one third of the books were in Greek. By the end of the century, the Greek manuscripts had reached 1000 and the total number of books at the same time in the Papal Collection surpassed 3600.

Collections of Hebrew manuscripts were also gathered during the same period. Pico della Mirandolla had in his own collection more than one hundred manuscripts.

In the numerous library collections, one can find the works of the champions of pagan antique thought—Aristotle, Homer, Virgil, and Ovid—next to the champions of Christian thought—S. John Chrysostom, Eusebius, Clement of Alexandria, Boethius, Orosius, Dionysius the Areopagite and S. Augustine.

The center of learning shifted from the Universities into the courts of patrons of art and culture or into similar intellectual gathering places. Learned book dealers made major contributions in disseminating classical culture. The bookstore of Vespasiano Bisticci during

the second half of the Quattrocento in Florence also served as an informal meeting place for learned men. Paul Kristeller pointed out that the literary culture which developed in Florence was not attached to the universities but rather centered in the Chancery of the Republic, in private circles of the leading families. For example, Leonardo Bruni (1370-1444), who wrote *Historiarum Florentini Populi Libri XII,* was chancellor to the Republic of Florence from 1427 to 1444. He wrote a biography of Dante and Petrarch. In addition to these individual works, he translated Greek originals into Latin, including the works of Demosthenes, Xenophon, Plato, and Aristotle. In his writing he tried to imitate the style of Livy and Cicero. After his death he received the great honor of being buried in S. Croce which soon turned into a pantheon of the great Renaissance men. The sculptor Bernardo Rossellino carved Bruni's tomb monument. Rossellino, in order to underline Bruni's great contribution to the classics, made the tomb itself reflect the revival of the antique spirit which Bruni advocated so eloquently during his lifetime. Bruni's face, the body lying on top of an ancient sarcophagus, looks like a Roman death mask crowned with a laureate wreath.

The interest in Plato, which centered in Florence during the 15th century, was greatly influenced by Manuel Chrysoloras, the envoy of the Byzantine Emperor. He stayed in the West in order to promote Greek studies. He translated Plato's *Republic* in Florence. In addition, he translated Homer, wrote innovative books on Greek grammar and authored the *Syncrisis,* which is a comparison between the old and new Rome. A relative of his, John Chrysoloras, was also active in Florence among humanist circles. His daughter married an Italian humanist, Francesco Filelfo. The Greek literary tradition of Italy was greatly enhanced when Giovanni Aurispa brought back from Constantinople the complete text of the Platonic Corpus. The activities of Gemisthos Pletho opened a dialogue between the followers of Plato and Aristotle. This was the decision of Cosimo de' Medici to open an Academy for Platonic studies and he appointed Marsilio Ficino as head of it. In 1462 Medici gave him a villa at Careggi with an endowment and a library in order to encourage him to devote his life to the study of Platonic philosophy. The title Academy was adopted from the name of Plato's Academy. Actually, this hermitage was only a gathering place for humanists around Ficino. Consequently, the chief activities of this so-called Academy were organized by

Ficino. He carried out a famous birthday celebration to commemo-rate Plato among other cultural festivities. Among his most notable achievements was his lecture in the Church of S. Maria degli Angeli on Plato, Plotinus and S. Paul.

Ficino was one of the chief advocates of the direct link between pagan philosphy and Christian theology—their common ground being in the concept of natural religion. Pico della Mirandola went forward along this road which was paved by the teaching of Ficino. He added to the Greek sources the Latin, Arabic, Chaldaic, and Egyptian sources, and Jewish cabalistic philosophy which contains some truths which are common to every religion.

With the dissemination of the works of the ancient philosophers, parallel archaeological excavations were also started, and the findings became part of the rapidly developing private collections. In order to understand the iconography of those antique artifacts the science of mythology also developed. Soon works of mythographers appeared to serve the growing public interest in ancient art.

Giovanni Battista Armenini mentioned that in his time artists who tried to work in the ancient manner considered almost as their bible, the *Metamorphoses* of Ovid, the *Geneology of the Gods* by Boccac-cio, or Cartari's *Images of the Gods*. However, Cartari's writing main-ly influenced the art in the Cinquecento, the Mannerist and the Baroque periods.

Boccaccio, in his *Genealogia Deorum Gentilum,* was influenced by Petrarch. The style of his writing about gods was quite medieval combined with a humanistic spirit. This work of Boccaccio was cer-tainly circulated among the artists of the Quattrocento, but as far as the middle of the Cinquecento we can find traces of his influence. For example, on several occasions the figure of the Demogorgon appeared, of which classical antiquity had never heard. This figure was based on a description by Boccaccio. We have documentation that the Demogorgon figure was used during the festivals of the celebration of the marriage of Francesco de' Medici to Johanna of Austria, and the weddings of Cesare d'Este and Ferdinando de' Medici. The text of Boccaccio was based upon his study of Latin authors and authors from medieval times, and not direct Greek stud-ies. He used sources from Martianus Capella, Rabanus Maurus, Vin-cent de Beauvais, and from the mysterious origin of Thodontius.

The Encyclopedic tradition, especially the *Mirrors* of Vincent de Beauvais, greatly influenced Gothic cathedral decoration. The Labors of the months—Zodiacs, Vices and Virtues, etc.—were carved on the facade of the Gothic cathedrals in order to demonstrate the pictoral representation of the universality of the Church. The depiction of the planetary gods resulted in the growing interest in astrology during the Trecento, and this custom continued throughout the Quattrocento as well. In addition to the planetary deities, for example, Agostino Duccio, in his sculptural decoration, populated the Il Tempio di Malatestiano in Rimini with the Olympian gods and goddesses. Duccio's gods were not exactly Greco-Roman. For example, Jupiter became an Assyrian sun god, and others, like Apollo appeared as Osiris, and Mercury borrowed the form of the Egyptian Thoth. It is documented that the source of Botticelli and Mantegna's ancient divinities were Philostratus, Calistratus and Lucian, which is the reason that their classical approach was more original.

After Botticelli was influenced by Neoplatonic literature, he painted companion panels, the *Primavera* and the *Birth of Venus.* *Primavera* was conceived from the celebrated poem by Poliziano, who used as the basis for his poem the ancient classic lyricists Lucretius, Horace, Virgil, and Theocritus. *The Birth of Venus* is certainly the result of the direct influence of the marble statue *Venus Pudica* in the Medici collection, pervaded by a poetic sentimentality.

Although Antonio Pollaiuolo is said to have been the first artist to use mythological subjects for his paintings and sculptures, his presentation, especially of his *Hercules and Anteus,* was not classical at all. His ultimate goal, to create muscular forms in action, is extremely exaggerated, destroying their classical feeling. Others, like Perugino, fell into the same error. Perugino tried to represent his *S. Sebastian* in a classical manner. He is presented in a classical standing pose but the overly sentimental expression on his face is a contradiction of the true classical spirit. Domenico Veneziano's *S. John in the Desert,* in the Kress Collection in Wash., D.C., is a good adaptation of a pagan classical figure which was influenced by small bronze classical statuettes. S. John appears as a naked antique figure, but the surrounding hillsides show, more or less, the technique of the International Gothic style which quite counteracts the classical effect of the image of the saint.

The ancient cupid and putto figures also became important themes during the Quattrocento. Even in religious paintings, these ancient child figures became dominant. In the painting of Fra Filippo Lippi, *The Madonna and Child with Angels,* the Madonna appears as a young Florentine lady. The Christ child is a putto-like child held up by two little cupid angels. At the beginning of the Cinquecento, Raphael went even further in this paganism and enveloped the nude body of the putto-like Christ child in a certain accentuated sensualism.

Puttos, as decoration, often appeared on tombs holding garlands or shields. The tomb of Illaria de Caretto by Jacopo della Quercia, in the Cathedral of Lucca, is an imitation of a Roman sarcophagus with a band of puttoes holding fruit garlands, but with an expression of sorrow on their faces. In contrast to this image, jubilant puttoes are singing and dancing on the famous *Cantoria Cantata* of Donatello and Robbia made for the Cathedral of Florence. The exterior pulpit of the Cathedral of Prato bears witness to the skill of Donatello in modeling charming puttoes.

Verrocchio also specialized in children's images. Among them is the most outstanding and celebrated putto with a dolphin on the summit of the fountain in the Palazzo Vecchio, Florence. Due to the sculptors' influences, one can find the classical motif of puttoes in several paintings. On the S. Zeno altarpiece of Mantegna, in the architectural decorative details of the background, one can recognize a frieze of puttoes similar to those which Donatello carved for his Cantoria. A frieze with classical garlands and the heads of puttoes appears as well on the fresco of Ghirlandaio which he painted for S. Maria Novella entitled; *The Birth of the Virgin.*

It is documented that although pagan literature was the daily bread of the humanists, painting and sculture favored mainly pagan themes during the Cinquecento. It is remarkable to note that the Quattrocento chose mainly from mythology those subjects which, in presentation, created classical harmony and balance, but the same mythology inspired the Cinquecento artists to represent the bizarre stories which were attached to the god or goddess. In this manner, Venus painted by Botticelli appears as an emotionless, almost marble image of the Goddess of Love, mainly in the Platonic sense. As a contrast, the artists of the Cinquecento observed the same Venus as the goddess of physical love and even as the goddess of adultry.

Beginning in the Middle Ages, theologians were strongly opposed to pagan mythologies. Giovanni da San Miniato, a Camaldolese monk, and Giovanni Dominicini, a Dominican, preached against mythology. Despite this opposition, Niccolo Pisano made a statuette of Samson simulating ancient Hercules on the pulpit of the Baptistery of Pisa. His son Giovanni erected an almost life size nude "Virtue" under the pulpit of the Cathedral of Siena in a pudic pose much like Venus of ancient times.

Collucio Salutati defended mythological representation but Aenaes Sylvius Piccolomini (Pope Pius II) charged that Malatesta had transformed the Church of San Francesco into a pagan temple. The anachronism is that the same Piccolomini, in his eloquent prose, paid tribute to mythological allegories by using the technique of Ovid's *Metamorphoses*. Cardinal Paleotto made continual attacks against this mythological paganism, which finally reached a climax at the Council of Trent through the Jesuits. The result was that mythological subjects were barred from church decoration.

In architecture, especially on the facade, the pagan motifs returned also. Filippo Brunelleschi (1371-1446) and Leon Battista Alberti (1404-1472), who as papal inspector of Monuments from 1447-1455, radically altered and restored the fifth century circular churches such as S. Stefano Rotunda. Michelozzo di Bartholomeo appeared as a pioneer in secular architecture next to Brunelleschi and Alberti during the Quattrocento.

It is interesting to notice that all the great pioneers of architecture were not trained architects. Brunelleschi began as a goldsmith and sculptor and was a member of the Guild of Arte della Seta. Later he was admitted to the goldsmith guild (1404), when he lost the competition for the bronze doors of the Baptistery of Florence. He went to Rome with Donatello to study antique sculptures in situ. There he received his inspiration for architecture.

Alberti was a trained canon lawyer, playwright, musician, painter, mathematician and art theorist before he became an architect. Michelozzo was also a sculptor. Bernardo Rossellino (1409-1464) was commissioned by Pope Pius II to develop an urban plan for Pienza, built the cathedral and the palace in that city. The Lombardo family in Venice, who successfully blended together the Veneto-Byzantine and Greco-Roman classical style, were primarily sculptors and later turned to architecture.

It is noticeable that at the beginning of the Quattrocento the architects could demonstrate their interest in pagan classical antiquities only through reconstruction of medieval churches. Brunelleschi's S. Lorenzo in Florence (designed 1418) and Alberti's Il Tempio di Maletestiano (1446-1450) in Rimini are the best examples of this.

Brunelleschi, in S. Lorenzo added a block of ancient entablature above the capital of the nave's support columns. Above those blocks he placed the semicircular support arches. Between the clearstory windows and the arches he employed a decorative band of the antique architrave, frieze and cornice. In the interior decoration, Brunelleschi repeated the pagan classical decorative motifs several times. On the decoration of the aisles, he used pilasters on which he placed the same classical entablature. The old sacristy of S. Lorenzo was the only new construction while the rest of the church was redecorated by Brunelleschi in the new pagan taste of Renaissance Christianity. The old sacristy also strongly accentuated the classical decorative elements. Even the two doors of the sacristy are an imitation of a facade of a pagan Roman temple. Two projecting Ionic columns support the complete pagan temple superstructure, including the triangular pediment.

Alberti transformed the facade of the church of San Francesco in Rimini by borrowing the decorative motifs from the triumphal arch of Augustus in Rimini. On the exterior of the church, Alberti followed the Brunelleschian motif and put arches on supports although he used massive pillars instead of slender columns. A bronze medal by Matteo de' Pasti shows the facade of the church. Above the central gateway, another story was erected which was finished with a semicircular arch. This story enclosed large triple-mullioned windows. The story was flanked by half semicircular arches which served as buttressing for the central elevated parts.

Clearly, pagan motifs were used in the interior and exterior of Alberti's S. Andrea in Mantua, which was designed in 1470 but built after the death of Alberti. He adopted an Early Christian basilica plan with a nave covered by a gigantic Roman barrel vault. Instead of side aisles, Alberti designed a series of barrel vaulted chambers along both sides of the nave. The facade of S. Andrea is a combination of a Roman triumphal arch and a prostyle-tetrastyle Roman temple portico.

The recognition of the importance of man resulted in the reconstruction of cities in order to provide better living conditions. Palaces, squares with fountains, hospitals and other public and private buildings began to be constructed throughout the Quattrocento. In these new constructions, the decorative elements of the antique past were reproduced with remarkable skill. The Palazzo Ruccelai in Florence (1446-1451), which was a joint undertaking by Alberti and Bernardo Rossellino, is one of the best examples. On the facade of the building, the stories are superimposed in the same way as the Roman Colosseum or the Theater of Marcellus in Rome. Here Alberti divided the stories with a decorative band of classical entablature by imitating its supports with pilasters. The large compound windows on the second and third stories give the impression of the open arches of the Colosseum. The actual construction of the exterior of the Colosseum was imitated in the courtyard which Alberti made for the Palazzo Venezia in Rome.

Similar arrangements were fashionable throughout the Quattrocento in the major cities in Italy with slight variations. The major aesthetic goal was to create on the surface of the Renaissance building a strongly accentuated parallel line balanced by verticals.

Toward the end of the Quattrocento, and especially the beginning of the Cinquecento, this strong linearity of the facade of the building was modified by projected architectural details. However, the projection still retained a strong horizontality.

Sources

Allen, D.C., *Mysteriously Meant, The Rediscovery of Pagan Symbolism and Allegorical Interpretation in the Renaissance,* Baltimore, 1970.

Armenini, G.B., *Precetti della Pictura,* Ravenna, 1586-1587.

Bolgar, R.R., *The Classical Heritage,* N.Y., 1964.

Baldini, B., *Discorso sopra la Mascherata della genealogia degl' iddei de'gentili,* Florence, 1565.

Clark, K., *The Nude,* N.Y., 1959.

Estienne, R., *Dictionarium nominum varorum, mulierum, populorum, idolorum, urbium et quae passim in libris prophanis leguntur,* Paris, 1512.

Gilmore, M., *The World of Humanism,* N.Y., 1962.

Piano, G., *L'enigma filosofico del Tempio Malatestiano,* Bologna, 1928.

Sernec, J., *The Survival of the Pagan Gods, the Mythological Tradition and its Place in Renaissance Humanism and Art,* N.Y., 1961.

Humanism and Its Reflection on the Regional Art Centers

It is evident that the humanistic approach focused on different basic interests in the various regions of Italy. Chastel mentioned in his latest book, *The Flowering of the Italian Renaissance, I,* that epigraphical and archaeological humanism centered in Padua and was evident in Northern Italy. Philological and philosophical humanism centered in Florence and mathematical humanism in Urbino. This basic classification is partly based upon contemporary generalizations.

Concerning mathematical humanism, Luca Pacioli stated that the greatest artists depended on mathematical humanism, which came from the Urbino area, as expressed in the preface of his *Summa de Arithmetica, Geometria, Proportione e Proportionalitate.* Among the members of the group from Urbino, he mentioned Bellini, Mantegna, Melozzo, Luca da Cortona, Perugino, Botticelli, Filippo Lippi and Domenico Ghirlandaio. For this book, and another, *On Divine Proportione,* published in Venice, Leonardo da Vinci prepared 60 drawings. The book itself was a result of a discussion on mathematical proportion held in Milan in which Leonardo also participated.

The Florentines declared that art must be an *Ordo Mathematicus.* Under this influence, Alberti and Brunelleschi, in their work and writings, searched for the mathematical and geometrical laws of perspective. Marsilio Ficino, who wrote a commentary for the translation of Philebus in Florence, mentioned that mathematics rescued arts from "uncertainty and mere approximation." In the Scuola d'Abbaco in Florence, during the time of Leonardo, mathematics was taught. A series of papers on mathematics, *The Trattato d'Ab-*

baco. were issued by this school. In addition, a well-known textbook on mathematics, *Liber Abaci* by Leonardo da Pisa, was used. Alberti's book, *Ludi Mathematici,* was also influential in Florence. The scientific activities of Paolo Toscanelli in Florence were no doubt another great influential factor on the Florentine mathematic tradition, which was also reflected in the compositions of Florentine art.

In addition to the book by Luca Pacioli, a book on *De Musica* by Boetius (1492) was published in Venice. Other books which were based upon mathematical studies were published mainly in Florence or Rome. In 1482, a Latin edition of *Euclid* was published, and in 1486 the first edition of *Vitruvius* by Sulpitius appeared. However, the basic work on perspective was written by Piero della Francesca in Urbino. Luca Pacioli also settled for a while in Urbino and belonged to the circle which formed around the court of that city's ruler.

Epigraphical and archaeological humanism had a stronghold in Padua, but the influence of the ancient ruins of the city of Rome was not negligible. It is known that Mantegna himself participated in archaeological explorations in Padua. Marcanova collected inscriptions which were compiled and edited by Felice Feliciano in 1465. Fra Giocondo da Verona as an engineer and architect represented archaeological humanism which, according to Chastel, was derived from Cyriacus of Ancona.

A certain inscription which was collected by Marcanova appears in the background of paintings by Mantegna and Jacopo Bellini. There is an inscription on a Roman arch which Mantegna painted for the background scenery of *S. James before Herod Agrippa* for the Ovetari Chapel in the Church of Eremitani. The arch itself, according to Hartt, is a recreation of a Roman triumphal arch in the manner of Alberti. One can see under the medallion decorations on the left pillar of the arch an inscription, "T.PVLLIO T. L. LINO." The inscription of "III IIII V (iri), septemviri" is erroneous because the original text, as pointed out by Chastel, was Severi. The same inscription appears on a Roman epigraphical drawing by Jacopo Bellini, which is now in the collection of the Louvre. Under the drawings of the obverse and reverse sides of a commemorative coin of Augustus for the annexation of Germania (Germania Capta), Bellini used the same inscription but made even more errors by inscribing "IIIIII viro."

In Venice about the end of the century appeared the book by Preti, *De amplitudine de vastatione et de instuaratione urbis Ravennae* (1489), which was written from an archaeological point of view.

Even in the Proto-Renaissance in Rome, the work of Pietro Cavallini of the late 1200's manifested, besides its Byzantine overtone, a strong Roman classical character. Niccolo Pisano's panel on the marble pulpit of the Baptistery of Pisa, the *Adoration of the Magi,* shows a close relationship to the ancient Roman Phaedra sarcophagus.

Andrea Pisano carved on the lower row of the Campanille's decoration in Florence (c.1334) a composition of *The Art of Sculpture* in which a bearded sculptor is shown chiseling a nude classical figure from a block of marble. It is documented that Leon Battista Alberti and Brunelleschi spent a considerable length of time together in Rome in order to study antique sculpture and antiquities in general.

In the middle of the Quattrocento, Rome became a center for archaeological studies which culminated by the beginning of the Cinquecento. Raphael became the Inspector of Antiquities of Rome on August 1, 1514. Specifically, his task was to stop the use of ancient materials for new building construction. This vandalism had gone so far, that by the order of Sixtus V, the Septizonium had been destroyed and used as building material for S. Peter's. Raphael's chief task was to select material from among the Roman ruins which could be reused in building projects. The instructions which Raphael received from the Holy Office especially emphasized the saving of stones with inscriptions on them.

It is noticeable that even from Florence, a group guided by Alberti, Donato Acciaiuoli, Giovanni Rucellai and Lorenzo the Magnificent made a study trip to Rome. Previously, Flavio Biondo had written a book on *Roma Instaurata.*

Chastel was in accord with others in pointing out that some of the collections which were in Venice had been taken to Rome. When Cardinal Pietro Barbo became Pope Paul II, he took his famous collection of Roman medals with him to Rome. Boldi started to imitate ancient coins in Venice and small Roman statuettes dominated the taste of Northern Italians for a long time. However, we learn from Michelangelo that when he first arrived in Rome what a folly this collecting was. The making of copies of antique statues had already been shifted to Rome by the end of the Quattrocento. Michelangelo wrote in his letter that the people of Rome had such a great love for

antiquity that some clever sculptors were manufacturing fake antiques. He bitterly added that he knew a man who paid 200 ducates for a questionable antique cupid, but would not have given 20 had it been signed by Michelangelo Buonarroti.

The philological and philosophical humanistic center was the Florentine Platonic Academy, which developed a Tuscan lyrical tone in its arts, both in literature and in painting. This touch is recognizable in the classical work of Botticelli. Chastel said that poetry, theology and mythology pointed to one and the same end. It is known that Venice was another disseminating center, through its printing presses, of the thought of the Greek classics. It's reaction on Venetian art, however, was far from the Florentine experience.

Sources

Benesk, O., "A New Contribution to the Problem of Fra Luca Pacioli," *G. B. A.,* LXIV, 1954, pp. 203-206.

Carden, R.W., Michelangelo, *A Record of his Life as told in his Own Letters and Papers,* London, 1913.

Chastel, *The Flowering of the Italian Renaissance,* N.Y., 1965.

Hart, I.B., *The Mechanical Investigations of Leonardo da Vinci,* Los Angeles, 1963.

Taylor, D., *The Notebook of Leonardo da Vinci,* N.Y., 1960.

Zerner-Klein, *Italian Art, 1500-1600,* N.J., 1966.

CHAPTER 7

Rediscovery of
Nature Through Science
Its Reflection on Art

In order to create a well-balanced and proportioned natural image, the most important prerequisite is the study of perspective, foreshortening, anatomy and nature itself. The artists of the Renaissance gradually became familiar with mathematics and geometry which were important for the creation of beauty through compositional harmony. Besides the conventional media of painting and sculpture, marquetry received recognition during the Quattrocento in Italy. These intersia works mostly depicted perspective city scapes in which the architectural views became dominant. In addition to these city or street views, landscapes, still lifes, and animal figures also appeared. The remarkable foreshortening and perspective representations bordered on extremely illusionistic optical effects. The mastery of depth was quite well advanced from the primitive imitation of perspective by Giotto, through Masaccio and Piero della Francesca, to the great masters of marquetry in the sensation of space.

Perspective

Giotto is considered the father of modern painting tradition, at least in Italy. In his wall paintings in the Arena Chapel in Padua, he attempted to create perspective and foreshortening through his personal observations. In certain compositions, as in *Christ Entering into Jerusalem,* he achieved a sensation of depth by setting his figures on a sloping road leading toward the city gate of Jerusalem. Giotto—by rendering the figures along the road, some of them bowing, some of them laying down—gives a real sense of perspective in contrast to the

group behind Christ which is arranged in the manner of the Italo-Byzantine tradition. The figures which are behind each other are only elongated in order to indicate space but they do not really create a sensation of depth.

Duccio fell into the same mistake on his *Christ before Pilate* which is part of his famous Majesta. The figures in the groups which flank the Christ figure in front of a door are arranged in a strong Italo-Byzantine manner; however, the architectural background behind Christ gives a certain impression of depth.

Masaccio first perfected perspective as Giotto and his followers had attempted to do. By the use of linear perspective and illusionistic plastic modeling of his figures, Masaccio gave a new direction for Renaissance artists throughout the whole century. His organization of space and his firm placement of figures on the ground were an example for others.

The discovery of the mathematical laws of perspective was attributed to Brunelleschi. After Brunelleschi, theorists like Alberti, Piero della Francesca and Leonardo da Vinci, among others, wrote and put these theories in practice. During the Cinquecento, a dispute developed over perspective between theorists and practicing artists.

Alberti, in his *De Pittura,* connected perspective with naturalism which required plasticity for the imitation of natural form. One of the best early followers of this theory was Fra Angelico. His *S. Marco Altarpiece,* (C.1438-1440) in the Museum of S. Marco, Florence, can be given as an example for a clear understanding of the theory of Alberti.

To help the artist even further, Alberti invented an instrument which the artist could place between himself and the object in order to create the correct perspective view. Alberti's approach was based upon mathematical and geometric calculations but as a means of rechecking the sensation of depth the device was quite helpful. Piero della Francesca's publication on the theory of perspective was a result of his life-time experimentation. It is evident that he absorbed Alberti's idea of proportion, but Francesca's perspective and proportion were based rather upon the Euclidean system. In addition to his mathematical and geometric calculations, Francesca placed emphasis on optical illusion, which created the sensation of depth by using the response of the retina of the human eyes. This tendency is clearly demonstrated in his *Legend of the True Cross* which he painted on

the walls of the Church of San Francesco, Arezzo. A similar organization of space already existed in the fresco cycle by Masaccio in the Brancacci Chapel of the Church of Carmini—specifically in the scene of *The Tribute Money.* However, the special organization of Piero della Francesca was accentuated as a visual sensation largely through the aid of the manipulation of the effects of colors.

The Venetian Jacopo Bellini also practiced Alberti's perspective method, which he expressed so well in his *Madonna and Child with Donor,* now in the Louvre. He left two sketchbooks which were bound in a hard cover. One is in the Louvre and the other in the British Museum. The drawings in his sketchbooks are an eloquent testimony to his keen interest, not only in mythological and fantastic drawings, but in Alberti's law of perspective. Bellini handed over this new knowledge to his sons and, through them, to the next generation of Venetian artists.

Alberti's perspective grid was also used by Mantegna and his followers. One of the best examples of Mantegna's understanding of this theory is the fresco cycle in the Ovetari Chapel of the Church of Eremitani in Padua. These frescoes were destroyed by bombardment in 1944.

Castagno also used the basic principles of Alberti's theory of perspective, but he added second vanishing points when he felt it was necessary. In his *Last Supper,* for example, which he painted for the Cenacolo of Santa Apollonia in Florence, he established a seperate vanishing point for the ceiling. In addition, with strong contrast of light and shade, Castagno reached a sensation of pictorial relief which also strengthened the feeling of three dimensionality. In some of his later works, the figures are so sculpturesque that they give the impression of actual statues. In Castagno's series of famous men and women, which he painted for the Villa Carducci in Legnaia, the figures strongly convey a sculptural quality and appear to be projecting out from the frame.

Vasari mentioned that Paolo Uccello was capable of projecting a polyhedron and was also a great master of perspective. The greatest demonstration of his skill is the equestrian portrait of Giovanni Acuto on the interior wall of the Cathedral of Florence. It is generally accepted that Uccello used the pattern of perspective according to Alberti's thesis. Recently, both Millard Meiss and Hans Ernst Mitting argued that Uccello did not use Alberti's formula, but followed the

perspective composition of Masaccio's *Trinity*. However, it is generally accepted that Uccello, in other compositions, followed the Albertian theory of perspective in clearly creating the "orthogonals" and "transversals."

It is important to note that Donatello already used the same constructional lines for his architectural background in his relief panels, later described by Alberti as a visual pyramid. However, certain parts of Donatello's relief composition did not follow his established use of one vanishing point.

Ghiberti, who was a personal friend of Alberti, also used the Albertian conception for the sensation of depth, especially in the panel reliefs on his celebrated *Porta Paradiso*.

\It is logical to conclude that Alberti's thesis of perspective was the result of a crystallization, in the mind of a theorist, of the efforts of several individual artists during the artistic fermentation period striving for nature's visual effect of depth. Pietro Lorenzetti, for example, long before Alberti's thesis, used one vanishing point to achieve a correct perspective view, but in a very primitive pictoral manner. In order to really achieve a natural look, the use of perspective was not enough. The next step was to use the objects and figures in space in correct proportional relationships.

It is noticeable that North Italian painters, especially those which we call the painters of the International style like Pisanello, were not really interested in proper perspective. Nevertheless, it is evident in some of the drawings of Pisanello that he was acquainted with Alberti's perspective methods and was able to handle them well.

Mantegna liberated himself from the International style and, through his classical studies and direct contact with the works of Donatello and Giotto, developed into a truly classical Renaissance painter. Despite his primary interest in classical themes and its imperative requirements of harmony, balance and proportion, he went to the extremes of illusionistic depth through his experimentation in foreshortening. The *Dead Christ* (1466) by Mantegna is only a prelude to the illusionistic space which he created in the ceiling of the Camera degli Sposi (1474) in the Palazzo Ducale, Mantua. This ceiling later certainly inspired Mannerist art and the ceiling painters of the Baroque.

Perugino (c. 1445-1523), studied mathematics first from Luca Pacioli and later from Verrocchio. He imbibed the Florentine's pref-

erence for Albertian perspective and introduced a type of spatial composition which was mastered by Raphael in the High Renaissance and which influenced the Umbrian painters of the late Quattrocento.

There is a clearly recognizable relationship between the spatial composition of Perugino's *Christ giving the Keys to S. Peter* (1481), on the wall of the Sistine Chapel and Raphael's panel of the *Marriage of the Virgin* (1504) in the Brera Gallery, Milan. The organization of space, the architectural manipulation of perspective, and the use of Alberti's grid is evident in both works. Raphael, in his *School of Athens,* still had a tendency to use the organization of space which he learned from his former master Perugino; but by overemphasizing the architectural background and setting several isolated groups in the picture plane, he disturbed the quiet compositional balance. This clearly reflects the influence of Perugino's work. At any rate, the High Renaissance already opposed the quiet, solemn, well balanced and proportioned tendency of the Quattrocento.

Francesco di Giorgio (1439-1502) was quite eclectic in his style. We can observe work which ranges from Duccio's tradition to Baldovinetti's bird's-eye view landscape, and the combination of the styles of Ghiberti, Donatello, and Pollaiuolo. In the numerous perspective drawings which he used for his proposed city plans, Francesco managed perspective in the same way as in his later paintings and sculptural reliefs. Luciano Laurana also designed architectural views similar to the ones by Francesco di Giorgio which appear as "portraits" of an architectural complex.

\ Leonardo da Vinci followed to a certain extent the one point perspective construction of Alberti, but Leonardo, on the other hand, appears to be an innovator of "aerial" perspective. Leonardo, in his writings, treated perspective only as an optical study. He concluded that our vision responds to color of the object which is transformed from time to time by atmospheric conditions. He advocated, in addition, that the surface of every opaque body shared in the color of the surrounding objects. The late 19th century painters expanded Leonardo's thesis in their own color theories.

Architectural Background

The importance of the use of architectural backgrounds to achieve a better sensation of space was indicated early in the works of Giot-

to. However, Giotto's architectural backgrounds and those of some other early artists of the Quattrocento were quite unnatural and give us an impression rather of a doll house, a stage design for a mystery play or tents for festivals, rather than a feeling for real architecture.

It took a considerable time to harmonize the size of figures with architecture in order to overcome the "miniature" effect of illuminated manuscripts.

Certain painters, like Benozzo Gozzoli, though he worked with the theory of the formula of perspective, give an extremely awkward image in the relations of figures to architectural setting. In contrast to this, *The Visitation* by Ghirlandaio in the S. Maria Novella, Florence is an excellent example of a well proportioned relationship between architectural setting and figures. In addition to this, the foreshortening of the wall and the architectural elements appear to be the main topic of the painting instead of the story of the Visitation. This painting is one of the best examples of how artists in the Quattrocento, to demonstrate their skill in one area, almost overpower the original subject matter.

Artists like Mantegna and Botticelli, as a result of their classical studies, sometimes used an imitation of a large monumental classical building as a triumphal arch for their backgrounds. In addition, they harmonized the proportion of the giant triumphal arch to the surrounding figures between the arch and the foreground quite well.

The development of cities like Florence and Rome, which at this time were being rebuilt from slums, also influenced the background arrangements of paintings. The backgrounds of more and more paintings employ contemporary architecture with classical overtones. This is the time when central types of architecture, especially central-type churches, became fashionable. Consequently, several artists used them for architectural backgrounds in their paintings. For example, an octagonal building with an immense central dome stands in the background of the canvas of Victore Carpaccio's *Arrival of the Ambassador of Britain at the Court of Brittany* (c.1495) now in the Accademia, Venice. During the early Cinquecento, Raphael, in his *Marriage of the Virgin,* was probably influenced in architectural background by his friend Bramante who had probably already made some sketches for his Il Tempietto di S. Pietro in Montorio. It is noticeable that the circular church in the background of the *Marriage of the Virgin* is still multi-faced, which was a product of the Quattro-

cento. However, Bramante's Il Tempietto in its basic plan clearly follows a Roman circular Vesta Temple plan.

The development of architectural backgrounds from the early attempts to the end of the Quatrocento is a rather remarkable achievement. The early "doll houses" slowly, through scientific studies by painters and sculptors, went through many naturalizing changes. Painters and sculptors became self-made architects or at least made architectural drawings in order to suggest new architectural styles and in order to be a part of the great urban planning program of the Quattrocento in Italy. The architectural suggestions of Francesco di Giorgio, Giuliano da Sangallo and Leonardo da Vinci were indeed incorporated to assist in architectural planning. In addition, Preti's *De amplitudine de vastatione et de instuaratione urbis Ravennae,* published in Venice, Fra Colonna's *Hypnerotomacchia Polyhili,* and Flavio Biondo's book *Roma instaurata,* strongly influenced art and architecture. The growing evidence of the interest in architecture naturally influenced artists in their wish to be more accurate in their depiction of architectural backgrounds. In order to recognize the differences in approach it is useful to compare Fra Angelico's *Miracle of S. Nicholas,* a predella from a polyptych in Peruggia, with Piero della Francesca's *Flagellation* in the Palazzo Ducale, Urbino. Both paintings have an extremely foreshortened architectural element which divides the space into two parts, but the total natural effect of architectural perspective is very different.

When perfection of harmony and proportion had been reached, painters went even further and searched for methods leading through imaginative space into the infinite. This new representation of space reached its culmination during the Mannerist and Baroque periods.

It is important to mention that Turkish design was also used in architectural drawings, perhaps due to the diplomatic relations of the Florentine Signoria. Benedetto Dei between 1460 and 1470 made a journey to Turkey on a diplomatic mission. Also, the great Turkish humanist, Mahomet II, invited Gentile Bellini to his court. At the same time, Pope Pius II, in a letter to the Sultan, offered to recognize the territories of the Turkish advancement if the Sultan would become a Christian. Documentation for this is given in Chastel's *Flowering of the Renaissance.* Pfefferman, in his book *Die Zusammenarbeit der Renaissance Papste mit der Turken* (Winterthur, 1946) was the first to document this. It is no wonder that this spirit of peaceful

coexistence was in the minds of some artists. The background of a painting by Filarete is in the classical manner, but has an addition which is reminiscent of a Turkish minaret.

However, painters were also influenced by the horror of the massacre by the Turks at Otranto. When Matteo di Giovanni painted his *Massacre of the Innocents* for the Sant'Agostino in Siena, he artistically alluded to the Otranto massacre. He painted the Sultan on a classical, decorated high throne with a devilish expression ordering the "massacre." By replacing the figures which was described in the New Testament, a biblical scene became a contemporary form of protest.

Landscape Background

Another important method in creating natural images was to borrow models directly from nature. A few Italo-Byzantine artists during the Dugento in Tuscany had already introduced a strongly schematized landscape as background for scenes flanking a crucifix. In the book by Cennino Cennini, one can find a formula for landscape painting. He advocated the observation of nature in a rather unusual way. Cennini urged the artists to keep some large rocks and several branches of trees in their studio. Perhaps Giotto had used this technique in his representation of rocks and vegetation. It is noticeable that Giotto's sky is simply a blue background without any indication of atmospheric conditions, as was suggested by Leonardo at the end of the Quattrocento. Leonardo summarized in his numerous writings the importance and the logical requirement of atmospheric conditions which alter natural colors. He gave instructions for the indication of aerial perspective in order to show the proper atmospheric conditions between the observer's eye and the object in the distance.

In his landscape backgrounds, in order to show depth within the foliage of the trees, Giotto painted the foremost leaves lighter. Several landscape backgrounds by Giotto represent only a tendency toward nature by depicting merely the aspects of the main iconographical requirements. In the *Flight into Egypt* (c.1305) in the Arena Chapel, for example, the rocky background is only a repetition of the triangular composition of the central group. The famed master of S. Francis figures, Giotto greatly advanced landscape technique with his fourteenth century *S. Francis Giving His Cloak to the Beggar*, a

portion of the fresco cycle in the upper church of S. Francesco at Assisi. The work is more or less based upon observation and not merely the imitation of nature. The representation of the hillside is still very primitive, but evidently not made after the Cennini recipe. It is well documented that Giotto's influence on the creation of landscape was strong until Masaccio, who in turn influenced most of the painters and several sculptors as well. A good comparison would be Giotto's small painted trees and the trees which are in Andrea Pisano's reliefs, specifically the relief decorations of the Campanile of Florence which was made around 1334 or later.

A similar tendency in landscape backgrounds is evident in the works of the painters of the school of Siena during the Trecento. The landscape backgrounds painted by Duccio also more or less reflect the imitation of nature and were used only to underline the major compositional elements. The direct observation of nature was already found in the work of Ambrogio Lorenzetti's *Allegory of the Good Government* (1338-39) in the Palazzo Publico, Siena. The artist, if only in a primitive way, depicted an easily recognizable farmland which is projected for a considerable distance.

The landscape by Gozzoli in his *Procession of the Magi* (1459), painted on the wall of the chapel in the Palazzo Medici-Riccardi, shows a rocky landscape with certain similarities to the landscape in *The Triumph of Death* in the Camo Sancto in Pisa, attributed to Traini. In Traini's landscape, two different styles are evident. The style of the trees behind the seated group follows the International style which gives the impression of an imitation of a Franco-Flemish tapestry. This tapestry-like image is even more accentuated on the altarpiece of Stefano da Zevio where the Madonna with her Child sit in a garden surrounded by angels, birds, and other imagery.

The first truly recognizable natural representation of landscape is attributed to Masaccio. In his fresco, *The Tribute Money,* one can find the model for landscape presentation which already indicated the soft atmospheric conditions of nature. In order to reinforce the spatial existence of the figures, he even projected the halos of the figures in perspective. In addition, it is most important to recognize that his figures are firmly standing on the ground. With his system of rendering light on the surface of figures, he created a truly sculptural effect which influenced painters throughout the entire Quattrocento.

Soon painters, especially in Florence, Padua, Venice, Perugia, and Urbino, developed through personal experimentation their own unique style of landscape.

In Florence, the rendering of landscape was quite varied. Ghiberti, in his *Porta Paradiso,* reflects the theory of Alberti as far as perspective is concerned, but the setting of the landscape is only made on the level of Giotto's landscape representation.

\The Florentine artists were more interested in perspective and from time to time would demonstrate their skill in landscape, but they did not develop a strong landscape tradition. Only Leonardo da Vinci was seriously interested in landscapes as result of his botanical studies, as seen in his *Madonna of the Rocks.*

It is possible that, due to the influence of Flemish art, the bird's-eye view type of landscape background appeared in Florence, especially as a background for portraits. Botticelli's *Young Man with a Medal* (1470's) or Ghirlandaio's *Old Man with a Child* (c.1480) are the best examples of this type of landscape.

\Outside of Florence, the Umbrian "soft" landscape style became influential. It was represented best by Perugino and his followers. In Padua, Mantegna created rocky landscapes and cityscapes as backgrounds for mainly religious compositions, which evidently influenced Venetian landscape tradition through the Bellini family. At the end of his career, Mantegna changed his landscape style to a more poetic character. His *Parnassus* (1497), in the Louvre, especially reflects his continued interest in mythology. It is not executed with his former powerful expression but rather has a more lyrical sentimental overtone. At the summit of a cave, Mars softly embraces the nude Venus while Vulcan at the left gestures menacingly at the amorous couple. Nymphs dance around the cave while Orpheus provides the music for them. At the right Mercury stands with his winged horse, Pegasus. The rhythm of the dancers serves to underline the melodic character of the scene.

The Quattrocento in Venice, especially under the leadership of the Bellini family, beheld the great awakening of Venetian landscape tradition. This tradition culminated during the Cinquecento in the works of Giorgione, Titian, Tintoretto and Veronese. Among Giovanni Bellini's experimentations, one can find a landscape which, besides its naturalistic achievement, shows some strong symbolic character.

The Pieta (c.1502) by Giovanni Bellini in the Accademia of Venice, depicts a cityscape in its background. In the foreground, he painted a very medieval-like Madonna who holds in the lap her dead son, Jesus. Next to the Madonna, Bellini painted a freshly-cut tree with new branches springing from the mutilated trunk. Here Bellini wanted to underline the death and the resurrection of Christ.

It is evident that Venetian art received direct and indirect influence from Flemish art and then from the rest of the art centers in Italy. These influences greatly changed landscape representation in Venice. For example, in Carpaccio's great fresco cycle, *Life of S. Ursula,* the minute details of the Flemish tradition are evident.

The indirect Flemish tradition was transmitted through Antonello da Messina who became acquainted with the Flemish pictoral manner in Naples and developed it to a high degree. During his short stay in Venice, Messina attracted several artists to this particularly meticulous style. In Central Italy at about the same time, certain works by Domenico Veneziano and Piero della Francesca were done in the Flemish fashion before Raphael developed it into a highly sophisticated style.

In Ferrara under the leadership of Cosimo Tura (c.1430-1495), Francesco del Cossa (c.1435-c.1477) and Ercole dei Roberti (1456-1496), a new Ferrarese landscape tradition developed which culminated in the allegorical frescoes of the Palazzo Schifanoia.

The technique of Cossa is rather bizarre. He placed a great number of carefully defined architectural fragments within his fantastic landscape.

Sources

Berenson, B., *Italian Painters of the Renaissance,* I-II, London, 1952.

Berti, L., *Masaccio,* Univ. Park, Pa., 1967.

Bode, W. von, *Florentine Sculpture of the Renaissance,* London, 1908.

Borenius, T., *Florentine Frescoes,* London, 1930.

Borsook, E., *The Mural Painters of Tuscany from Cimabue to Andrea del Sarto,* London, 1960.

Brandi, C., *Il Tempio Malatestiano,* 1956.

Chastel, A., *Botticelli,* Greenwich, Conn., 1958.

Crowe and Cavalcaselle, *History of the Painting in Italy,* N.Y., 1961.

Dewald, E., *Italian Painting, 1200-1600,* N.Y., 1961.

Gardner, E., *The Painters of the School of Ferrara,* N.Y., 1911.

Hartt, F., *History of Italian Renaissance Art,* N.Y., 1970.

Marle, R., *The Development of the Italian Schools of Painting,* I-XIX, The Hague, 1923-38.

Mather, F., *A History of Italian Painting,* N.Y., 1960.

Meiss, M., *Giotto and Assisi,* N.Y., 1960.

Nicholson, B., *The Painters of Ferrara,* Cosimo Tura, Francesco de Cossa, Ercole de Roberti, et al., London, 1950.

Ofner, R., *A Critical and Historical Corpus of Florentine Painting,* N.Y., 1930-1967.

Pope-Hennessy, J., *Italian Gothic Sculpture,* London, 1963.

Turner, R., *The Vision of Landscape in Renaissance Italy,* Princeton, 1966.

Venturi, L., *Italian Painting,* N.Y.

Light and Shade

With few exceptions, cast shadows were not indicated in painting until the beginning of the Quattrocento. They were not even found in the works of Giotto, who is considered the originator of naturalism in the Trecento. Gentile da Fabriano is believed to be the first Italian painter who started to paint cast shadows. He followed the efforts of Taddeo Gaddi and Lorenzo Monaco in depicting night scenes. This theme later became fashionable during the late Mannerism and the Baroque periods.

Frederick Hartt pointed out in his latest publication, *History of Italian Renaissance Art*, that Pietro Lorenzetti used "material" and "spiritual" light for his fresco of the *Last Supper* in the lower church of S. Francesco, Assisi (1320's or 1330's). The room where the Last Supper takes place is lit by the halos of Christ and the apostles. The adjacent kitchen is illuminated by a fire in the fireplace. In addition, the stars and the crescent moon indicate night in the background. Until the work of Piero della Francesca night scenes were rendered rather artificially. By experimenting with light, Piero della Francesca in his *Vision of Constantine* made an accurate representation of moonlight. The scene is part of the fresco cycle for the *Legend of the True Cross* in the Church of S. Francesco, Arezzo. Although he caught the true sensation of natural light, he divided the highly lit areas from the dark by creating a linear distinction in the lighting on the surface. This technique does not give the real sensation of naturally thrown light which smoothly penetrates the surface according to its formation. Masaccio, for example, used *chiaroscuro* masterfully in his frescoes in the Brancacci Chapel of S. Maria del Carmine,

Florence. It was Leonardo who finally codified this technique in his notebook, which Masaccio had felt only through his appreciative senses of how an artist should create form through the play of light and shade. Leonardo wrote that with the "intensification of light and shadows, the face gains relief, for the illuminated part has almost imperceptible shadows and the shaded part has almost imperceptible light." In regard to shadows, he declared that "when a white object is seen in the open air all its shadows are blue." Masaccio indicated shadows—as Leonardo did later—by giving a bluish light to distant landscapes. He manipulated light and color in order to establish, as far as possible, a natural scene. Leonardo was against working in direct daylight because, as he expressed it, the morning light or late-afternoon light helped bring out the strong contours of nature and lends grace to the face. He even gave directions as to how artists should equip their studios in order to achieve a dimmed light effect.

Ghirlandaio followed Masaccio's tradition in his *Calling of SS. Peter and Andrew* (1481) fresco for the Sistine Chapel in the rendering of light although he was never able to achieve the same dramatic quality. On the smoothly lit faces, Chirlandaio masterfully employed the diffusion of light. In contrast to this, Botticelli, with his direct light usually lit the background as well as the foreground. This use of light minimized the possibility of a gracious play of light and shade on the figures. In addition to this, Botticelli displayed a strong anti-atmospheric tendency in his paintings which was violently criticized by Leonardo.

The acceptance of naturalism and sculptural effects during the second half of the Quattrocento resulted, during the Cinquecento, in exaggerated extremes of naturalistic representations.

By the Quattrocento, artists, mainly Florentine, began to experiment with the creation of form through light and shade. Masaccio had already taken the initial steps, but often the shadow side of his forms diffused into the background. In contrast, Piero della Francesca wanted to achieve a form which had reflected light on the shadow side. Piero detached the form from the background and created a solid sculptural image in the lighted space. In order to underline this effect, he often darkened the foreground. He used warm colors for light and cold colors for shades. The Neo-Impressionists like Seurat and Signac in the late 19th century adopted and revived this manipulation of color.

The interest in the effect of light on form was already occupying artists before Piero della Francesca, especially seen in the work of Domenico Venetiano. As a follower of Venetiano, Piero della Francesca wished to achieve light on form through the theories of Brunelleschi and Alberti by using supplementary architectural background. Uccello and Castagno achieved a sculptural effect rather, in a flat background.

There is, certainly, a recognizable chain in the development of the use of light through Masaccio, Fra Filippo Lippi, Domenico Veneziano and Piero della Francesca. Masaccio's tendency to use deep shadows was eliminated by Fra Filippo Lippi in his use of brilliant colors. In order to reach the plastic value within one dominant color, Lippi varied the intensity of the color. Domenico Veneziano's innovation was the use of outdoor light which he manipulated to gain sculptural forms. His forms, perhaps were derived from the Burgundian tradition of heavy drapery which was also used by the sculptor Donatello with a high degree of mastery. Finally, Piero della Francesca continued Veneziano's innovation in the use of outdoor light. In addition to this, he developed the use of natural light for indoor scenes as well.

Some Florentine artists, inspired by the works of Jan Van Eyck, whose paintings appeared in Florence about one decade after the death of Masaccio, used similar light sources. Fra Angelico, despite his strong inheritance from Giotto and Masaccio, made numerous panels in which the light was treated according to the Northern manner. However, the use of light sources through the windows and open doors was not handled by Fra Angelico entirely in the Northern fashion. In Flemish art, the light which comes through the doors or windows casts shadows and lights the rooms; they are the primary light sources. In the *Miracle of the Deacon Justinian* from the predella of the S. Marco Altarpiece in the Museum of S. Marco, Florence, Fra Angelico used primarily light which came from the front and was directed slightly toward the door. The tiny window and the open outside door which is visible through the door of the box-like room serve just as a secondary light sources. However, the existence of the Northern light effect can not be denied in Florentine painting. In general, it was foreign to the Florentine tradition and was only used as a curiosity by certain artists. The strong revival of the Flemish manner took place in Venice and was inspired by Antonello da Mes-

sina who studied this technique from Flemish-trained Spanish masters in Sicily. Some of his works, especially his handling of light sources, resembles the works of the Van Eyck brothers and Hans Memling. This style, which opened the era of the Venetian Cinquecento, was employed by Victore Carpaccio who demonstrated his skill in the *Dream of S. Ursula* of the S. Ursula fresco cycle, now in the Accademia in Venice.

Mystical light was also often used by artists. Here the source of light came from the holy object itself. Halos often radiated light around the figure. A particularly sacred symbol, like the dove which symbolized the Holy Spirit, appears in a pool of golden light. Perhaps this practice was associated with the teachings of the Neoplatonic philosopher Plotinus (205-270 A.D.) which were being re-examined in the Quattrocento. He avowed the possible union with God through moral purification and intellectual enlightenment, in which God functions as the source of light. Fra Angelico demonstrated this golden atmosphere with a gigantic ray of light behind the scene of the *Coronation of the Virgin* (c.1430) in the Uffizi, Florence. Pope-Hennessy labeled this style as a "negative" mystical tendency in contrast to a "positive" one in which landscape architectural details, valleys with curling rivers, serve as background for the scene in the life of Christ, which thus takes place on earth and not in heaven. Figures with contemporary garments around Christ underline this positive mysticism. This change appeared around 1435-1445. At first, they were used simultaneously with the negative mysticism which diminished as the naturalism of the Quattrocento progressed. Fra Angelico painted another *Coronation of the Virgin*, now in the Louvre, in which the coronation takes place on earth and not in heaven. It is naturally lighted in order to express the early atmosphere.

Sculptors also contributed to the light studies of the Quattrocento. They sometimes aided the studies of painters who would watch the effect of light on their sculpture in order to develop a sensitivity for pictoral plasticity and employ their observations in the painting.

Ghiberti crystallized his technique in the rendering of light on the surface of his sculpture. He codified this technique in his *Commentarii*.

Donatello, in his *Rilievo Schiacciato,* suggested an optical method for obtaining form which was achieved by light effects. Donatello's

use of extremely high and low relief within the same composition gave infinite possibilities to the play of light and shade on the surface of his highly polished marble reliefs. A pupil of Donatello, Desiderio da Settignano, reached the height of luminosity in marble but he was never really able to portray a true physiognomy, as Benedetto da Majano had been able to achieve. Antonio Rossellino, by roughening the surface to get the right light effects, made a brilliant lifelike bust of Matteo Palmieri. Benedetto da Maiano was able to capture a realistic quality for the bust of Pietro Mellini by rejecting a highly polished surface in favor of a Flemish precision which was combined with an ancient Roman majestic realism. In this case, light and shade were naturally employed by following the minutely detailed formation of the portrait head.

Donatello, in his late period, introduced an extremely rough surface which was later used in the late work of Michelangelo. This technique was again found in the work of the Impressionist sculptors of the 19th century, particularly in the work of Medardo Rosso and Rodin.

Sources

Argan, G., *Fra Angelico; Biographical and Critical Study,* Cleveland, 1955.

Brandi, C., *Pietro Lorenzetti,* Rome, 1958.

Carli, E., *All the Painting of Paolo Uccello,* N.Y., 1963.

Chastel, A., *Botticelli,* Greenwich, Conn., 1958.

Clark, K., *Piero della Francesca,* N.Y., 1951.

DeWald, E., *Italian Painting,* N.Y., 1961.

Hartt, F., *History of Italian Renaissance Art,* N.Y., 1970.

Hendy, P., *Masaccio, Frescoes in Florence,* Greenwich, Conn., 1956.

Jahnson, H.W., *The Sculpture of Donatello,* I-II, N.Y., 1957.

Lauts, J., *Domenico Ghirlandaio,* Vienna, 1943.

Meiss, M., *Giotto and Assisi,* N.Y., 1960.

Oertel, R., *Fra Filippo Lippi,* Vienna, 1942.

Pope-Hennessy, J., *Italian Renaissance Sculptors,* London, 1958.

Richter, J., ed., *The Literary Work of Leonardo da Vinci,* Oxford, 1939.

Richter, G.M., *Andrea del Castagno,* Chicago, 1943.

Toesca, P., *Florentine Painting of the Trecento,* N.Y., 1929.

Biographies of
Artists and Architects

ALBERTI, Leon Battista (1404-1472)

Alberti was born in Genova, February 18, 1404 and died at Rome in April of 1472. He was an Italian humanist, painter, poet, writer, philosopher, and musician as well as renowned architect.

1414 Alberti's family moved to Venice.

1426 Wrote two small works on love, *Ecatomfilea* and *Deifira.*

1428 Graduated in law.

1428 Hired by Cardinal Albergati as secretary and with him travelled to Borgogue and Germany.

1431 Hired by the papal secretary, Biagio Molin, and worked as clerk for the court of Eugenius IV in Rome. His residence in Rome was very decisive to his future for there he could study the ancient buildings of Rome, such as the Pantheon, Colosseum, Terme, and Marcellus Theater.

1434 Pope Eugenius IV had to escape from Rome to Florence and Alberti went with him. In Florence, he met such men as Cosimo and Lorenzo de' Medici, Donatello, Brunelleschi, Lucia della Robbia, and also observed Masaccio's works.

1435 Wrote *De Statua,* a treatise for sculptors, and another for painters, *De Pictura,* dedicated to Brunelleschi.

1436 Pope Eugenius IV moved to Bologna and Alberti again went with him. There he wrote the following essays: *Religio, Virtus, Patientia, Felicitas, Parsimonia, Paupertas, Teogenio, Della Tranquillita dell' Animo* and *De Equo Animante.* The last was dedicated to Lionello d'Este on the occasion of the erection of an equestrian statue in Ferrara. He also wrote four books called *Della Famiglia.*

1447 The newly elected Pope Nicholas V asked for Alberti's cooperation in the renewal of the urban pro-

gram for Rome. Alberti described his ideas about this program in a book called *Descriptio Urbis Romae.*

1448 Prince Prospero Colonna engaged Alberti to raise an ancient Roman ship from the bottom of Lake Nemi.

1450 *De re Aedificatoria* appears in 10 volumes. He based this large work about architectural theories of aesthetics and mathematics on the work of Vitruvius. Prince Sigismondo Pondolfo Malatesta invited Alberti to Rimini to enlarge and modify the exterior of the church of S. Francis in Rimini.

1455 Because of the death of Pope Nicholas V, Alberti had to stop his activity as an architect. In this year, he wrote *Mosca, Trivia,* and *Canis*—the last work dedicated to the young Lorenzo de' Medici.

1459 Under Pope Pius II, Alberti was again active in architecture. He went to Mantova to build the church of S. Sebastiano.

1460 In Florence, Alberti built the Palazzo and Loggia Rucellai, the S. Sepolcro chapel and the facade of S. Maria Novella. All these works were sponsored by the well-to-do Giovanni Rucellai.

1463 In Florence, he planned the project for the Coro of the Annunziata Church on commission from Prince Gonzaga of Mantova.

1464 In Mantova, for Prince Gonzaga, he built the church of S. Andrea.

Selected Bibliography

Berrer, *L.B. Albertis Bauten und ihr Einfluss,* Kassel, 1911.

Clark, K., *L.B. Alberti on Painting,* London, 1945.

Hoffmann, O., *Studien zu Albertis,* Frankenberg, 1883.

Londi, I.E., *L.B. Alberti Architetto,* Firenze, 1906.

Mancini, G., *Vita di L.B. Alberti,* Firenze, 1911.

Michel, P., *La Pensee di L.B. Alberti,* Paris, 1930.

Rettembacher, R., *L.B. Alberti,* Lipsia, 1878.

Ricci, C., *Il Tempio Malatestiano,* Milano, 1924.

Ricci, C., *L.B. Alberti Architetto,* Torino, 1917.

Ritscher, E., *Die Kirche S. Andrea in Mantua,* Berlin, 1899.

Rolfs, W., *L'Architettura Albertiana e l'Arco Trionfale d'Alfonso d'Aragona in Napoli,* Berlin, 1904.

Schumacher, F., *L.B. Alberti und seine Bauten,* Berlin, 1899.

Semprini, G., *L.B. Alberti,* Milano, 1927.

Stegmann, C. and Geymiller, H., *L.B. Alberti, in Architektur der Renaissance in Toscana,* Munich, 1888.

Venturi, *L.B. Alberti,* Rome, 1923.

Wittkower, R., *Architectural Principles in the Age of Humanism,* N.Y., 1950.

Yriarte, C., *Un Condottiere Italien au XV Siecle, Rimini,* Paris, 1882.

AMADEO, Giovanni Antonio (1447-1522)

The sculptor-architect Giovanni Amadeo belongs to the so-called Pavian group of Lombardi. His "un-Florentine" style combines elements of the late Gothic Franco-Flemish "naturalism" with the classicizing tendency prevalent at the end of the Quattrocento.

1466-70	Terracotta decoration for the large cloister and marble doorway for the small cloister, Certosa, Pavia.
c.1470 (or earlier)	*Virgin and Child with Three Angels,* Misericordia sacristy, Florence.
1470-76	Tomb of Medea Colleoni for Church of Santa Maria della Basella, Bergamo.
1470-75	Colleoni Chapel, Bergamo.
1474-75	Lower story for the facade of Certoza, Pavia (collaborated with Christoforo Mantegazza).
1481-84	Arca of San Inerio, Cathedral of Cremona.
1482	Arca of the Persian Martyrs, Cathedral of Cremona.

1485	Marble reliefs of Old and New Testament scenes for facade of Cathedral of Cremona.
1491-99	Resumed decoration of facade for Certosa, Pavia.
1492	Designed courtyard of Palazzo Bottigella, Pavia.
1498	*Coronation of the Virgin* over the lavabo of the Church of the Carmine, Pavia.
c.1498	Arca of S. Lanfranco for Church of S. Lanfranco, Pavia.
1502	Active as *ingeniario* for the Cathedral of Pavia.
1522	Died in Pavia.

Selected Bibliography

Pope-Hennessy, J., *Italian High Renaissance and Baroque Sculpture,* London, 1963.

Seymour, C., *Sculpture in Italy, 1400-1500,* Baltimore, 1966.

FRA ANGELICO (Guido di Pietro) (c.1387/1400-1455)

Fra Angelico largely followed the Giotto-Masaccio line of painters, but his early works reveal a Gothic undertone. It is generally accepted that as a youth he studied under Lorenzo Monaco at the famed school of manuscript illuminators, the Camaldolesian monastery of Santa Maria degli Angeli. The tender figures of Fra Angelico's "Virgins" dominate the early paintings. The flowing linear rhythm combined with the Gothic quality of the ornamentation and composition in his first works are clearly influenced by the lavish miniatures of Lorenzo Monaco. The stylistic features of Fra Angelico's art—the monumentality, the organization of space, the tactile value of the figures, the attempts at perspective and foreshortening—were gradually achieved after his contact with Masaccio and the works of Renaissance sculptors in Florence. The charm and elegance of Gentile da Fabriano's "International Style" was also an influential factor in the artistic development of Fra Angelico.

1418	Recorded to be in Fiesole.
c.1425	*Burial and Assumption of the Virgin,* Gardner Museum, Boston.
c.1425-30	*Annunciation and Adoration of the Magi,* San Marco Museum, Florence.
c.1430	*Last Judgment,* San Marco Museum, Florence.
c.1430	*Deposition,* San Marco Museum, Florence.
c.1430-33	*Coronation of the Virgin,* Uffizi Gallery, Florence.
c.1433	*Linaiuoli Madonna* commissioned, San Marco Museum, Florence.
1435-38	Frescoes over the doorway of the Church of San Domenico, Cortona.
1435-40	*Coronation of the Virgin,* Louvre, Paris.
c.1435-38/39	Frescoes in the church of San Domenico, Fiesole.
1436-45	Frescoes for the convent of San Marco, Florence.
1438-40	*Annalena* altarpiece for the convent of S. Vincent d'Annalena, San Marco Museum, Florence.
c.1440	*Sacre Conversationi* (two) for the convent of San Marco, Florence.
1440-45	*Lamentation* for the convent of San Marco, Florence.
c.1440-45	*Sacra Conversatione* for the monastery of Basco ai Frati, Mugello.
1440-45	*San Domenico* altarpiece, Cortona (Uffizi Gallery, Florence).
1440-45	*Annunciation* altarpiece, Diocesan Museum, Cortona.
1440	*S. Peter Martyr* lunette above the door leading from the cloister to the church of San Marco, Florence.
1440-42	*SS. Cosmas and Damian before Lysias,* Pinacoteca, Munich.
1440-42	*Entombment,* Pinacoteca, Munich.

c.1445 *Adoration of the Magi* tondo, Kress Collection, Washington, D.C. (in collaboration with Fra Filippo Lippi).

1446-49 *Scenes from the Lives of S S. Stephen and Lawrence,* frescoes in the Chapel of Nicholas V, Vatican.

1447 Frescoes for the Orvieto Cathedral (completed by Luca Signorelli).

1449-52 Elected prior of the Dominican convent in Fiesole.

c.1452 Frescoes for the Chapel of the Sacrament, Vatican (destroyed).

1455 Died in Rome.

Selected Bibliography

Argan, G.C., *Fra Angelico,* Geneva, 1955.

Baldinucci, F., *Notizie dei professori del disegno. . .I,* Florence, 1681-1728.

Banti, A., *Fra Angelico,* Milan, 1953.

Bazin, G., *Fra Angelico,* Paris, 1949.

Bertini-Calosso, A., *Il B. Angelico e la pittura umbra,* Spoleto, 1940.

Bottonio, T., *Annali Manuscritti della Biblioteca Comunale di Perugia,* 1770.

Catalogue of Anelico Exhibition, Rome, Florence, 1955.

Frey, K. (ed.), *Codice Magliabecchiano,* Berlin, 1892.

Gengaro, M.L., *Il Beato Angelico a San Marco,* Bergamo, 1944.

Gualandi, M., *Memorie originale italiane riguardanti le Belle Orti,* Series IV, Bologna, 1845.

Lanzi, L., *Storia pittorica dell'Italia. . .,* lst edition, Bassano, 1789.

Manetti, A., *Uomini singolari in Firenze del MCCC inanzi, Operette istoriche. . .,* ed. Milanesi, Florence, 1887.

Orlandi, S., *Beato Angelico;* note Cronologiche, 1955.

Papini, R., *Fra Giovanni Angelico,* Bologna, 1925.

Pope-Hennessy, J., *Fra Angelico,* London, 1952.

Salmi, *Il Beato Angelico,* Florence, 1958.

Schottmuller, F., *Fra Angelico: Des Meisters Gemalde,* Stuttgart, 1924.

Urbani, G., *B. Angelico,* Milan, 1957.

Wingenroth, M., *Angelico da Fiesole,* Leipzig, 1926.

ARCA, Niccolo dell' (c. 1435-1494)

No evidence about his life or art is available until he arrived in Bologna in 1463. It is documented that he worked in France after his Naples period. His emotional style shows a mixture of Burgundian and Northern Italian elements.

c.1435	Born perhaps in Bari.
c.1463	Moved to Bologna.
1463 (or 1485-90)	*Lamentation over the Dead Christ,* Santa Maria della Vita, Bologna.
1469-73	Cover of the Arca of S. Dominic in S. Domenico Maggiore, Naples.
1473	Mentioned as "Nicolaus de Apulia" and "Barrensem."
1477	*Madonna di Piazza,* Bologna.
1493	Mentioned as "Niccolo da Ragusa."

Selected Bibliography

Pope-Hennessy, J., *Italian Renaissance Sculpture,* London, 1958.

BALDOVINETTI, Alesso (1425-1499)

Baldovinetti was a Florentine painter, mosaicist and stained glass craftsman. While apprenticed to Domenico Veneziano, he learned color sensitivity and the mutation of pigments by light. For a time, he was influenced by Andrea del Castagno, but his gentle nature rejected the brutality of Castagno's style. He generally created his

background compositions in *alsecco*. His gentle, delicate landscapes were intermingled with a sense of solemn severity.

c.1445-50 *Annunciation* for the Church of S. Giorgio alla Costa, Florence (Uffizi Gallery, Florence).

1450-55 *Madonna and Child,* Louvre, Paris.

1460-62 Frescoes for SS. Annunziata, Florence.

c.1465 *Portrait of a Young Woman,* National Gallery, London.

1466-67 Frescoes for S. Miniato al Monte, Florence.

1470 *Trinity with SS. Benedict and John,* Academy, Florence.

1471-97 *Prophets, Sacrifice of Isaac and Moses,* Trinity Church, Florence.

Selected Bibliography

Fry, R.E., "On a Profile Portrait by A.B.," *Burlington Magazine,* XVIII, 1910-11, pp.311-16.

Londi, E., *A. Baldovinetti,* 1907.

Pogg, G., *I Ricordi di A. Baldovinetti,* 1909.

Siren, G., *A Picture by A.B.,* 1914.

Van Marle, R., *The Development of Italian Painting,* 1929.

Weisbach, W., *Kunstler-Lexikon,* 1908.

BANCO, Nanni di (c. 1384/85-1421)

As a Florentine sculptor, his name was attached to the building program of the Cathedral of Florence. He became a rival to Donatello with his Roman classicism which he demonstrated on his free-standing sculptures and some reliefs as well. His departure was the Gothic style which he recouped with an antique flavour.

1405 Inscribed in Arte di Pietra e Legname, Florence.

1406-07 Sculptures for the Cathedral of Florence.

1407-08	*Prophet,* Porta della Mandorla, Cathedral of Florence.
1408	*Isaiah,* Cathedral of Florence.
1408	*S. Luke* commissioned for facade of Cathedral of Florence.
c.1413	*Quattro Santi Coronati* (Four Crowned Martyrs), Orsanmichele, Florence.
1414-21	*Assumption of the Virgin* commissioned for Cathedral of Florence.

Selected Bibliography

Hartt, F., *History of Italian Renaissance Art,* N.Y., 1969.

Muray, P. and L., *A Dictionary of Art and Artists,* Middlesex, 1968.

BELLANO, Bartolommeo (c. 1434-c. 1496)

The sculptor Bellano was a member of Donatello's workshop in Padua and subsequently followed his master to Florence. He visited the Turkish Porta, Mahomet II, with Gentile Bellini and one year later resumed activity in his native Padua. Pomponius Gauricus, a contemporary aesthetician, described him as "ineptus artifex" (clumsy craftsman)—a stricture of his characteristically heavy style.

1453	Travelled with Donatello from Padua to Florence.
1466-67	*Pope Paul II* seated bronze statue, Perugia (lost).
1466	Reliefs for Donatello's pulpit, S. Lorenzo, Florence.
1469-72	Returned to Padua. Marble decoration for the reliquary chest in the sacristy of S. Antonio, Padua.
1469-72	*Lamentation* relief, Victoria and Albert Museum, London.
1479	Moved to Venice. Nominated to visit Mahomet II.
1480	Ended his stay in Turkey and returned to Venice.
1480-90	Work for the Santo, Padua.

1481	Ten bronze reliefs for the choir screen of S. Antonio, Padua.
c.1491-98	Roccabonella Monument, S. Francesco, Padua.
c.1492	De Castro Monument, S. Maria dei Servi, Padua.
1496	Died.

Selected Bibliography

Pope-Hennessy, J., *Italian High Renaissance and Baroque Sculpture.* London, 1963.

BELLINI, Gentile (c. 1429/30-1507)

Gentile first gained recognition as a portrait painter in Venice. Later he collaborated with his brother, Giovanni, on the decorations of the Doge Palace in Venice, and consequently adopted the latter's approach. Gentile is noted for introducing the panoramic cityscape with full-length portraits in procession.

1464	Decoration for the organ in the Church of S. Marco, Venice.
1465	*Portrait of the Patriarch Lorenzo Giustiniani,* Accademia, Venice.
1474	Decoration for the Doge Palace, Venice (destroyed).
1479/80	*Portrait of Mahomet II,* Layard Collection, Venice.
1479/80	*Portrait of a Turkish Boy,* pen and gouache on parchment, Gardner Museum, Boston.
1488-1505	Decoration for the Doge Palace, Venice (destroyed).
1496	*Procession of the Relic of the True Cross,* Accademia, Venice.
1507	*S. Mark Preaching at Alexandria,* Brera Gallery, Milan (completed by Giovanni Bellini).
1507	Died in Venice.

Selected Bibliography

Gronau, G., *Die Kunstlerfamilie Bellini,* 1909.

Thieme-Becker, *Kunstler-Lexicon,* 1909.

BELLINI, Giovanni (c. 1430-1516)

The Venetian painter, son of Jacopo Bellini, from his early Manteg-nasque style to his *Sacre Conversationi,* made great progress in the manipulation of color and light, especially in the adaptation of an oil technique in which his colors became warmer and deepened. Alberti's innovations in color began with the Venetian colorist tradition. As a portrait painter, he followed the Flemish tradition of three-quarter views against a landscape background. His landscapes were developed to a high degree with mythological scenes which he composed with great iconographic inventiveness.

1464	Four triptychs for the Church of Carita, Venice.
1465-70	*Christ on the Mount of Olives,* National Gallery, London.
1465-70	*Madonna and Child,* Metropolitan Museum of Art, N.Y.
c.1470-75	*Pietà,* Vatican Museum.
c.1470	*Resurrection,* Berlin.
c.1470	*S. Jerome,* National Gallery, London.
c.1470	*The Blood of the Redeemer,* National Gallery, London.
c.1470	*Transfiguration,* Museum of Naples.
c.1470	*Pietà,* Brera Gallery, Milan.
c.1470-75	*Pessaro* altarpiece, Pinacoteca, Pessaro.
c.1480	*Portrait of a Young Man in Red,* National Gallery, Wash. D.C.
c.1480	Frescoes for Palazzo Ducale, Venice.

1480-90	*Christian Allegory,* Uffizi, Florence.
1483-85	*Sacra Conversatione* for S. Giobbe, Venice (now in the Accademia, Venice).
1487	*Madonna degli Alberetti,* Accademia, Venice.
1488	*Frari* triptych, S. Maria Gloriosa dei Frari, Venice.
1488	*The Doge Agostine Barbarigo before the Virgin and Child with SS. Augustine and Mark,* S. Pietro Martire, Murano.
1488	*Virgin and Child with SS. Paul and George,* Accademia, Venice.
1495	*Portrait of Doge Loredano,* National Gallery, London.
c.1495	*Pietà,* monochrome panel, Uffizi, Florence.
1496	*Procession of the Reliquary of the Holy Cross on the Square of S. Marco,* Accademia, Venice.
1500-05	Official painter for the state of Venice.
1505	*S. Zaccharia* altarpiece, S. Zaccharia, Venice.
1507	*Madonna and Child,* S. Francesco della Vigna, Venice.
1507	*The Doge Leonardo Loredano with Four Councillors,* Private Collection, Munich.
1510	*A Man in Black Before a Landscape,* National Gallery, Wash., D.C.
1510	*S. Jerome Reading in a Rocky Landscape,* National Gallery, Wash., D.C.
1510	*Virgin and Child in a Landscape,* Brera Gallery, Milan.
1513	Altarpiece for S. Giovanni Crisostomo, Venice.
1514	*Feast of the Gods,* National Gallery, Wash., D.C.
1515	*Toilet of Venus,* Kunsthistorische Museum, Vienna.
1515	*Teodora da Urbino as S. Dominic,* National Gallery, London.

Selected Bibliography

Dussler, L., *Giovanni Bellini,* 1949.

Fry, R., *Giovanni Bellini,* London, 1899.

Gamba, C., *Giovanni Bellini,* Milan, 1937.

Gronau, G., *Giovanni Bellini* (in Klassiker der Kunst series), 1930.

Heinemann, F., *Giovanni Bellini;* Belliniani, I-II, Venice, 1962.

Hendy and Goldscheider, *Giovanni Bellini,* N.Y., 1965.

BELLINI, Jacopo (c. 1400-1470/71)

The founder of the Venetian school of Renaissance painting, Jacopo Bellini initially trained with Gentile da Fabriano. Though Gentile's International Style was influential, Jacopo's early work involved a certain Italo-Byzantine rigidity rather than the Gothic elegance of Fabriano. Jacopo assisted his master in Florence and returned to Venice with a fresh style basically inspired by the new Florentine approach. Unfortunately, most of Jacopo's work is missing. However, his sketchbook, extant in the Louvre and the British Museum, are eloquent documentations of his developed artistic imagination.

1420	Followed Gentile da Fabriano to Florence.
1437	Returned to Venice and matriculated in the Scuola di S. Giovanni Evangelista.
c.1438	*S. John the Baptist Preaching,* drawing, Louvre, Paris.
1441	Defeated Antonio Pisanello in the competition for the portrait of Lionello d'Este, Ferrara.
1445	*Annunciation,* S. Alessandro, Brescia.
c.1448	*Madonna and Child,* Accademia, Venice.
c.1450	*Flagellation,* leadpoint with pen retouching, Louvre, Paris.
c.1450	*Nativity,* leadpoint, British Museum, London.
c.1450	*Lamentation,* leadpoint, British Museum, London.
c.1450	*Crucifixion,* leadpoint, British Museum, London.
c.1460	Altarpiece for the Basilica of S. Antonio, Padua (lost).

Selected Bibliography

Goloubew, V., *Les Dessins de Jacopo Bellini,* Paris, 1912.

Ricco, C., *Jacopo Bellini e i suo libri di Disegni,* 1908.

Tietze, H. and Tietze, C.E., *The Drawings of the Venetian Painters in the 15th and 16th Century,* 1944.

BERTOLDO, Giovanni di (c. 1420-1491)

Bertoldo was the Florentine sculptor trained by Donatello. He later was appointed director of the Medici sculpture garden where he counted Michelangelo among his pupils. Most of Bertoldo's surviving works express a keen interest in classical antiquity.

c.1460-70 Assisted Donatello on the pulpits for S. Lorenzo, Florence.

1480-81 Medal of Sultan Mahamet II, Museum, Berlin.

1483 Bronze reliefs for choir of the Santo, Padua (continued by Bartolommeo Bellano).

c.1483-85 *Bellerophon and Pegasus,* bronze, Kunsthistorisches Museum, Vienna.

c.1484-90 Battle relief, Bargello, Florence.

1486 Crucifixion relief, Bargello, Florence.

1486 *Apollo,* Bargello, Florence.

1486 *Hercules,* Fredericks Collection, The Hague.

1486 *Hercules with the Golden Apples of the Hesperides,* Victoria and Albert Museum, London.

1486 *Prisoner and S. Jerome,* Kaiser Friedrich Museum, Berlin (destroyed).

1486 *Hercules on Horseback,* Pinacoteca Estense Modena.

1486 Two bearded male figures, Lichtenstein Collection, Vaduz and Frick Collection, N.Y.

1490 *Adoration of the Magi,* National Gallery, Wash., D.C.

Selected Bibliography

Bode, W. von, "Bertoldo di Giovanni," *Florentine Sculptors of the Renaissance,* N.Y., 1928.

Rohwaldt, K., *Bertoldo,* Berlin, 1896.

Semrav, M., *Bertoldo di Giovanni,* Breslav, 1891.

BOTTICELLI, Sandro (c. 1445-1510)

The Florentine painter, Sandro Botticelli, probably began as a student in Fra Filippo Lippi's workshop. Both master and pupil were endowed with an innate sense of nature, but Botticelli attained a more systematic manner of expression. He was also associated with Andrea del Verrocchio and Antonio Pallaiuolo whose styles facilitated his scientific approach toward nature. However, after a visit to the Vatican and concomitant work on the Sistine Chapel, he abandoned his early naturalism for a poetic quality which culminated in an intense linear rhythm. His compositions took on a monumental grandeur which inclined toward a mystical contemplation in his later years. His mature paintings achieved a prophetic value, a kind of vatic spirituality.

1468	*Madonna and Child,* Louvre, Paris.
1470-75	*Judith Returning to Bethulia* and *Discovery of the Body of Holofernes,* Uffizi, Florence.
1470-76	*Allegory of Force,* Uffizi, Florence.
1470	*Madonna and Child with Six Saints,* Accademia, Florence.
c.1470	*Self-Portrait with Medal,* Uffizi, Florence.
1472	*Madonna and the Eucharist,* Gardner Museum, Boston.
1473	*Madonna and Child with Young S. John,* Louvre, Paris.
1473	*Madonna with Child and Two Angels,* Uffizi, Florence.

1473	*Madonna and Child with Angels,* Von Rath Collect., Amsterdam.
c.1474	*S. Sebastian* for the church of S. Maria Maggiore, Florence, (Berlin Dahlem).
c.1474	*The Annunciation,* Private Collection, Berlin.
c.1475	*La Belle Simonetta,* Private Collection, Berlin.
c.1475	*Giuliano de' Medici,* Kaiser Friedrich Museum, Berlin.
c.1475	*Adoration of the Magi,* National Gallery, London.
c.1475	*Portrait of a Man with a Medal,* Uffizi, Florence.
1475	*La Primavera,* Uffizi, Florence.
1475-80	*Adoration of the Magi,* Uffizi, Florence.
1476-80	*Mars and Venus,* National Gallery, London.
c.1478	*Portrait of Giuliano de' Medici,* National Gallery, Wash., D.C.
1480	*S. Augustine,* Church of Ogni Sancti, Florence.
1480-85	*Birth of Venus,* Uffizi, Florence.
c.1480-85	*Portrait of Dante,* Bodmer Collection, Geneva.
1481-82	*Adoration of the Magi,* National Gallery, Wash. D.C.
1481	*Archangel Gabriel* fresco for the wall of the open loggia of the church of S. Maria della Scala (Museum forte de Belvedere, Florence).
1481-82	Frescoes for the Sistine Chapel, Vatican.
1482	*Drawing of Autumn,* British Museum, London.
c.1482	*Pallas and the Centaur,* Uffizi, Florence.
1483	*Nastagio degli Onesti* (a story of Boccaccio), Madrid, Prado.
c.1483-85	*Madonna of the Magnificat,* Uffizi, Florence.
1485-86	*Villa Lemni* frescoes, Louvre, Paris.
1485	*Madonna and Child with S. John,* Berlin Dahlem.

1486	*Giovanna degli Albizzi and the Cardinal Virtues,* Louvre, Paris.
1486	*Lorenzo Tornabuoni in front of the Seven Liberal Arts,* Louvre, Paris.
c.1487	*Madonna with Four Angels and Six Saints,* Uffizi, Florence.
c.1487	*Madonna of the Pomegranate,* Uffizi, Florence.
1488-90	*Coronation of the Virgin,* Uffizi, Florence.
1489	*Annunciation,* Uffizi, Florence.
c.1490-1500	*S. Augustine in His Study,* Uffizi, Florence.
c.1490	*S. Barnabas* altarpiece, Uffizi, Florence.
1490	*The Last Communion of S. Jerome,* Metropolitan Museum, N.Y.
1491-98	*Coronation of the Virgin,* Accademia, Florence.
c.1491-95	*Calumny,* Uffizi, Florence.
1491-1500	*The Story of Lucretia,* Gardner Museum, Boston.
c.1495-1500	*Pietà,* Pinacoteca, Munich.
1499	*Judith,* Rijksmuseum, Amsterdam.
c.1500	*The Mystic Crucifixion,* Fogg Art Museum, Cambridge, Mass.
1501	*The Mystic Nativity,* National Gallery, London.
1501-02	*The Agony in the Garden,* Royal Chapel, Granada.
1503	*Scenes from the Life of S. Zenobius,* Dresden Gallery and National Gallery, London.

Selected Bibliography

Argan, G., *Botticelli: Biographical and Critical Study,* N.Y., 1957.

Bode, W. von, *Sandro Botticelli,* N.Y., 1925.

Chastel, A., *Botticelli,* Greenwich, Conn., 1958.

Gombrich, E.H., "Botticelli's Mythologies," *Journal of the Warburg and Cortauld Institutes,* VIII, 1945.

Horne, H.P., *Botticelli,* London, 1908.

Mesnil, J., *Botticelli,* 1938.

Salvini, R., *All the Paintings of Botticelli,* vol. I-IV, N.Y., 1965.

Venturi, L., *Botticelli,* London, 1961.

Yashiro, Y., *Sandro Botticelli and the Florentine Renaissance,* London, 1929.

BRAMANTE, Donato (Donato di Pascuccio d'Antonio; also known as Donato d'Agnola and Lazzari.) (1444-1517)

The architect Bramante began his career as a painter of the "illusionistic" perspective. However, after moving from Urbino to Milan, he devoted his interests to architecture. When Bramante went to Rome in 1499, his "Lombard" style was notably changed by the classical milieu of the city of Rome. Even before his Roman period Bramante gained interest in the classical tendencies of Leon Battista Alberti and Michelozzo. Leonardo da Vinci's sketches of centrally planned churches were also influential to his architecture. The design for S. Peter's in Rome was his masterpiece.

1466	Studied painting under Piero della Francesca.
1476-1514	Reconstructed S. Maria presso S. Satiro, Milan.
1476	Design for the church of S. Maria Incoronata, Lodi.
1477	Painted perspective decorations for the facade of Palazzo Podesta, Bergamo.
c.1479	Entered the service of Duke Ludovico Sforza.
1481	Architectural perspectives, Milan (engraved by Bernardo Prevedari).
1485	Plans for Ospedale Maggiore, Milan.
1488	Consultant to the Pavia Cathedral.
1488	The central-planned east end of S. Maria della Grazie, Milan.

1492	Designed the Canon's Cloister for S. Ambrogio, Milan.
1498	Wood model for the Monastery of S. Ambrogio, Milan.
1499-1502	Il Tempieto, S. Pietro in Montorio, Rome.
1500-04	S. Maria della Pace, Rome.
1503	Commissioned by Pope Julius II for a plan for S. Peter's.
c.1503	Spiral ramp in the tower of the Belvedere Vatican.
1505-09	Choir for S. Maria del Popolo, Rome.
1506-13	Building of S. Peter's Rome.
1514	Designed the Palazzo Caprini, Rome (later altered).
1514	Died in Rome.

Selected Bibliography

Baroni, C., *Bramante,* Bergamo, 1944.

Beltrami, L., *Bramante Poeta,* Milan, 1884.

Biscaro, G., *Archivo Storico Lombardo,* XXXVIII, 1910.

Forster, *Bramante,* Vienna, 1956.

Semper, H., *Kunst und Kunstler,* v. I, part 2, Leipzig, 1887.

Suida, W., *Bramante pittore ed il Bramantino,* Milan, 1953.

Vogel, J., *Bramante und Raffael,* Leipzig, 1910.

BREGNO, Andrea (1421-1506)

Although considered a Roman sculptor of the Renaissance, Andrea Bregno was actually born in Northern Italy near Como. His main works were tombs, altars and tabernacles. Bregno demonstrated a high technical skill in his creations but offered little in the way of aesthetic individuality. The linear Lombardic style of his early years changed to the classical style of Rome. His new classical style was carried to the north by Gian Christophoro Romano and disseminated among the sculptors of Ferrara, Mantua and Pavia.

1457	Or earlier; Tomb of Francesco Foscari, S. Maria dei Frari, Venice.
c.1464	Tomb of Cardinal Nicholas of Cusa, S. Pietro, Vincoli.
c.1465	Tomb of Labretto, S. Maria in Aracoeli, Rome.
c.1466	Tomb of Thebaldi, S. Maria Sopre Minerva, Rome (collaborated with Giovanni da Dalmata).
1473	The Borghia Altar, S. Maria del Popolo, Rome.
1474-77	Tomb of Cardinal Pietro Riario, Santi Apostoli, Rome.
1477	Tomb of Raphaello della Rovere, Santi Apostoli, Rome.
c.1478	Or after; Tomb of Ferrici, S. Maria Sopre Minerva, Rome (with Giovanni da Dalmata).
1479	Tomb of Christiphoro della Rovere, S. Maria del Popolo, Rome.
1483	Palazzo Cancellaria, Rome.
1485	Tomb of Cardinal Lebreton, S. Maria Aracoeli, Rome.
1490	Commissioned for tabernacle in S. Maria della Quericia, Viterbo.
1495-98	Tomb of Savelli, S. Maria Aracoeli, Rome.

Selected Bibliography

Pope-Hennessy, J., *Italian Renaissance Sculpture,* London, 1958.

BRUNELLESCHI, Filippo (1377-1446)

The Florentine architect and sculptor Brunelleschi invented the hoisting machine and introduced the use of linear perspective. His architectural style did not rely as strongly upon classical elements as did the approaches of Leon Battista Alberti and Michelozzo. Rather, his concern was with structural problems and constructional tech-

niques. His greatest achievement in this respect was the innovation of a new method of dome construction with relatively few elements borrowed from classical antiquity.

1398	Member of the Arte della Seta.
1399-1400	Two half-length figures for the Silver Altar of S. James, Cathedral of Pistoia.
c.1400	Wood *S. Mary Magdalen* in S. Spirito, Florence (lost).
1401-02	Participated in the competition for the bronze doors of the Baptistery of Florence.
c.1402	Journey to Rome.
1404	Matriculated as a goldsmith.
1410-15	Wood crucifix, Gondi Chapel, S. Maria Novella, Florence.
1415	Repaired the Ponte Mare in Pisa.
1417	Project for the dome of the Cathedral of Florence.
1418	Domed chapel in S. Jacopo Sopre Arno (destroyed).
1418-19	Barbadori Chapel, S. Felicita (partly destroyed).
1418/19	Palazzo di Parte Guelfa (later altered).
1419	Ospedale degli Innocenti designed (built 1421-44).
1420-36	Began construction of the cupola of the Cathedral of Florence.
1421-46	Church of S. Lorenzo (unfinished).
1427	Design for the tabernacle for S. Jacopo in Campo Corbellini (executed by F. da Settignano; lost).
1428	Palazzo Pitti, Florence.
1429/30-40	Pazzi Chapel in the cloister yard of S. Croce, Florence.
1429	Sagrestia Vecchia of S. Lorenzo, Florence.

1432	Designed the lavabo for the north sacristy of the Cathedral of Florence (completed by Buggiano in 1440).
1433	Visited Rome.
1433	Tomb and altar for Old Sacristy completed, S. Lorenzo, Florence (executed by Buggiano).
1434	Church of S. Maria degli Angeli (unfinished 1446).
1436	Construction of S. Spirito begun, Florence.
1443	Wood model for the pulpit of S. Maria Novella, Florence (completed by Buggiano).
1443	*Four Evangelists* tondo, Pazzi Chapel, S. Croce, Florence (attributed).

Selected Bibliography

Bruscoli, G., *L'ospedale di s. Maria degli Innocenti dalla sua fondazione ad oggi,* Florence, 1900.

Cantoni, A., *Brunellesco,* Milan, 1933.

Carli, E., *F. Brunelleschi,* Florence, 1949.

Comolli, A., *Bibliografia Storica-critica dell' architettura civile e subalterne,* Rome, 1788-92.

Dvorak, M., *Geschichte der italianischen Kunst in Zeitalter der Renaissance,* Munich, 1927-28.

Fabriczy, C. von, *Brunelleschi, Sein Leben und Seine Werke,* Stuttgart, 1892.

Funghiri, V., *S. Maria del Fiore di Firenze,* Arezzo, 1887.

Gori-Montanelli, L., *Brunelleschi e Michelozzo,* Florence, 1957.

Gotti, A., *S. Maria del Fiore e i suoi architetti,* Florence, 1887.

Hope, T., *Storia dell' architettura,* Milan, 1840.

Knight, H.G., *The Ecclesiastical Architecture of Italy,* London, 1840.

Molini, G., *La Metropolitana fiorentina illustrata,* Florence, 1820.

Muller, O.R., *Über die Anfange und über das Wesen der malerischen Perspective,* Darmstadt, 1913.

Neuschloss, C., *Brunelleschi es Alberti,* Doctoral Dissertation, University of Budapest, 1903.

Nielsen, C.V., *Filippo Brunellesco og Brundlaeggelsen af theorien for Perspectiven,* Copenhagen, 1896.

Nyberg, D.F., *A Study of Proportion in Brunelleschi's Architecture,* Thesis, Institute of Fine Arts, New York University.

Poggi, G., *S. Maria del Fiore di Firenze,* Rome, 1891.

Reymond, M.F., *Brunelleschi et l'architecture de la Renaissance an XV Siecle,* Paris, 1912.

Sanpaolesi, P., "Brunelleschi," *Encyclopedia of Art,* McGraw Hill, N.Y., 1958.

Schild-Bunim, M., *Space in Medieval Painting and the Forerunners of Perspective,* N.Y., 1940.

Scott, G., *The Architecture of Humanism,* Boston, 1914.

Venturi, A., *Architettura dal XV al XVIII Secolo,* Rome, 1923.

Wittkower, *Architectural Principles in the Age of Humanism,* London, 1950.

CARPACCIO, Vittore (c. 1460/5-1523/6)

He was the Venetian painter whose early work was influenced by Gentile Bellini and Antonello da Messina. He developed a certain luminous atmosphere in his paintings by a masterly rendering of architectural backgrounds. He became the first Venetian painter of *vedute* (cityscapes).

c.1488 *Christ with Four Disciples,* Contini-Bonacossi Collection, Florence.

c.1490-96 *Legend of S. Ursula* fresco cycle, Accademia, Venice.

late 1490's *Meditation on the Passion,* Metropolitan Museum, N.Y.

1502 *Life of S. Jerome* fresco cycle, Scuola di S. Giorgio degli Schiavoni, Venice.

1504 *Life of the Virgin* fresco cycle for Scula degli Albanesi (separated and distributed among the Brera

Gallery, Milan; C'a d'Oro and Museo Correr, Venice; and Accademia Carrara, Bergamo).

1510	*Presentation in the Temple,* Accademia, Venice.
1511-20	*Life of S. Stephen* fresco cycle, Scuola di S. Stefano, Venice (divided among the Kaiser Friedrich Museum, Berlin; Brera Gallery, Milan; Louvre, Paris; and Stuttgard).
1523	Two organ shutters for the Duomo at Capodisteria.

Selected Bibliography

Fiocco, G., *Carpaccio,* Rome, 1942.

Molmenti, P. and Ludwig, G., *The Life and Work of Vittorio Carpaccio,* 1907.

Moschini, V., *La Leggenda di S. Orsola,* Milan, 1948.

Murano, M., *Vittore Carpaccio alla Scuola degli Schiavoni,* Milan, 1956.

Pignatti, T., *Carpaccio,* Geneva, 1955.

CASTAGNO, Andrea del (c. 1421/23-1457)

Castagno was the Florentine painter who was nicknamed Andreino degl' Impiccati (Andreino of the hanged man) for his frescoes at the Palazzo del Podesta depicting the vanquished of the Battle of Anghiari being hanged by their heels. He was strongly influenced by the scientific realism of Masaccio although some of his works feature the anti-realistic style of the International Gothic style. His admiration for Donatello led him to place emphasis upon sculptural effects in his compositions. This technique is best demonstrated in his equestrian fresco portrait now in the Cathedral of Florence.

1434	Frescoes on the facade of the Palazzo del Podesta (lost).
c.1442	Frescoes for the S. Tarasio Chapel, S. Zaccaria, Venice (collaborated with Francesco da Faenza).

1444	Designed stained glass windows for the Cathedral of Florence.
1444	*Last Supper* fresco, S. Apollonia, Florence.
1445-50	*Passion Scenes,* fresco, S. Apollonia, Florence.
1445	*Portrait of a Man,* National Gallery, Wash. D.C.
1449-50	*Assumption,* S. Miniato fra le Torri (now in Berlin).
1450-55	*Famous Men and Women* series for the villa at Legnia.
1456	Equestrian protrait of Niccolo da Tolentino, fresco, Cathedral of Florence.
1457	Died in Florence.

Selected Bibliography

Richter, G.M., *Andrea del Castagno,* Chicago, 1943.
Salmi, M., *Andrea del Castagno,* Novara, 1961.

CIVITALI, Matteo (1436-1501)

Civitali, the Luccan sculptor and architect, derived much of his style from Florentine models. Like the sculptures of Antonio Rossellino, his work mainly concentrates on grace and beauty of line. The influence of Donatello is clearly recognizable in the execution of his large draperies. As an architect, Civitali similarly demonstrated a lack of creative initiative. Mainly involved with tomb sculptures, he closely followed the Donatello-Rossellino sarcophagus approach.

1467	Or earlier; Medallion portrait relief of Pietro d'Avanza, Cathedral of Lucca.
1467-72	Tomb of Piero da Noceto, Cathedral of Lucca.
1473-76/7	*Altar of the Sacrament,* Cathedral of Lucca.
1475	*Faith,* marble, Bargello, Florence.
1479	Tomb of Domenico Bertini and his wife, Cathedral of Lucca.

1479	*Virgin and Child with Bertini's Stemma,* S. Michele, Lucca.
1480	*Madonna della Tosse* for S. Ponziano (now in S. Trinitata, Florence).
1481	Chapel of Volto Santo, Cathedral of Lucca.
1484/5	*Altar of S. Regolo,* Cathedral of Lucca.
1486-88	Altar, Cathedral of Pisa.
1489	Tabernacle, Church of S. Frediano, Lucca.
1490	Tomb of S. Romano, Lucca.
c.1491	Tomb of S. Pellegrino, S. Pellegrino Alpi, Lucca.
1493	Tabernacle, S. Maria del Palazzo, Lucca.
1494-98	Pulpit, Cathedral of Lucca.
1494	Or after; Moved to Genoa.
c.1495	*Adam and Eve, Elizabeth and Zacharias,* Chapel of S. John the Baptist, Cathedral of Genoa.
1500	*St. George and the Dragon,* Palazzo Communale of Sarzana.

Selected Bibliography

Pope-Hennessy, J., *Italian Renaissance Sculpture,* London, 1958.

COSSA, Francesco de (1435/6-c. 1477)

A typical Ferrarese painter who combined the Florentine and Paduan traditions with a strong overtone of simplified but sculpturesque forms. Piero della Francesca's work is evident in his organization of group compositions.

1496-70	Frescoes in the Palazzo Schifanoia, Ferrara.
1473	*S. John the Baptist,* Brera Gallery, Milan.
1473-75	*The Griffoni Triptych* for S. Pietronio, Bologna (two

panels are now in the Brera Gallery, Milan and the centerpiece is in the National Gallery, London).

Selected Bibliography

Nicholson, B., *The Painters of Ferrara,* London, 1951.

Ortolani, S., *Cosme Tura Francesco del Cossa, Ercole de Roberti,* Milan, 1941.

Padovani, *La Critica d'arte e la pittura Ferrarese,* Rovigo, 1955.

COSTA, Lorenzo (c. 1460-1535)

When the Ferrarese painter Lorenzo Costa moved to Bologna, he changed his style. His former style was strongly sculpturesque and rigid. Through his partnership with Francesco Francia, Costa's style was transformed into a softer Umbrian manner.

1483	Moved to Bologna.
1497	*Ghedini* altarpiece, S. Giovanni in Monte, Bologna.
1506	Court painter in Mantua.

Selected Bibliography

Gardner, E. G., *The Painters of the School of Ferrara,* N.Y., 1911.

Longhi, R., *Officina Ferrarese,* Rome, 1956.

Nicholson, B., *The Painters of Ferrara,* London, 1950.

CRIVELLI, Carlo (c. 1435-c. 1495)

Crivelli was a painter of Venetian origin although he is usually considered a Central Italian artist. He was forced to leave Venice after six months of imprisonment and never returned to his native land. However, he always retained a sense of identity there, proudly signing his works as "Carolus Crivellus Venetus." Crivelli took refuge on the coast of Dalmatia where he worked for a time before settling in the Marches, principally at Ascoli Piceno. Throughout his lengthy

career, he never altered his elaborate linear style which featured jewelry, floral decorations, and lavish fruit garlands. His minutely detailed arabesques were probably influenced by Francesco Squarcione.

c.1463	*Virgin and Child,* Museum, Verona.
1465	Recorded in Zara (Zadar).
1468	*Virgin and Saints,* Municipio of Massa Fermana.
1468	Documented in Ascoli Piceno.
c.1470	*Pietà,* John G. Johnson Collection, Philadelphia.
1473	*Virgin and Child* altarpiece, Cathedral of Ascoli Piceno.
1481	*Pietà,* polyptych, Vatican.
1482	*Pietà,* Brera Gallery, Milan.
1482	*Madonna,* Brera Gallery, Milan.
1486	*Annunciation,* National Gallery, London.
1487	*Christ giving the Keys to S. Peter,* Staatliche Museen, Berlin.
c.1487	*Pietà,* Detroit Institute of Arts, Detroit, Michigan.
1490	Knighted by Prince Ferdinand of Capua.
1493	*Coronation of the Virgin,* Venice.
1495	Died in Fermo.

Selected Bibliography

Berenson, B., *The Venetian Painters of the Reanissance,* 1899.

Murray, P. and L., *A Dictionary of Art and Artists,* Middlesex, 1968.

DONATELLO (Donatello Benedetto di Betto Bardi) (c. 1386-1466)

Donatello was the extraordinary Florentine sculptor whose dramatic innovations long stimulated the artists of Florence and Padua. Through the work of Andrea Mantegna and Giovanni Bellini, his

influence spread to the painters and sculptors of Venice. Donatello's initial compositions are marked by the use of Gothic formal ideas, but his own heroic style soon exceeded these early influences. His journey to Rome reinforced his classical tendencies and resulted in the execution of the earliest known freestanding nudes and monumental equestrian statues since the decline of the Roman Empire. In his later years a certain anti-classical religious feeling emanated from his carved wood statues. His last works convey an expression of dramatic ugliness and reveal the germs of the extreme distortions from which Mannerist art developed. Michelangelo's work also exhibits these tendencies.

1404-07	Recorded as being among the assistants of Ghilberti.
1406-08	Marble *Prophet,* Porta della Mandorla, Cathedral of Florence.
1408-09	*David,* marble, Bargello, Florence.
1408-09	*S. John the Evangelist,* seated figure, commissioned.
1410	*Joshua,* gigantic statue (destroyed).
1411-17	Statues for Or San Michele, Florence.
1413-15	*St. John,* seated figure, Cathedral of Florence.
1515-36	Statues for the Campanille, Cathedral of Florence.
1419	Model for the cupola of the Cathedral of Florence.
1419	Carved the *Marzocco* for the staircase of the quarters of Pope Martin V, S. Maria Novella, Florence.
1420-30(?)	Or earlier; *Pazzi Madonna,* Berlin.
1423-34	Worked on the Sienese Baptismal fountain.
1425-1432/3	Shared the studio of Michelozzo di Bartolommeo.
1425-27	Tomb of Antipope John XXIII, Baptistery, Florence.
c.1425	*S. Louis of Toulouse,* Or San Michele, Florence (now in Museo dell' Opera di S. Croce, Florence).
1427-28	Brancacci monument, S. Angelo a Nile, Naples (collaborated with Michelozzo).

1427	Reliquary bust of S. Rossore, Ogni Sancti, Florence.
1430	Military engineer in the Florentine army against Lucca, then moved to Rome.
c.1430	*The Ascension with Christ Giving the Keys to S. Peter,* Victoria and Albert Museum, London.
1430	*Tabernacle of the Sacrament,* Sagrestia di Beneficiati of S. Peter, Rome. Project for the fortification of Lucca.
1432	Tomb slab of Giovanni Crivelli, S. Maria in Aracoeli, Rome.
1432-33	Tomb slab of Pope Martin V, S. John Lateran, Rome.
1433	External pulpit for the Cathedral of Prato commissioned.
1433	Cantoria Cantata for the Cathedral of Florence commissioned. /
1434	Designed stained glass windows for the Cathedral of Florence.
1434-35	Bronze doors and stucco decorations for the Sagrestia Vecchia of S. Lorenzo, Florence.
1435	*David* for the Casa Martelli, National Gallery, Wash., D.C.
1435-39	*David,* Bargello (dating is controversial—may be 1430-32).
c.1435-39	*Cavalcanti Annunciation,* S. Croce, Florence.
1437	Contracted for two bronze doors for the sacristy of the Cathedral of Florence. Contract later transferred to Masso di Bartoldo (1446) and then to Lucca della Robbia (1464).
1439	Wax model for the altar of S. Paul, Florence.
1444-53	Transferred his studio to Padua.
1446-51	High altar, S. Antonio, Padua.

1447-53	Equestrian statue of Gattamelata, Padua.
1450-51	Model for the shrine of S. Anselmo at Mantua.
1451	*S. John the Baptist,* wood, S. Maria dei Frari, Venice.
1451	Visited Ferrara. Negotiated for an equestrian statue of Borso d'Este, Modena.
1453	Pulpit for S. Lorenzo, Florence (interrupted; continued 1460-66, left unfinished).
1453	Returned to Florence.
1453	*Judith,* bronze, Piazza della Signoria, Florence.
1454-55/6	*Mary Magdalen,* wood, Baptistery, Florence.
1457-61	Resided in Siena.
1457	*S. John,* bronze, Baptistery, Florence.
1458-59	Bronze doors for Siena Cathedral (abandoned).
1461	Returned to Florence.
1466	Died in Florence.

Selected Bibliography

Bertaux, E., *Donatello,* Paris, 1910.

Bocchi, F., *Le Bellezze della Citta di Fiorenza,* Florence, 1591. Revised ed., G. Cinelli, Florence, 1677.

Bode, W. von, *Denkmaler der Renaissance—Sculptur Toscanas,* 12 volumes, Munich, 1892-1905.

Bode, W. von, *Die Italienische Plastick,* 6th ed., Berlin, Leipzig, 1922.

Cavallucci, O.I., *Vita ed Opere di Donatello,* Milan, 1886.

Cecchi, E., *Donatello,* Rome, 1942.

Colasanti, A., *Donatello,* 1927.

Cruttwell, M., *Donatello,* London, 1911.

Gloria, A., *Donatello Fiorention e le sue Opere Mirabili nel Tempio di S. Antonio in Padova,* Padua, 1895.

Dvorak, M., *Geschichte der Italienischen Kunst,* 2 volumes, I, Munich, 1927.

Galassi, G., *La Scultura Fiorentina del Quattrocento,* Milan, 1949.

Goldscheider, L., *Donatello,* 1941.

Gonzati, B., *La Basilica di S. Antonio di Padova,* Padua, 1854.

Grassi, L., *Tutta la Scultura di Donatello,* Milan, 1958.

Janson, H.W., *The Sculpture of Donatello,* 2 volumes, Princeton, 1957.

Marangoni, M., *Donatello e la Critica,* Florence, 1930.

Milanesi, G., *Catalogo della Opere di Donatello e Bibliografia degli Autori che ne Hanno Scritto,* Florence, 1887.

Milanesi, G., *Documenti par la Storia dell Arte Sense,* II, Siena, 1854.

Muntz, E., *Donatello,* Paris, 1885.

Pastor, W., *Donatello,* Giessen, 1892.

Perkins, C.G., *Les Sculptures Italiens,* Paris, 1869.

Planiscig, L., *Donatello,* Vienna, 1939.

Reymond, M., *La Sculpture Florentine,* II, Florence, 1898.

Sanpaolesi, P., *Brunellesco e Donatello nella Sacristia Vecchia di San Lorenzo,* Pisa, 1940-42.

Schmarsow, A., *Donatello,* Breslau, 1886.

Schottmuller, F., *Donatello,* Munich, 1904.

Schubring, P., *Donatello, Klassiker der Kunst,* Stuttgart, Leipzig, 1907.

Semper, H., *Donatellos Leben und Werke,* Innsbruch, 1887.

Semrau, M., *Donatellos Kanzeln in S. Lorenzo,* Breslau, 1891.

Valentiner, W. R., *Studies of Italian Renaissance Sculpture,* N.Y., 1950.

DUCCIO, Agostino di (1418-1481)

Although he was principally a Florentine sculptor, he gained his reputation outside that city. He was probably a pupil of Jacopo della Quercia whose influence is reflected in Agostino's flat and linear

style. He worked mainly on low reliefs, although he produced some important high reliefs also. The cumulative effect of Duccio's artificial bending lines dominate his work rather than the verisimilitude of his figures.

c.1433 Left Florence and became a mercenary soldier of Giovanni da Tolentino.

1442 Carved the antependium depicting the story of S. Gemignano for the Cathedral of Modena.

1442 Altar for the Cathedral of Modena.

1446 Returned to Florence, but fled to Venice when accused of the theft of silver from the Annunciata Church.

1450-57 Decorations for the Il Tempietto di Malatestiano, Rimini.

1457-62 Moved to Peruggia where he worked on the Oratory of S. Bernardino.

1462-63 Moved to Bologna and designed a model for the facade of S. Petronio.

1463 Returned to Florence. Colossal statues for the Cathedral of Florence.

c.1470 A number of marble *Virgin and Child* reliefs, Florence.

1473-74 *Altar of Pietà* for the Cathedral of Peruggia.

1475 Facade of the Maesta dello Volte (now in the Pinacoteca Nationale, Peruggia).

Selected Bibliography

Pointner, A., *Die Werke des Florentinischen Bildhavers Agostino d'Antonio di Duccio,* Strasbourg, 1909.

Pope-Hennessy, J., *Italian Renaissance Sculpture,* London, 1958.

Ricci, C., *Il Tempio Malatestiano,* Milan, n.d.

Seymour, C., *Sculpture in Italy, 1400-1500,* Baltimore, 1966.

FABRIANO, Gentile da (c. 1370-1427)

Master painter of the International style, Gentile was one of the chief exponents of the Gothic revival in the early Quattrocento and influenced a number of Florentine artists. While contemporaries such as Masaccio were concerned with the realistic expression of space and volume, Gentile restored to full vitality the elegant style of the Northern manuscript illuminators with his rich panoramas depicting far-off granges. The earliest documented evidence of his activity occurred in 1408, but his birth date remains uncertain and open to speculation.

c.1400-20	*Valle Romita* altarpiece, Brera Gallery, Milan.
1408	Recorded to be active in Venice.
1408	Frescoes for the Sala del Gran Consiglia, Palazzo Ducale, Venice (destroyed by fire).
c.1408	*Virgin and Child,* Palazzo Communale, Peruggia.
1414-19	Moved to Brescia to paint the Chapel of Pandolfo Malatesta (lost).
c.1420	*Virgin and Child,* National Gallery, Wash., D.C.
1423	*Adoration of the Magi,* Uffizi, Florence.
1424/5	*Quaratesi* altarpiece, Church of S. Niccolo, Florence (dismembered).
1425-26	Active in Siena and Orvieto.
1426	Moved to Rome.
1427	Frescoes for the church of S. John Lateran, Rome (destroyed; completed by Pisanello).

Selected Bibliography

Berenson, *Italian Pictures of the Renaissance,* Oxford, 1932.

Colasanti, A., *Gentile da Fabriano,* Bergamo, 1909.

Grassi, L., *Tutta la Pettura di Gentile da Fabriano,* Milan, 1953.

Malojoli, B., *Gentile da Fabriano,* 1927; 2nd ed. 1934.

Malojoli, B., *Bibliografia di Gentile da Fabriano,* B. de Reale lst di
 Archeologia e Storia dell' arte, III, 1929.

Serra, *L'arte nelle Marche,* II, Rome, 1934.

FILARETE (Antonio Averlino) (c. 1400-1469)

Antonio Averlino, best known as Filarete, was a Florentine sculptor
and architect. As a sculptor, he appears to have been a member of
Lorenzo Ghilberti's studio and is remembered for the bronze door he
cast for S. Peter's in Rome. His architectural concern was mainly
performed in the service of Francesco Sforza in Milan. It was in
Milan that he wrote his theoretical study, *Trattato d'Architettura,*
but it was dedicated to a former patron, Piero de Medici, probably
because of difficulties with Sforza. The treatise was based upon the
architectural theories of Vitruvius and Leon Battista Alberti and pre-
sented an elaborate plan of an ideal city named "Sforzinda."

1433/39-43/45	Bronze doors for S. Peter's, Rome.
1447	Commissioned for the monument of Antonio Chiaves, Cardinal of Portugal (abandoned).
1447	Accused of the attempted theft of the head of S. John from S. John Lateran, Rome. He fled to Todi, Rimini, Mantua and finally Venice.
1449	Processional cross for the Cathedral of Bassano.
1451-53	Employed by Francesco Sforza. Terracotta decoration for the Castello, Milan.
1457-65	Central area of the Spedale della Scala, Siena.
1465	Completed *Trattato d'Architettura.*
c.1465	Bronze reproduction of the equestrian statue of Marcus Aurelius for Piero di Medici (now in Albertinuns, Dresden).

Selected Bibliography

Blunt, A., *Artistic Theory in Italy, 1450-1600,* Oxford, 1966.

Holt, E.G., *A Documentary History of Art,* I, N.Y. 1957.

Wittkower, R., *Architectural Principles of the Age of Humanism,* London, 1962.

FOPPA, Vincenzo (1427/30-1515/16)

Foppa was the leading painter of the Milanese school and dominated painting in Lombardy until the appearance of Leonardo da Vinci. He trained as a pupil of Francesco Squarcione and not long afterwards became influenced by Andrea Mantegna and Giovanni Bellini. This diversity of influences lends a heterogeneous character to his frescoes.

1456	*Crucifixion,* Accademia Carrara, Bergamo.
1463-c.1490	Worked in Pavia.
1468	Portinari Chapel frescoes, S. Eustorgio, Milan.
c.1476	Polyptych, S. Maria delle Grazie, Bergamo (now Brera Gallery, Milan).
c.1480's	*Martyrdom of S. Sebastian,* Brera Gallery, Milan.
c.1500	*Adoration of the Magi,* National Gallery, London.

Selected Bibliography

Ffoulkes, C.J. and Maiocchi, R., *Vincenzo Foppa,* 1909.

Wittgens, F., *Vincenzo Foppa,* 1945.

FRANCESCA, Piero della (Piero di Benedetto dei Franceschi or Piero dal Borgo) (1410/20-1492).

The Tuscan painter was born in Borgo San Sepulcro. During his sojourn in Florence, he centered his attention on the aesthetic elements of perspective, light, form and color, and these considerations

continued to preoccupy him for the duration of his artistic career. Near the close of his lifetime, Francesca summarized his aesthetic convictions in the treatises, *De Prospectiva Pengendi* (On Painting in Perspective) and *De Quinque Corporibus Regolaribus* (On the Five Regular Bodies). The latter work provides a detailed elucidation of his Euclidean studies.

1439	Moved to Florence.
1439-45	Frescoes in the church of S. Egidio, Florence (lost).
1440-45	*Baptism of Christ,* National Gallery, London.
1442	Returned to Borgo San Sepolcro.
1445-48/49	*Madonna della Misericordia* polyptych, Compagnia della Misericordia, Borgo S. Sepolcro.
1450	*S. Jerome,* Kaiser Friedrich Museum, Berlin.
1451	*Sigismondo Malatesta Kneeling before his Patron Saint,* S. Francesco, Rimini.
c.1452	Or earlier; *Resurrection,* S. Agostino, Borgo S. Sepolcro.
1452-59	*Legend of the True Cross,* choir of S. Francesco, Arezzo.
c.1454	*Flagellation of Christ,* Gallery, Urbino.
c.1454-69	*Sacra Conversatione,* Borgo S. Sepolcro (dismembered).
1459	Moved to Rome.
1459	*S. Luke the Evangelist,* S. Maria Maggiore, Rome (attributed).
1459	Or earlier; *Resurrection,* Town Hall, Borgo S. Sepolcro.
1460	*Madonna del Prato,* Monterchi Cemetery Chapel.
c.1465	*Portrait of Duc and Duchesse of Urbino* (date highly disputable, possibly 1472).

c.1472-75 *Brera Madonna,* Brera Gallery, Milan (partly by Berruguete).

c.1472-75 *Nativity,* National Gallery, London (unfinished).

Selected Bibliography

Alazard, J., *Piero della Francesca,* Paris, 1948.

Berenson, B., *Piero della Francesca or the Ineloquent in Art,* London, 1954.

Bianconi, P., *All the Paintings of Piero della Francesca,* N.Y., 1962.

Clark, K., *Piero della Francesca,* N.Y., 1951.

Fasola, G.N., ed., *De Prospectiva pingendi,* by Piero della Francesca, Florence, 1942.

Focillion, H., *Piero della Francesca.* Paris, 1952.

Formaggio, D., *Piero della Francesca,* Milan, 1957.

Harzen, E., *Uber den Maler Piero die Franceschi und seinen vermeintlichen Plagiarius, des Franziskanermonch Luca Pacioli, Arch. fur die zeichnendan Kunste,* Leipzig, 1856.

Hendy, P., *Piero della Francesca and the Early Renaissance,* N.Y., 1968.

Longhi, R., *Piero della Francesca: La leggenda della Croce,* Milan, 1955.

Longhi, R., *Piero della Francesca,* 1946.

Meiss, M., "Ovum Struthionis: Symbol and Allusion in Piero della Francesca's Montefeitro Altarpiece," *S. in Art and Literature for Belle da Costa Greene,* Princeton, 1954.

Salmi, M., ed., *Piero della Francesca: Gli affreschi di San Francesco in Arezzo,* 2nd ed., Bergamo, 1944.

Stokes, A.D., *Art and Science: A Study of Alberti, Piero della Francesca, and Giorgione,* London, 1949.

Tolnay, C. de, *Religious Conceptions in the Painting of Piero della Francesca,* N.Y., 1966.

Venturi, L., *Piero della Francesca,* 1946.

Wittgens, F., *La Pala Urbinate de Piero,* Milan, 1952.

FRANCESCO di Giorgio (Francesco Maurizio di Giorgio Martini) (1439-1501/02)

A dominant personality of the Sienese Renaissance, Francesco di Giorgio was a painter, sculptor, and leading architectural figure. He painted mainly during his youth and generally followed the Sienese and International Gothic styles. As a sculptor, his early bronze reliefs reveal the influence of Bertoldo, Pollaiuolo, and even Leonardo da Vinci. His later sculptural approach involves delicate architectural settings as background composition and employs tightly crowded groups in movement as foreground material. The figures in his sculptures range from obscure incised profiles to extreme high relief forms executed in a very personal and expressive manner. As an architectural designer and inventor, he influenced Leonardo who owned a manuscript of his treatise on architecture. Giorgio is credited with the invention of the *Piano Nobile* (Noble Story) with balcony. His unique method of window placement lent a special character to his buildings by crowning each frame with large projecting triangular pediments which often rested upon pilasters and columns. This idea was highly exploited by other Renaissance and even Baroque architects.

1464	*S. John the Baptist,* wood, for the Compagnia di S. Giovanni Battista della Morte, Siena.
1464-75	Shared a joint studio with Verocchio.
1471	Or later; *Altarpiece of the Coronation of the Virgin* for Monteolovetto Maggiore (now in Pinacoteca, Siena).
1475	*Altarpiece of the Annunciation and Nativity* for S. Benedetto fuori Porta Tufi (now in Pinacoteca, Siena).
1475	*Allegory of Discord,* stucco, Victoria and Albert Museum, London and private collection in Siena.
1475-78	*Flagellation* relief, Pinacoteca Nationale dell'Umbria, Perugia.
1476	Relief for the Oratorio di S. Croce, Urbino.

1477-78	In the service of F. da Montefeltre, Urbino, as medallist and military engineer.
1479-80	Work for Alfonso, Duke of Calabria.
1480	Returned to Urbino.
c.1482	*Trattato di architetura civile e militare.*
1484-85	Model for S. Maria del Calcinaio at Cortona (completed 1516).
1485	Official engineer of Siena. S. Maria degli Angeli (attributed).
1486	Design for the Palazzo del Comunale, Jesi.
1489	Worked in Gubbio, Palazzo Ducale (attributed).
1489-90	Two bronze putti for the high altar of the Cathedral of Siena.
c.1490	*Adoration of the Magi,* S. Domenico, Siena.
1490	Visited Milan and made model for the dome of the Cathedral.
c.1490-95	Anthropomorphic derivation of church plan, Bibliotheque Nationale, Florence.
1491	Plan for the facade of the Cathedral of Florence.
1491-95	Visited Naples.
1497	Bronze angels completed for the Cathedral of Siena.
1499	Became the Capomaestro of the Cathedral of Siena.

Selected Bibliography

Brinton, S., *Francesco di Giorgio Martini of Siena, Painter, Sculptor, Engineer, Civil and Military Architect,* London, 1934.

Papini, R., *Francesco di Giorgio, Architetto,* I-III, 1946.

Promis, C., ed., *Francesco di Giorgio's Trattato di Architettura Civile e Militare,* I-II, 1841.

Weller, A.S., *Francesco di Giorgio,* Chicago, 1943.

GHIBERTI, Lorenzo (1378/81-1455)

The Florentine sculptor, Lorenzo Ghiberti, gained his recognition with the two bronze doors he designed for the Baptistery of the Cathedral of Florence. Though he developed a certain sensibility toward antiquity, he never was able to express it fully. He made considerable progress toward classicism in his second bronze doors, especially in the figure of Samson which resembles the ancient Hercules. Despite this, the overall appearance of the gate is not entirely classical. Ghiberti carefully calculated the perspective of the second bronze doors by following the methods of Brunelleschi and Donatello. As a self-made art critic and historian, Ghiberti compiled his important volume, *Commentarii,* which only considered sculptors of his own time. He contended that the important breakthrough was made in painting by Giotto and Cimabue in the 1300's but only after 1400 was this new trend in art fully realized by the Renaissance sculptors.

1401	Competition for the bronze doors of the Baptistery, Florence.
1404-24	First bronze doors, Baptistery, Florence.
1414	*S. John* Or San Michele, Florence.
1417-27	Two reliefs, Baptistery of Siena.
1418	Model for the dome of the Cathedral of Florence.
1420-22	*S. Matthew,* Or San Michele, Florence.
1423	Tomb of Leonardo Dati, S. Maria Novella, Florence.
1424	Trip to Venice.
1424-52	*Porta Paradiso,* second bronze doors, Bapistery, Florence.
1425-52	Cartoons for stained glass windows, Cathedral of Florence.
1427	*S. Stephen,* Or San Michele, Florence.
1428	*Shrine of the Three Martyrs,* bronze, Bargello, Florence.

1432-42 Reliquary of S. Zenobius, Cathedral of Florence.

1440 *Hunt for S. Zenobius,* Cathedral of Florence.

c.1453 Wrote his *Commentarii.*

Selected Bibliography

Friedmann, B., *Ghibertis Verhaltnis zur Gotik und Renaissance,* Berne, Vienna, 1913.

Goldscheider, L., *Ghiberti,* London, 1949.

Krautheimer, R. and Krautheimer-Hess, T., *Lorenzo Ghiberti,* Princeton, 1956.

Perkins, C., *Ghiberti et son Ecole,* Paris, 1886.

Reymond, M., *La Sculpture Florentine,* Florence, 1897.

Schlosser, J. von, *Leben und Meinungen des Florentinischen Bildners Lorenzo Ghiberti,* 1941.

Schlosser, J. von, *Lorenzo Ghibertis Denkwürdigkeiten,* 1910.

White, J.D., *The Birth and Rebirth of Pictorial Space,* London, 1957.

Wittkower, R., *Architectural Principles in the Age of Humanism,* London, 1949.

GHIRLANDAIO (Domenico di Tommaso Bigordi) (1449-1494)

Ghirlandaio was a painter born in Florence who studied painting and mosaics with Alesso Baldovinetti. His work, however, reflects several influences and constitutes an eclectic record of the whole Florentine movement. His frescoes in the Sasetti Chapel of S. Trinita in Florence echo the work of Giotto. The stability of Masaccio's approach is recalled in Ghirlandaio's frescoes for the Vatican. Donatello-like puttos appear in his frescoes for S. Maria Novella in Florence. His portraits closely follow the naturalistic sensitivity of Flemish artists of that period. Ghirlandaio's artistic synthesis fittingly draws the Quattrocento to a close. His *Massacre of the Innocents* anticipates the turbulence of the battle scenes which were to appear in the Cinquecento.

1468-75 Frescoes for the altar of S. Fina, S. Gimignano.

c.1479	Frescoes in the Sala Latina, Vatican.
1480	*S. Jerome* and *The Last Supper,* Ogni Sancti, Florence.
1481-82	Frescoes for the Sistine Chapel, Vatican.
1482-84	*Zenobius and the Heroes of Antiquity,* Palazzo Vecchio, Florence.
1483-86	Frescoes for the Sasetti Chapel, S. Trinita, Florence.
1485	*Adoration of the Shepherds,* Accademia, Florence.
1485-90	Frescoes for S. Maria Novella, Florence.
1487	*Adoration of the Magi,* Uffizi, Florence.
1488	*Adoration of the Magi,* Ospedale degli Innocenti, Florence.
c.1490	*Portrait of Francesco Sasetti with his Grandson,* Louvre, Paris and the Bache Collection, N.Y. A drawing of the grandfather in Stockholm, Rolay Collection.

Selected Bibliography

Davies, G.S., *Ghirlandaio,* London, 1908.

Hauvette, H., *Ghirlandaio,* Paris, 1907.

Küppers, P.E., *Die Tafelbilder des Romenico Ghirlandaio,* Strasbourg, 1916.

Lauts, J., *Domenico Ghirlandaio,* Vienna, 1943.

Steignman, E., *Die Sixtinische Kapelle,* I, Munich, 1901.

GOZZOLI, Benozzo (c. 1420/1-1497)

Gozzoli was the Florentine painter who assisted Fra Angelico and who worked with Lorenzo Ghiberti on the bronze doors for the Baptistery of Florence. His architectural backgrounds clearly derive from his former associates. He was also influenced by the International Gothic style manifested in the work of Pisanello and Gentile

da Fabriano. Gozzoli's last project, the frescoes for the Campo Sancto in Pisa, truly expresses the Florentine Masacciesque tradition.

1450-52 *Life of S. Francis* frescoes, Montefalco.

1453 *Life of S. Rose of Viterbo,* nine frescoes (destroyed).

1456 *Collegio Gerolominiano* altarpiece (now in the Galleria Nationale dell' Umbria, Perugia).

c.1459 *The Medici Family as the Magi,* frescoes, Medici Palace, Florence.

c.1463-65 *Life of S. Augustine* fresco in the choir of S. Agostino, Cathedral of S. Gimignano.

1464 Frescoes for the Tabernacle of Castelfiorentino.

1468-85 *Old Testament Scenes,* frescoes, Campo Sancto, Pisa.

Selected Bibliography

Bargellini, P., *La Fiaba Pittorica di Benozzo Gozzoli,* Florence, 1947.

Hoogewerff, G., *Benozzo Gozzoli,* Paris, 1930.

Lagaisse, M., *Benozzo Gozzoli,* Paris, 1934.

Wigenroth, M., *Die Jungenwerke des Benozzo Gozzoli,* Heidelberg, 1897.

LAURANA, Francesco (c. 1430-1502)

The Dalmatian sculptor appears to have been a pupil of Giorgio da Sebenico. His early activities remain uncertain because of the lack of documentary evidence. However, a major portion of his signed and dated works were executed in France and Sicily. In France, he was stimulated by the late Gothic sculpture and his style slightly inclined toward a Gothic naturalism. Most of his female portrait busts were crafted with a subtle lyric sentimentality and simplicity. Only his medallion portraits exhibit a slight play with realism, but Laurana was an inferior medalist and thus unable to develop this tendency.

1459-60 Or before; Active in Rimini.

1453	Worked on the triumphal arch of the Castelnuovo, Naples, as an assistant to Pietro da Milano.
1459-60	Decorative carving in the Sala della Iole, Palazzo Ducale, Urbino.
1461-66	Moved to France where he is employed by Rene of Anjou as medalist.
1467-71/4	Moved to Sicily.
c.1467-71	Or later; Mastrantonio Chapel, S. Francesco, Palermo.
1471	*Virgin and Child,* Church at Noto.
1471	*Virgin and Child,* S. Maria della Neve, Palermo.
1472-74	*Madonna,* over entrance to S. Maria Materdomini, Naples.
1472-75	Bust of Ipolita Maria Sforza, National Gallery, Wash., D.C.
1473	Bust of Beatrice of Aragon, Rockefeller Collection, N.Y.
1474	*Madonna,* over entrance to chapel of S. Barbara, Castelnuovo, Naples.
1475-76	Bust of Battista Sforza, Bargello, Florence.
1477-83	Returned to France.
1477-81	Chapel of S. Lazarus in the old Cathedral of Marseilles.
1479-81	*Christ carrying the Cross between S S. Benedict and Scholastica,* relief, Church of the Celestins, Avignon.
1479-81	Tomb of Giovanni Cossa, S. Marthe at Tarascon.
1479-81	Tomb of Charles IV, Anjou at Le Mans.
1487-88	Bust of a Woman, Paris, Palermo and Vienna.

Selected Bibliography

Burger, F., *Francesco Laurana,* 1907.

Kennedy, R.W., *Four Portrait Busts by Francesco Laurana,* 1962.

Pope-Hennessy, J., *Italian Renaissance Sculpture,* 1958.

Rolfs, W., *Francesco Laurana,* 1907.

LAURANA, Luciano (c. 1420-1479)

The Dalmatian born Luciano was the official architect of Federigo da Montefeltre in Urbino. He transplanted to that city the Florentine concept of architecture based upon the doctrines of Leon Battista Alberti. His supremely elegant manner of treating such particulars as chimneys, doors and windows anticipated the delicacy of 18th century architecture.

c.1466 Worked for Federigo da Montefeltre, Urbino.

1468-72 Architect for the Ducal Palace, Urbino.

Selected Bibliography

Budnich, G., *Il Palazzo Ducale di Urbino,* Trieste, 1904.

Colasanti, A., "Luciano Laurana," *Architetti dal XV al XVIII secolo,* Rome, 1922.

Franceschini, G., *Figure del Rinascimento urbinate,* Urbino, 1959.

Michelini-Tocci, L., *I due manoscritti urbinate dei privlegi del Montefeltro con una appendice lauranesca,* Florence, 1959.

Rotondi, P., Il *Palazzo Ducale di Urbino,* 2 volumes, Urbino, 1950-51.

Salmi, M. *Piero della Francesca e il Palazzo Ducale di Urbino,* Florence, 1945.

Serra, L., *L'Arte nelle Marche,* II, Rome, 1934.

LEONARDO da Vinci (1452-1519)

Celebrated as a universal genius of the High Renaissance, Leonardo employed his versatile talents in painting, sculpture, architecture, science, and technological discovery. His paintings strongly reflect his scientific learnings. His botanical and mineralogical studies are manifested in his *Madonna of the Rocks.* His physiognomical analyses are

discernible in the *Last Supper.* Leonardo's use of *chiaroscuro* and a dim atmosphere influenced artists up to the end of the nineteenth century. Although he had limited success as a sculptor, he won considerable fame as a military engineer. His concepts of aesthetics and art technique are elucidated in his *Notebook.*

1469-72	Moved to Florence and entered Andrea Verrocchio's studio.
1472	Enrolled in the Painters' Guild of S. Luke, Florence.
c.1472/75	*Annunciation,* Uffizi, Florence.
c.1473/78	*Annunciation,* Louvre, Paris.
1473	First dated "landscape" (Arno River), Uffizi, Florence.
1476	Accused of sodomy.
1478	Received commission for an altarpiece for the Chapel of S. Bernardo, Palazzo Vecchio, Florence.
1478	*Madonna and Child,* Pinacoteca, Munich.
c.1481	*Ginevra d'Benci,* National Gallery, Wash. D.C.
1481	*Adoration of the Magi,* preparatory panel, Uffizi, Florence.
c.1482	*S. Jerome,* Vatican.
1482-83	Moved to Milan.
1483	*Lady with Ermine,* Crachow.
1483	*Virgin of the Rocks,* Louvre, Paris.
1483	Began work on the Sforza Monument.
1485	*Portrait of a Musician,* Ambrosiana Library, Milan (unfinished).
1487-89	*Virgin of the Rocks,* National Gallery, London.
1487-90	Active as an engineer, artist and decorator. Designed and organized festivals: the pageant of Il Paradiso and the double wedding of Beatrice d'Este and Bianca

Sforza. As an architect, he prepared a model for the dome of the Cathedral of Milan (not executed).

1490	Visited Pavia with Francesco di Giorgio.
1490	Salai joined Leonardo.
c.1490	Projects for church plan, Bibliotheque d'Arsenal, Paris.
1490	Leonardo, Michelangelo, Giuliano da Sangallo, Baccio d'Agnolo, and Cronaca called to Florence as consultants for the Great Council Hall in the Signoria.
1495	Began to paint *The Last Supper* in the refectory of the convent church of S. Maria della Grazie, Milan (not completed until 1497-98).
1498	Ceiling fresco for the Castello Sforzesco, Milan.
1499	Left Milan to return to Florence via Mantua and Venice.
1499	*Portrait of Isabelle d'Este,* Louvre, Paris.
1501	*Virgin and Child with S. Anne* altarpiece for the Servite Brothers of Annunciata (now in London at the Burlington House).
1502	Entered the service of Cesare Borgia as military engineer and architect.
1503	Joined the painters' guild in Florence, then began work on the *Battle of Anghiari* (not completed).
1503	Began work on *Mona Lisa,* Louvre, Paris.
1506	Summoned to Milan, then went back to Florence.
1511	Sketches for an equestrian statue in honor of Gian Giacopo Trivulzio, Milanese general and conqueror of the Moors.
1513	Left Milan and traveled to Rome with his pupils, Melzi, Salai and Fanfoia.
1514	Occupied with botany and geometry.

1516 Left Italy for France.

1517 Lived in the Chateau of Cloux near Amboise.

1519 Died at Cloux.

Selected Bibliography

Baldacci, A., *Leonardo da Vinci botanico e fondatore del metods sperimentale,* Bologna, 1914.

Baratta, M., *Leonardo da Vinci e i problemi della terra,* Turin, 1903.

Baroni and others, *Leonardo da Vinci,* Novarra, 1939.

Baroni, *Tutta la pittura di Leonardo,* Milan, 1958.

Biblioteca Medicea Laurenziana, *Quinto Centenario della nascita di Leonardo da Vinci,* Florence, 1952.

Bode, W. von, *Studien über Leonardo da Vinci,* Berlin, 1921.

Bodmer, H., *Leonardo,* Stuttgart, 1931.

Bongioanni, *Leonardo pensatore,* Piacenze, 1935.

Bovi, A., *L'opera di Leonardo per il Monumento Sforza a Milano,* Florence, 1959.

Brion, M., *Leonard de Vinci,* Paris, 1952.

Calvi, I., *L'architettura militare di Leonardo da Vinci,* Milan, 1943.

Castelfranco, G., *La Pittura di Leonardo da Vinci,* Milan, 1956.

Castelfranco, G., *Leonardo da Vinci,* Milan, 1952.

Clark, K., *Leonardo da Vinci,* Baltimore, 1967.

Congress: *Alti del Congress di Studi Vinciani,* Florence, 1953.

Cook, T.A., *Leonardo da Vinci, Sculptor,* London, 1923.

De Toni, G.B., *Le piante e gli animali in Leonardo da Vinci,* Bologna, 1922.

Douglas, R.L., *Leonardo da Vinci,* Chicago, 1944.

Einem, H. von, *Das abendmahl des Leonardo da Vinci,* Cologne-Opdalen, 1961.

Esche, S., *Leonardo da Vinci: das anatomische Werk,* Basel, 1954.

Fumagalli, G., *Leonardo ieri e oggi,* Pisa, 1959.

Gantner, J., *Leonardas Visionen von der Sintflut und vom Untergang der Welt,* Berne, 1958.

Hart, I.B., *The mechanical investigations of Leonardo da Vinci*, London, Chicago, 1925.

Hart, I.B., *The World of Leonardo da Vinci*, London, N.Y., 1961.

Heydenreich, L.H., *Die Sakralbaustudien Leonardo da Vincis*, Engelsdorf, 1920.

Heydenreich, L.H., *Leonardo da Vinci*, I-II, Basel, 1956.

Hildebrant, E., *Leonardo da Vinci*, Berlin, 1927.

Jaspers, K., *Lionard als philosoph*, Berne, 1913.

Keele, K.D., *Leonardo on movement of the Heart and Blood*, Philadelphia, London, Montreal, 1952.

Lorenzo, G. de, *Leonardo da Vinci e la geologia*, Bologna, 1920.

Los Angeles County Museum, *Leonardo's Loan Exhibition*, Los Angeles, 1949.

Lübke, W., *Leonardo da Vinci als architect*, in Kunstwerke und Kunstler, Breslau, 1888.

Luporini, C., *La mente di Leonardo*, Florence, 1953.

Malaguzzi, F. and Valeri, P., *La Corte di Ludovico il Moro II; Leonardo e Bramante*, Milan, 1915.

Malaguzzi, F. and Valeri, P., *Leonardo da Vinci e la Scultura*, Bologna, 1922.

Marcolongo, R., *La meccanica di Leonardo da Vinci*, Naples, 1932.

Marcolongo, R., *Leonardo da Vinci artista-scienziato*, Milan, 1939.

McMurrich, J.P., *Leonardo da Vinci the anatomist*, Baltimore, 1930.

Mignon, M. and others, *Leonard de Vinci*, Rome, 1919.

Müller and Walde, *Leonardo da Vinci, Lebensskizze und forschungen*, Munich, 1889-90.

Müntz, E., *Leonard de Vinci: L'artiste, le penseur, la savant*, Paris, 1899.

Musee de Louvre, *Hommage a Leonard de Vinci*, Paris, 1952.

Pedretti, C., *A Chronology of Leonardo da Vinci's Architectural Studies after 1500*, Geneva, 1962.

Popham, A.E., *The Drawings of Leonardo da Vinci*, N.Y., 1945.

Richter, J.P., *The Literary Work of Leonardo da Vinci*, London, 1939.

Royal Academy of Arts, *Leonardo da Vinci Quincentenary Exhibition,* London, 1952.

Sartoris, A., *Leonard architecte,* Paris, 1952.

Seailles, G., *Leonard de Vinci: L'artiste et le savant,* Paris, 1892.

Seidlitz, W. von, *Leonardo da Vinci: Der Wendepunkt der Renaissance,* Berlin, 1909.

Siren, O., *Leonardo da Vinci: The Artist and the Man,* New Haven, 1916.

Solmi, E., *Leonardo,* Florence, 1900.

Solmi, E., *Scritti Vinciani,* Florence, 1924.

Steinitz and Belt, *Manuscript of Leonardo da Vinci,* Los Angeles, 1948.

Suida, W., *Leonardo und sein Kreis,* Munich, 1929.

Valery, P., *Introduction a la methode de Leonard de Vinci,* Paris, 1919.

Vallentin, A., *Leonard de Vinci,* Paris, 1950.

Verga, E., *Bibliografia Vinciana,* I-II, Bologna, 1931.

LIPPI, Fra Filippo (c. 1406-1469)

The initial works of this Florentine painter manifest a pronounced Massacchiesque influence. It is possible that he was a student of Massaccio, but no documentation presently exists to substantiate this. Later in his career, he demonstrated a Donatellesque and Flemish propensity. His work developed a lyrical and religious emotion which he retained even after the notorious "Lucretia" scandal which forced him to abandon his monastic order. Nevertheless, his undisciplined private life is noticeably reflected in the fluctuant mutability of his executions.

1414	As an orphan was put into the Carmine, Florence.
1421	He assumed the religious habit in the same convent.
1430	Recorded for the first time as a painter.
c.1432	*Relaxation of the Carmelite Rule* fresco, S. Maria della Carmine, Florence.

1434	Left for Padua.
1437	*Tarquinia Madonna,* National Gallery, Rome.
1437	*Barbadori* altarpiece, Louvre, Paris.
1441-47	*Coronation of the Virgin,* Uffizi, Florence.
1443-45	*Annunciation,* Pinacoteca, Munich.
1450	Appointed chaplain to the Monastery of S. Niccolo de'Frari, Florence.
1452-64	Frescoes in the Cathedral of Prato.
1452	*Bartolini* tondo.
c.1453	*Madonna adoring the Child,* two in Uffizi, third in Berlin.
1455-64	*Madonna of the Niche,* Berlin and Kress Collect, Wash., D.C.
1455-60	*Madonna and Child with Two Angels,* Uffizi, Florence, and a miniature in Munich.
1456	Appointed chaplain to the nuns of S. Margherita, Prato.
1457	His son, Filippino Lippi, is born.
c.1460	*Salome,* Prado, Madrid.
c.1460	*Virgin and Child,* Pinacoteca, Munich.
1464	Trial for fraud and abduction of a nun.
1466-69	Frescoes in the Cathedral of Spoleto.

Selected Bibliography

Oertel, R., *Fra Filippo Lippi,* 1942.

Strutt, E., *Fra Filippo Lippi,* London, 1906.

LIPPI, Filippino (1457-1504)

The son of Fra Filippo Lippi, the Florentine painter received his first training from his father. After Fra Filippo's death, he studied under Botticelli whose technique had a pronounced effect upon him. He later demonstrated a capability toward the Massachiesque firm style and adopted the chiaroscuro method. Nonetheless, the antique backgrounds of his late works reflect a Hellenistic persuasion rather than a classic one. This Greek interest is further underscored by the presentation of near-Eastern garments on his Santa Maria Novella frescoes.

c.1482 Frescoes in the Palazzo Signoria, Florence.

1483-85 *Annunciation,* S. Gimignano.

1483-88 *Vision of S. Bernard,* Badia, Florence.

1485 *Madonna and SS. John the Baptist, Victor, Zenobius,* Sala dei Duccenti, Palazzo della Signoria, Florence.

1484-85 Frescoes in the Brancacci Chapel, S. Maria del Carmine, Florence.

c.1485-90 *Allegory of Hate,* Uffizi, Florence.

1486 *Madonna and Saints,* Uffizi, Florence.

1487-1502 Frescoes, Strozzi Chapel, S. Maria Novella, Florence.

c.1488 *Nerli* altarpiece, S. Spirito, Florence.

1488-93 Frescoes, Caraffa Chapel, S. Maria Sopre Minerva, Rome.

1494-96 *Adoration of the Magi,* Uffizi, Florence.

1498 Frescoes for the Strada S. Margerita, Prato (now in Museo Communale, Prato).

1504 Died in Florence.

Selected Bibliography

Berti, L. and Balaini, U., *Filippino Lippi,* Florence, 1957.

Brandi, C. et al., *Saggi su Filippino Lippi,* Florence, 1957.

Fossi, M., *Disigni di Filippino Lippi e Piero di Cosimo,* Exhibition Catalog, Florence, 1955.

Gamba, F., *Filippino Lippi nella storia della critica,* Florence, 1958.

Kanody, P.G., *Filippino Lippi,* London, N.Y., 1905.

Neilson, K., *Filippino Lippi,* Cambridge, Mass., 1938.

Nungin, U., *Les deux Lippi,* Paris, 1932.

Scharf, A., *Filippino Lippi,* Vienna, 1935.

Scharf, *Filippino Lippi,* Vienna, 1950.

Supino, J.B., *Les deux Lippi,* Florence, 1904.

LOMBARDO, Pietro (c. 1435-1515)

Although he was born in Lombardy, Pietro Lombardo became the leading Venetian sculptor of his time. He was already an established artist when he moved to Venice in about 1467. His early style was appreciably influenced by his Florentine journey and his subsequent stay in Padua. Though the figures of his late work derived from classical methods, their forms and movements do not reflect a complete grasp of the settings and modelings of antiquity.

1462	Or later; Tomb of Pasquale Malipiero, SS. Giovanni e Paolo, Venice.
1467	Tomb of Antonio Reselli, S. Antonio, Padua.
c.1467	Or later; Moved his studio to Venice.
c.1474/5	Decoration for Capella Maggiore, S. Giobbe, Venice.
c.1475-81	Tomb of Niccolo Marcello, SS. Giovanni e Paolo, Venice.
c.1476-81	Tomb of Pietro Mocenigo, S. Maria dei Frari, Venice.
1481	*S. Andrea della Cartosa* (destroyed).
c.1481	Tomb of Ludovico Foscarini, S. Maria dei Frari, Venice.
1481-89	Church of S. Maria dei Miracoli.

1482	Tomb of Dante, Ravenna.
1485/6-88	Tomb of Zanetti, Treviso.
1487	Palazzo Dario, Venice (attributed).
1488-90	Worked at the Scuola di S. Giovanni Evangelists and the facade of the Scuola di S. Marco, Venice.
c.1491	Tomb of Onigo, S. Niccolo, Treviso.
1495	Project for the chapel of Palazzo Ducale, Mantua.
1498-1515	Protomagister of the Palazzo Ducale, Venice.
1501	Supervised the construction of the Capella dell SS. Sacramento in the Cathedral of Treviso.
1507	Supervised the construction of S. Salvatore, Venice.
1509	Made model for the Scuola Grand della Misericordia, Venice.

Selected Bibliography

Planiscig, P., *Venezianische Bildhaver,* 1921.

Pope-Hennessy, J., *Italian Renaissance Sculpture,* London, 1958.

LOMBARDO, Antonio (c.1458-1516)

One of the sculptor sons of Pietro Lombardo, Antonio worked in his father's workshop in his early years during which time he was obliged to follow the aesthetic tasks of his father. However, his own interests were always inclined towards the methods of antiquity. Later, when he worked independently for the court of Este at Ferrara, he developed a decorative quality which his father's work lacked.

1475-1506	Active as a helper for his father and brother Tullio.
1501-05	Two reliefs for the Chapel of S. Anthony, S. Antonio, Padua.
1504-06	Worked on the tomb and chapel of Cardinal Zen, S. Mark Venice (completed by Paolo Savin).

1506 Transferred his studio to Ferrara and worked on the Camerini d'Alabastro in the Castello d'Este.

Selected Bibliography

Paoletti, P., *L'Architettura e la scultura del Rimascimento a Venezia,* 1893.

Pope-Hennessy, J., *Italian Renaissance Sculpture,* London, 1958.

LOMBARDO, Tullio (c. 1455-1532)

Another son of Pietro Lombardo, he left Lombardy with his father for Venice where he developed as a sculptor and architect. Although Tullio's style generally followed the mode of his paternal master, his sculpture achieved a more dramatic character while also realizing the true spirit of classical antiquity.

1485 Or later; Tomb of Giovanni Mocenigo, SS. Giovanni e Paolo, Venice.

1488 Participated in the work on the Monument of Giovanni Zanetti, Cathedral of Treviso (with Antonio); also reconstructed the damaged part of the Cathedral.

c.1493 Tomb of Andrea Vendramin, S. Maria dei Servi (now in SS. Giovanni e Paolo, Venice).

1500-02 Altarpiece, S. Giovanni Crisistomo, Venice.

c.1503-04 Chapel of S. Anthony, S. Antonio, Padua.

1505-07 Decorations for Palazzo Ducale, Venice.

1515 Work on the Capella dell'Argenti, Cathedral of Ravenna.

1517 Model for Cathedral of Belluno.

1523 Carved doorway, Palazzo Ducale, Mantua.

1528 Tomb of Matteo Bellati, Cathedral of Feltre.

Selected Bibliography

Palniscig, L., *Venezianische Bildhaver,* 1921.

Paoletti, P., *L'Architettura e la scultura del Rimascimento a Venezia,* 1893.

Pope-Hennessy, J., *Italian Renaissance Sculpture,* London, 1958.

MAIANO, Benedetto da (1442-1497)

The Florentine sculptor and occasional architect intermingled the elements of both fields in his artistic output. Much of his sculpture work reflects his architectural studies and he preferred to sculpt such pieces as *ciboria,* pulpits and elaborately designed tombs which could benefit from his edificial skills. His designs for the Palazzo Strozzi were executed under the strong influence of Michelozzo. His sculptural style was clearly stimulated by the techniques of Donatello and Settignano. As a portrait sculptor, Maiano by and large followed Alberti's thesis. He worked outside Italy for Matthias Corvinus, King of Hungary.

1468-72	Shrine of S. Savino, Cathedral of Faenza (with Giuliano da Maiano).
1468-75	*Altar of S. Fina,* Collegiata at S. Gimignano.
1471	Or later; Ciborium for the high altar, S. Domenico, Siena.
c.1472-75	Pulpit of S. Croce, Florence.
c.1472-75	Tabernacle in Aaezzo.
1473	Matriculated in the Arte dei Maestri di Pietra e Legname.
1474	Bust of Pietro Mellini, Bargello, Florence.
1480-81	Worked on the marble doorway, Sala dei Gigli, Palazzo Vecchio, Florence (with Giuliano da Maiano).
1480	*Tabernacle of the Madonna del Olivo,* Cathedral of Prato.

1481	Completed Antonio Rosellino's Tomb of Mary of Aragon.
1481	Door of Lys, Palazzo Signoria, Florence.
1481-89	Mastroguide Chapel altar, S. Anna dei Lombardi, Naples.
c.1484-87	Worked for the Basilica of the Holy House at Loreto: lavabo and the lunettes of the evangelists.
c.1489	Design for the Palazzo Strozzi, Florence (completed by Cronaca).
1491	Or before; Tomb of Filippo Strozzi, S. Maria Novella, Florence.
c.1493	Altar of S. Bartolo, S. Agostino, S. Gimignano.
1493	Bust of Onofrio di Pietro, S. Gimignano.
1493-95	*Coronation of Ferdinand of Aragon,* group for the Porta Capua, Naples.
1496-97	*S. Sebastian and Virgin and Child,* Church of Misericordia, Florence.

Selected Bibliography

Balogh, J., *A muveszet Matyas Kiraly udvaraban,* Budapest, 1966.

Dussler, L., *Benedetto da Maiano,* 1926.

Pope-Hennessy, J., *Italian Renaissance Sculpture,* London, 1958.

MANTEGAZZA, Antonio (? -1495)
MANTEGAZZA, Cristophoro (? -1482)

The brothers Mantegazza were born in Milan at a date yet unknown. They were mainly active as sculptors in Pavia where together with Amadeo they formed the so-called "Certosa-Pavia Group." This school of sculpturing featured the Franco-Flemish style embracing a classicizing tendency.

1464-66	Cristoforo sculpts terracotta decoration for the cloister of Certosa, Pavia.

| 1467 | Cristoforo worked for Sforza in Milan and made marble carvings for the Castello. |

1473-75 Cristophoro and Antonio sculpt facade of the Certosa, Pavia (with Amadeo).

1482-89 Antonio continues the work on Certosa facade after the death of Cristoforo.

1482-88 Antonio crafts *Lamentation over the Dead Christ, The Adoration of the Magi* and *Christ Washing the Feet of the Disciples,* all in Certosa, Pavia.

Selected Bibliography

Pope-Hennessy, *Italian Renaissance Sculpture,* London, 1958.

MANTEGNA, Andrea (c. 1431-1506)

Mantegna was the foremost painter of Padua whose imaginative approach dominated the style of Northern Italian artists, including those of Venice. He was adopted as a son and trained by Francesco Squarcione who was a devoted observer of classical archaeology. Through Squarcione's influence, Mantegna also gained an interest in antiquity and developed himself into a profound expert of the Antique past. He broke away from the Franco-Flemish style practiced by Northern Italian painters. Through his Albertian studies, he achieved a natural balance in proportion and executed his classical setting with utmost clarity. His landscapes express his perspective and keen observation of nature. Mantegna's perspective developed an illusionistic depth which the later Mannerist and Baroque artists explored to the extreme.

c.1449-59 *Life of S. James* fresco cycle, Ovetari Chapel, Church of Eremitani, Padua (with Niccolo Pizzolo).

1453 *S. Luke with Other Saints,* Brera Gallery, Milan.

1453 *S. Euphemius,* Museum, Naples.

1455 *Adoration of the Shepherds,* Metropolitan Museum, N.Y.

1457-59	*Madonna and Saints,* S. Zeno, Verona (predella in Louvre, Paris).
1459	*Crucifixion,* Louvre, Paris.
1459	*Christ on the Mount of Olives,* Museum, Tours.
1459	*Resurrection,* Museum, Tours.
1459-60	*S. Sebastian,* Vienna.
1460	Left Padua and became court painter at Mantua.
1460	*Adoration of the Magi,* Uffizi, Florence.
c.1460	*Portrait of Cardinal Ludovico Mezzarotta,* Berlin.
1460-65	*Death of the Virgin,* Prado, Madrid.
1460-70	*Portrait of Matthias Corvinus, King of Hungary* (lost).
1460-74	Frescoes for the Camera degli Sposi, Mantua.
1462	*Circumcision* (or *Presentation*), Uffizi, Florence.
1465	*Ascension,* Uffizi, Florence.
c.1466	*Portrait of Cardinal Carlo de 'Medici,* Uffizi, Florence.
c.1475-80	*S. Sebastian,* Louvre, Paris.
c.1482-94	*Triumph of Caesar,* cartoon, Hampton Court.
1488-89	Or 1466/67; *Madonna of the Quarries,* Uffizi, Florence.
1488-89	Frescoes for the Belvedere, Rome (destroyed).
c.1490	*Sacred Allegory,* Uffizi, Florence.
c.1490	*Judith and Holofernes,* National Gallery, Wash. D.C.
1495-96	*Madonna della Victoria,* Louvre, Paris.
1495-97	*Parnassus,* Louvre, Paris.
c.1496	*Dead Christ,* Brera Gallery, Milan.

Selected Bibliography

Balogh, J., *A Muveszet Matyas Kiraly udvaraban,* Budapest, 1966.

Beyen, H.G., *Andrea Mantegna ende Verouering derruimte in de schilderkunst,* The Haque, 1913.

Blum, I., *Andrea Mantegna und die Antike,* Strasbourg, 1936.

Brandolese, P., *Testimonianze intorno alla patavinita di Andrea Mantegna,* Padua, 1805.

Cipriani, R., *Tutta la pittura del Mantegna,* Milan, 1956.

Coletti, L., and Camesaca, E., *La Camera degli Sposi del Mantegna's,* Mantova, Milan, 1959.

Cruttwell, M., *Andrea Mantegna,* London, 1901.

D'Ancona, P., ed. *Mantegna,* Milan, 1956.

Fiocco, G., *L'arte di Andrea Mantegna,* Bologna, 1927, 2nd ed. Venice, 1959.

Fiocco, G., *Mantegna,* Milan, 1937.

Fiocco, G., *Mantegna; La Cappella Ovetari nella chiesa degli eremitani,* Milan, 1944.

Knapp, F., *Andrea Mantegna,* 2nd ed., Stuttgart, 1910.

Kristeller, P., *Andrea Mantegna,* London, 1901.

Lauts, J., *Andrea Mantegna: Die Madonna della Uittoria,* Berlin, 1947.

Meiss, M., *Andrea Mantegna as Illuminator: An Episode in Renaissance Art, Humanism and Diplomacy,* N.Y., 1957.

Moschini, V., *Affreschi del Mantegna agli Bremitani di Padova,* Bergamo, 1944.

Paccagnini, G., and Amezzetti, *Andrea Mantegna,* Exhibition Catalog, Venice, 1961.

Paccagnini, G., *Mantegna: La Camera degli Sposi,* Milan, 1957.

Pacchioni, G., *La Camera picta de Andrea Mantegna nel Castello di Mantova,* Milan, 1960.

Thode, H., *Mantegna,* Bielefeld Leipzig, 1897.

Tietze-Conrat, E., *Mantegna,* London, Florence, N.Y., 1955.

Vertova, L., *Mantegna,* Florence, 1950.

White, J., *The Birth and Rebirth of Pictorial Space,* London, 1957.

Wilenski, R.H., *Mantegna and the Paduan School,* London, 1947.

Yriate, C., *Mantegna,* Paris, 1901.

MASACCIO (Tomasso di ser Giovanni di Simone Guidi) (1401-c. 1428)

He was the Florentine painter who reinspired the Florentine tradition which derived from Giotto's solid style. His sensitivity for balance, form and light gave a new impetus to the art of Early Renaissance Florence and to those who came to study in Florence even long after the death of Masaccio. His truly realistic style contains most of those components which made the Early Renaissance art in Florence so great.

1420	Or earlier; Worked on the frescoes of S. Clemente, Rome (with Masolino).
1422	Entered the Arte Medici e Speziali, Florence.
c.1424	*S. Anne with Virgin and Child* for the church of the Benedictine convent of S. Ambrogio, Florence (now in the Uffizi, Florence).
c.1424	*SS. Jerome and John the Baptist,* double-sided altarpiece for S. Maria Maggiore, Rome (with Masolino; dismembered, sections in National Gallery, London).
1425-28	*Life of S. Peter* fresco cycle in the Brancacci Chapel, S. Maria del Carmine, Florence.
1425	*Madonna of Humility,* Duveen Collection, N.Y.
1426	Polyptych for S. Maria del Carmine, Pisa. Dismembered, partly lost, and sections distributed among the following: *Enthroned Madonna and Child,* National Gallery, London; *Adoration of the Magi,* Dahlem Museum, Berlin; and *Crucifixion of S. Peter,* Dahlem Museum.
1426-28	*Crucifixion,* Museum, Naples.
c.1427/8	*Trinity,* S. Maria Novella, Florence.
1428	*Resuscitation of the King's Son* (finished in Florence).
1428	Left Florence and went to Rome where he soon died.

Selected Bibliography

Berti, L., *Masaccio,* University Park, Pa., 1967.

Hendy, P.H., *Masaccio: Frescoes in Florence,* Greenwich, Conn., 1956.

Mesnil, J., *Massacio et les debuts de la Renaissance,* Paris, 1927.

Pittagula, M., *Massacio,* 1935.

Salmi, M., *Masaccio,* 1948.

MASOLINO da Pinacale (Maso di Cristofano Fini) (c. 1383-1447?)

He was a Florentine painter who was first influenced by the International style. Before he entered the painters' guild, he may have worked as a helper of Ghiberti on the first bronze doors of the Baptistery of Florence. His style, probably under the influence of Masaccio, changed to a more solid though clumsier manner. Toward the end of his career, he returned to his early style.

1405-07	May have worked with Ghiberti.
c.1423	*Founding of S. Maria Maggiore,* triptych, Museo di Capodimonte, Naples.*
1423	Entered the Arte dei Medici e Speziali, Florence.
1423	*Madonna,* Kunsthalle, Bremen.
1423-26	Frescoes in the Brancacci Chapel, Florence.
1424	Frescoes in S. Agostino, Empoli.
1425	*Annunciation,* National Gallery, Wash. D.C.
1427	Went to Hungary.
1428	Resumed work on Brancacci Chapel frescoes, Florence.

Note: Founding of S. Maria Maggiore in the Museo di Capodimonte, Naples is dismembered. The left panel, perhaps painted by Masaccio (*SS. Jerome and John the Baptist*), is in the National Gallery, London and the right panel (*S. John the Evangelist and S. Martin of Tours*) is in the John G. Johnson Collection, Philadelphia, Pa.

c.1430 Frescoes in Branda Chapel, S. Clemente, Rome.

1435 Worked for Cardinal Branda Castiglione in Castiglione d'Olona, near Como.

Selected Bibliography

Lindberg, H., *To the Problem of Masolino and Masaccio*, I-II, Stockholm, 1931.

Salmi, M., *Masaccio*, 1948.

Toesca, P., *Masolino da Pinacale*, 1908.

Vayer, L., *Masolino*, Budapest, 1968.

MATTEO di Giovanni (c. 1435-95)

The Sienese painter, Matteo di Giovanni, was a pupil of Vecchietta. He became acquainted with the Florentine tradition but still remained Sienese in character. His figures have more sculpturesque sensations, but this is still set in a traditional Sienese gold background. When he used classical architectural backgrounds for his paintings, their antique dignity was completely destroyed by the contrast of his anti-classical emotionalism and the use of the grotesque. Certain faces and draperies echo the art of Botticelli but without his charm. Despite this awkwardness, his style is highly personal which moved the Sienese tradition into an entirely new channel.

1465 Polyptych for the priory at Borgo S. Sepolchro (central panel by Piero della Francesca; now in the National Gallery, London).

1479 *S. Barbara* altarpiece, S. Domenico, Siena.

1482 *Massacre of the Innocents,* S. Agostino, Siena.

Selected Bibliography

Berenson, B., *Italian Painters of the Renaissance II; Florentine and Central Italian Schools,* London, 1968.

Encyclopedia of World Art, X-XV, McGraw-Hill, N.Y., 1959-68.

Hartt, F., *History of Italian Renaissance Art*, N.Y., 1960.

Mather, F.J., *A History of Italian Painting*, N.Y., 1960.

MELOZZO da Forli (1438-1494)

A painter from Forli, Melozzo was considered the creator of the extreme foreshortening method called *sotto in su*. His studies in perspective derived from the theoretical work of Piero della Francesca. A categorical evaluation of Melozzo's art is hazardous to make since a major part of his paintings are either lost or in a fragmentary state.

1475-77	Frescoes in the Vatican Library.
1478	Became a member of the Compania di S. Luca.
c.1480	Frescoes in the sacristy of S. Peter's, Rome.
1480	*Ascension* apse of the church of SS. Apostoli, Rome (the central *Christ* is in the Palazzo Quirinale, Rome; other parts are missing).
1480	Frescoes in the Sistine Chapel, Vatican.
1484	Frescoes on the vault of S. Marco, Casa Sancta in Loreto.
c.1484	Design for the cupola frescoes in the Capella del Tesoro, Loretto.
c.1489	Cartoons for the mosaics in S. Croce in Gerusalemme, Rome.
1493	Frescoes in the Palazzo Comunale, Ancona.
1493	Frescoes for the Capella Feo in S. Biagio, Forli (destroyed in 1944).

Selected Bibliography

Buscaroli, R., *Melozzo da Forli*, Rome, 1938.

Okkonen, O., *Melozzo da Forli und sune Schule*, Helsinki, 1910.

Schmarsow, A., *Joos van Gent und Melosso da Forli in Rom und Urbino*, Leipzig, 1912.

Schmarsow, A., *Melozzo da Forli*, Berlin-Stuttgart, 1886.

MESSINA, Antonello da (c. 1430-1479)

Messina was a Sicilian who came to Venice in 1475 and changed the whole course of Venetian painting. He may have been a pupil of Collantonio in Naples who was directly influenced by Flemish painters. In Naples, he met the Master of Aix who similarly worked in the Flemish tradition and possibly influenced Messina also. From 1475 to 1476, he was in Venice and Milan and had a strong influence on Venetian painters.

1465	*Salvator Mundi*, National Gallery, London.
c.1470	*Madonna and Child*, National Gallery, Wash., D.C.
1473	*S. Gregory* polyptych, Museo Nazionale, Messina.
c.1476	*S. Cassiano* altarpiece (fragments of copies are in Vienna). Visited Venice.
1475-76	*Portrait of Condottiere*, Louvre, Paris.
1475	*Calvary*, Royal Museum, Anvers.
1475	*Madonna of the Rosary*, Royal Museum, Anvers.
1475	*Portrait of Michele Vianello*, Gallery Borghese, Rome.
1475	*Portrait of Alvise Pasqualino*, Schwarzberger Collect, Vienna.
1476	*Head of a Man*, Museum, Torino.

Selected Bibliography

Bottari, S., *Antonello da Messina*, 1953.

Lavts, J., *Antonello da Messina*, 1941.

Vagni, G., *Tutta di Pittura di Antonello da Messina*, 1952.

MICHELANGELO Buonarotti*

He was a painter, sculptor and architect of the High Renaissance. At first, he was an apprentice of Ghirlandaio. He then studied at the school which was connected with the Medici sculpture garden in Florence, supervised by Bertoldo. The Florentine milieu, Massaccio, Leonardo and Raphael, all influenced his approach until the end of the century. It was then that he developed his heroic style which is attached to the city of Rome. Lastly, in his final style, he became the chief inspiration of the Mannerist movement in Baroque art.

1488	Apprenticed to Ghirlandaio.
c.1494	Or earlier; *Madonna della Scala* relief.
c.1494	Or earlier; *Herakles and Centaur* relief.
1494	*Angel* for the arca of S. Domenico in Petronio, Bologna.
1496	*Bacchus.*
1498	*Pietà*, Vatican.

Selected Bibliography

Ackerman, J., *The Architecture of Michelangelo,* I-II, N.Y., 1961-64.

Arslan, E., *Michelangelo,* 1944.

Barocchi, P., *Michelangelo e la sua schuola,* 1962.

Carden, R.W., *Michelangelo: A Record of His Life As Told in his Own Letters and Papers,* 1913.

Carli, E., *All the Paintings of Michelangelo,* N.Y., 1963.

Clemets, R.T., *Michelangelo's Theory of Art,* N.Y., 1961.

De Tolnay, C., ed. *The Art and Thought of Michelangelo,* N.Y., 1964.

De Tolnay, C., ed. *The Complete Works of Michelangelo,* N.Y. 1965.

Note: The chronology of the rest of the works of Michelangelo will be treated in Volume II, Renaissance art between 1500-1600.

De Tolnay, C., ed. *Michelangelo*, I-V, N.J., 1943-60.

Dussler, L., *Die Zeichnungen des Michelangelo*, 1959.

Frey, C., *Die Dichtungen des Michelangelo Buonarotti*, 1897.

Geymüller, H. von, *Michelangelo als Architect*, 1904.

Goldscheider, L., *A Survey of Michelangelo's Models in Wax and Clay*, London, 1962.

Goldscheider, L., *Michelangelo's Bozzetti for Statues in the Medici Chapel*, London, 1957.

Goldscheider, L., *Michelangelo Drawings*, London, 1966.

Goldscheider, L., *Michelangelo: Paintings, Sculptures and Architecture*, N.Y., 1962.

Goldscheider, L., *The Paintings of Michelangelo*, London, 1939.

Grimm, H., *The Life of Michelangelo*, I-II, 1893.

Hartt, F., *Michelangelo*, N.Y., 1965.

Milanesi, ed., *Le Lettere di Michelangelo Buonarotti*, 1825.

Morgan, C.H., *The Life of Michelangelo*, N.Y., 1960.

Newell, W.W., *The Sonnets and Madrigals of Michelangelo*, I-II, 1900.

Perrig, A., *Michelangelos Letzte Pieta-Idee*, 1960.

Russoli, F., *All the Sculpture of Michelangelo*, N.Y., 1963.

Salmi, M., ed. *The Complete Works of Michelangelo*, I-II, London, 1966.

Schiavio, A., *Michelangelo Architetto*, 1949.

Steinmann, E., *Die Porträtdarstellungen des Michelangelo*, 1913.

Steinmann, E. and Wittkower, R., *Michelangelo Bibliographie, 1510-1926*, 1927.

Symonds, J.A., *The Life of Michelangelo Buonarotti*, I-II, N.Y., 1899.

Symonds, J.A., *The Sonnets of Michelangelo*, London, 1878 and 1950.

Venturi, A., *Michelangelo*, London, 1928.

Weinberger, M., *Michelangelo the Sculptor*, I-II, N.Y., 1967.

MICHELOZZO di Bartolommeo (1396-1472)

Michelozzo was a Renaissance sculptor and architect born in Florence. His father was originally a Burgundian but became a Florentine citizen in 1376. During his sculptural career, Michelozzo was successively associated with Lorenzo Ghiberti, Donatello, and Luca della Robbia. When his interests turned to architecture around 1430, he presented a strong, rusticated style. Later, through the influence of Filippo Brunelleschi, his designs acquired a more graceful and elegant manner. The classical spirit attracted him also, especially in his work on church domes. His architectural style, however, involved Early Christian and Byzantine forms as well as the antique classical inspiration.

1417-24	Employed by Ghiberti on the first doors of the Baptistery of Florence. *S. Matthew* statue for Or S. Michele.
1420's	Medici Church of S. Francesco, Muguello.
1425-33	Shared a studio with Donatello.
1425	Or later; Cascia Monument.
1427	Brancacci Monument, S. Angelo a Nilo, Naples.
1433	Medici Villa Loggia, Careggi.
1433	Bronze capital for Prato's pulpit.
c.1434	Medici Chapel, S. Croce, Florence.
1436-51	Restored the convent and church of S. Marco, Florence.
1437-42	Re-employed by Ghiberti.
1437-38	Aragazzi Monument, Cathedral of Montepulciano.
1437	Terracotta reliefs for facade of S. Agostino, Montepulciano.
1444-59	Palazzo Medici Riccardi, Florence.
1444-45	Tribune, atrium, cloister and sacristy of S. Annunciata, Florence.

1445-47	Bronze door of the north sacristy of the Cathedral of Florence (with Lucca della Robbia).
1445-50	*Virgin and Child* relief, SS. Annunciata, Florence.
1446-51	Became Capomaestro of the Cathedral of Florence.
1447-48	Tabernacle, SS. Annunciata, Florence.
1451	S. Girolamo, Fiesole.
1452	*S. John,* silver, Baptistery of Florence.
1458-61	Villa Medici, Fiesole.
1460 (?)	Tabernacle, Church of Impruneta.
1462	Portinari Chapel, S. Eustorgio, Milan.
1462-63	Ragusa Palazzo dell Rittore, Dubrovnik, Yugoslavia.
1463-64	Work on bronze door of Lucca della Robbia in the Cathedral of Florence.
1465	Work on the Palazzo Signoria, Florence.

Selected Bibliography

Morisani, O., *Michelozzo, Architetto,* 1951.

Stegmann, C., *Michelozzo di Bartolommeo,* 1888.

Wolff, F., *Michelozzo di Bartolommeo,* 1903.

MINO da Fiesole (1429-1484)

Mino da Fiesole, the Florentine sculptor, began as a pupil of Desiderio da Settignano according to Giorgio Vasari's *Lives.* Some of his early work was done in Naples, but he executed most of his sculptures in Rome, Florence, and the Florentine environs of Prato, Volterra, and Fiesole. Although his style is to a great extent borrowed from ancient Roman forms, Mino demonstrates a virtuosity and sensitivity of linear technique, particularly in his portraitures.

1453	Moved to Rome.
1453	Bust of Piero de'Medici, Bargello, Florence.

c.1454	Or earlier; Bust of Niccolo Strozzi, Berlin.
1455	Bust of Astorgio Manfredi, National Gallery, Wash., D.C. Moved to Naples.
1456	Bust of Alessandro di Luca Mini, Berlin.
c.1460	Bust of Giovanni de'Medici, Bargello, Florence.
1461	Bust of Rinaldo della Luna, Bargello, Florence.
1463	Returned to Rome and worked on the Benediction Pulpit of Pius II (with Paolo Romano, Isaia da Pisa, Pagno di Settignano and other sculptors).
1464	Bust of Diotisalvi Neroni, Louvre, Paris.
1464-80	Mural drawings of elegant figure combined with studies in mathematical calculations; executed in his home in Florence.
1464	Returned to Florence. Engaged with the Salutati Monument in the Cathedral of Fiesole and the Giugni Monument in the Badia.
1469-81	Monument of Count Hugo of Tuscany, Badia, Florence.
1471	Tabernacle, Cathedral of Volterra.
1471-73	Reliefs for A. Rossellino's pulpit in the Cathedral of Prato.
1474	Altar for the Sacristy of S. Marco, Florence (with Giovanni da Dalmata).
1474-78	Active again in Rome. Worked with Andrea Bregno, Giovanni da Dalmata and others.
1474-78	Tomb of Pope Paul II, Vatican Grotto (with Giovanni da Dalmata).
1474-80/1	Forteguerri Monument, S. Cecilia in Tratavere, Rome.
1474-80	Ammanti Monument, S. Maria del Popolo, Rome.
1474-80	Riario Monument, SS. Apostoli, Rome.

1474-80	Della Rovere Monument, S. Maria del Popolo, Rome.
1474-80	Francesco Tornabuoni Monument, S. Maria Sopra Minerva, Rome.
1475	Altar of S. Jerome, S. Maria Maggiore, Rome.
1481	Tabernacle, S. Ambrogio, Milan.
1481	Returned to Florence.

Selected Bibliography

Angeli, D., *Mino da Fiesole,* Florence, 1906.

Lange, H., *Mino da Fiezole,* Greifswald, 1928.

Pope-Hennessy, *Italian Renaissance Sculpture,* London, 1958.

Valentiner, W.R., *Studies of Italian Renaissance Sculpture,* London, 1950.

MONACO, Lorenzo (c. 1370/2-1422/5)

Monaco was probably a Sienese painter. He settled in Florence, working as a monk on manuscript illuminations at the S. Maria degli Angeli. His style reflected the combination of a manuscript technique and the International style. Toward the end of his life, he returned to the use of color found in the International style.

1406-10/13	*Coronation of the Virgin* and *Annunciation,* Uffizi, Florence.
c.1420	*Adoration of the Magi,* Uffizi, Florence.
1420	Bartolini Chapel frescoes, S. Trinita, Florence.
1422	*Adoration,* Uffizi, Florence (his final work).

Selected Bibliography

Berenson, B., *Italian Painters of the Renaissance,* II, London, 1968.

De Wald, E.T., *Italian Painting, 1200-1600,* N.Y., 1961.

Hartt, F., *History of Italian Renaissance Art,* N.Y., 1970.

PAOLO, Giovanni di (c. 1403-1482/3)

A leading Sienese painter of the International style, Giovanni di Paolo stands between the style of Sasetta and that of Gentile da Fabriano. His late style introduced harsh and ugly forms, which attracted the expressionists of the early 20th century.

1427	*Madonna,* Robert von Hirsch Collect., Basel, Switzerland.
1440	*Annunciation* (dismembered: *Expulsion from the Garden,* National Gallery, Wash., D.C.; *Nativity,* Vatican Gallery; *Presentation,* Metropolitan Museum, N.Y.; *Crucifixion,* Berlin-Dahlem; and *Adoration of the Magi,* Cleveland Museum, Cleveland).
c.1455	*S. John the Baptist in the Wilderness,* Art Institute, Chicago.
c.1455	*Ecco Agnus Dei,* Art Institute, Chicago.
1447-49	*Presentation of Christ,* Gallery, Siena.
c.1460	*Madonna and Child in a Landscape (Madonna of Humility)* Museum of Fine Arts, Boston.
1463	*Madonna* altarpiece in Cathedral of Pienza.
1475	*Assumption,* polyptych, Stapgia.

Selected Bibliography

Brandi, C., *Giovanni di Paolo,* 1967.

Pope-Hennessy, J., *Giovanni di Paolo,* 1937.

PASTI, Matteo de' (c. 1420-1467/8)

He made his fame first as an illuminator for Petrarch's *Trionfi,* then became celebrated as a medalist. As a sculptor, he was noted for his decorations for the Il Tempietto di Malatestiano, Rimini. His style as a sculptor is closely related to that of Agostino Duccio.

1441	Illustrations for Petrarch's *Trionfi*.
1446-64	Sculptural decoration for interior of Il Tempio di Malatestiano, Rimini.
c.1446	Medals for Sigismondo Malatesta and Isotta degli Atti.
1446	Or later; Illustrations for breviary for Lionello d'Este (with Giorgio Tedesco).
1449-67/8	Sold his house in Verona and moved to Rimini.
1460-64	Visited Mahamet II.
1464-68(?)	Worked again on the Il Tempio di Malatestiano, Rimini.

Selected Bibliography

Brandi, C., *Il Tempio Malatestiano,* Turin, 1956.

Ricci, C., *Il Tempio Malatestiano,* Milan, 1925.

PERUGINO (Pietro Cristoforo Vannucci) (c. 1445/50-1523)

Perugino was the Umbrian painter born in Citta della Pieve. A leading exponent of the Perugian school, he counted Raphael among his students. He developed a mastery of spatial compositions which is often associated with the so-called Umbrian landscape backgrounds. Most of his paintings offer a strong poetic value, but the repetition of poses and uniformly set figures invite boredom. The manner of execution manifested in his portraits is reminiscent of Memling.

1472	Listed as a member of the Company of S. Luke, Florence.
1473	*Life of S. Bernardino,* Museum, Perugia.
1480	*Christ Giving the Keys to S. Peter,* Sistine Chapel, Vatican.
1480-90	*Portrait of a Boy,* Uffizi, Florence.
1481-85	*Crucifixion,* National Gallery, Wash. D.C.

c.1490	*Madonna and Saints,* tondo, Uffizi, Florence.
c.1490	*Resurrection of Christ,* Vatican Museum.
c.1490	*Assumption of the Virgin,* Uffizi, Florence.
1490-1500	*Apollo and Marsyas,* Louvre, Paris.
1490	*Madonna with S. John,* National Gallery, London.
1493-94	*Pietà,* Uffizi, Florence.
1493	*Madonna with S. John the Baptist and S. Sebastian,* Uffizi, Florence.
c.1493-95	*S. Sebastian,* Louvre, Paris.
1493-96	*Crucifixion,* S. Maria Maddalena dei Pazzi, Florence.
1493	*Madonna Enthroned,* Kunsthistorisches Museum, Vienna.
1495/6	*Vision of S. Bernard,* Pinacoteca, Munich.
1495	*Entombment,* Palazzo Pitti, Florence.
1499	Frescoes in the Cambio, Perugia.*
1499	Altarpiece for the Chartreuse of Pavia, National Gallery, London.

Selected Bibliography

Bombe, W., *Geschichte der Peruginer malerei* (Italienische Forschungen V), Berlin, 1912.

Bombe, W., *Perugino,* Stuttgart, Berlin, 1914.

Bombe, W., *Urkunden sur Geschichte der Peruginer Malerei im 16. Jahrhundert,* Leipzig, 1929.

Broussole, J.C., *La teunesse du Perugin et les origines de l'ecole ombrienne,* Paris, 1901.

Camesasca, *Tutta la pittura del Perugino,* Milan, 1959.

Canuti, F., *Il Perugino,* 2 volumes, Siena, 1931.

Note: His planetary allegories depend on the illustrations in Johannes de Spira's *Astrolabium Planum in Tabulis Ascendens,* 1494.

Gnoli, C., *I documenti su Pietro Perugino,* Perugia, 1924.

Gnoli, C., *Pietro Perugino,* Spoleto, 1923.

Hutton, E., *Perugino,* N.Y., 1907.

Mariottii, A., *Lettere pittoriche Perugine,* Perugia, 1788.

Mezzanotte, A., *Della vita e della opendi Pietro Vannucci,* Perugia, 1836.

Orsini, B., *Vita, elogio e memorie dell egregio pittore Pietro Perugino e degli scollari di esso,* Perugia, 1804.

Scholsser, K.F. von, *Perugino,* Frankfurt am Main, 1920.

Venturi, L., et al., *Il Perugino,* Turin, 1955.

Williamson, G.C., *Pietro Vanucci, called Perugino,* London, 1903.

PINTORICCIO (Bernardino di Betto) (c. 1454-1513)

A Perugian painter and pupil of Perugino, he probably assisted his master in Rome on the Sistine frescoes. The influence of Perugino remained evident until the end of his artistic activity.

1481	*Nativity,* S. Maria dell Popolo, Rome.
1484	*Moses and Egypt* and *Baptism of Christ,* Sistine Chapel, Rome (with Perugino).
1490	*Portrait of a Young Man,* Museum, Dresden.
c.1492-95	Borghia Apartment frescoes, Vatican.
1496	*Virgin, SS. John, Augustine and Jerome,* Museum, Perugia.
1501	Frescoes for S. Maria Maggiore, Spello.
1503-08	Frescoes in Piccolomini Library, Siena.
1509	*Madonna Enthroned with Saints,* S. Andrea, Spello.

Selected Bibliography

Bombe, W., *Geschichte der Peruginer Malerei,* Berlin, 1912.

Carli, E., *Il Pintoricchio,* Milan, 1960.

Philips, E., *Pintoricchio,* London, 1901.

Ricci, C., *Pintoricchio,* Philadelphia, 1902.

Saxl, F., *Lectures,* 1917.

Schmarsow, A., *Bernardino Pintoricchio in Rome,* Stuttgart, 1882.

PISA, Isaia da (active 1447-1467)

He worked with Donatello on the Brancacci Monument and made several tomb monuments independently in Rome. Later, he is documented in Orvieto and Naples. His sculptural imagination was greatly influenced by the ancient Greek style but with a Praxitelian sensitivity.

1431	Employed by the Vatican.
1439(?)	*Virgin and Child Enthroned with SS. Peter and Paul,* Vatican Grotto.
1447	Chiaves Monument, S. John Lateran, Rome.
1447	Monument of Pope Eugenius IV, S. Salvatore, Lauro.
1450-51	Worked in Orvieto.
1456	Worked on the Arch of Castelnuoco, Naples.
1460	Worked with Paulo Romano for Pius II.
1462-63	Tabernacle of S. Andrew, S. Peter's, Rome.
1463-64	Benediction Pulpit of Pope Pius II.

Selected Bibliography

Paducci, A., *Monumenti sepolcrati della Seconda meta' del Quattrocento in Roma,* 1932.

Pope-Hennessy, *Italian Renaissance Sculpture,* London, 1958.

PISANELLO, Antonio (c. 1395-1455/6)

Born in Verona, Pisanello was both a painter and a medalist. As a painter, he followed Gentile da Fabriano's International Gothic style. His drawings are in the Vallardi Codex, the Louvre, Paris.

1415-22	Frescoes for the Doge Palace, Venice (destroyed).
c.1420	*Profile of a Girl,* National Gallery, Wash., D.C.
1424	*Annunciation with SS. George and Michael,* S. Fermo, Verona.
c.1430/7	*Vision of S. Eustache,* National Gallery, London.
1431/2	Frescoes for the Lateran Basilica, Rome (destroyed).
c.1433	*Study of Hanged Men,* British Museum, London.
1433 or 35-40	*Portrait of Princess d'Este,* Louvre, Paris.
1437/38	*S. George and the Princess of Trebizond, S. Anastasia,* frescoes, Verona.
1438	First datable portrait medallions.
1439	*Portrait of Jean VIII Paleologus,* medallion.
c.1441	*Portrait of Lionello d'Este,* Accademia Carrara, Bergamo.
1443	*Self-Portrait,* medallion.
1447	Medallion portraits of Cecile Gonzaga.
1448/49	Set of medals of Alfonzo of Aragon.

Selected Bibliography

Babelon, J., ed. *Bibliotheque Nationale: Exposition de l'oeuvre de Pisanello,* Paris, 1932.

Brenzoni, R., *Pisanello,* Florence, 1952.

Coletti, L., *Pisanello,* Milan, 1953.

Degenhart, B., *Antonio Pisanello,* Vienna, 1940.

Guiffrey, J., ed., *Les dessins de Pisanello conserve's au Musus de Louvre*, I-IV, Paris, 1911-20.

Habich, G., *Die Medaillen der Italianischen Renaissance*, Stuttgart, 1923.

Hentzen, A., *Pisanello: Die Vision des Hl. Eustachius*, Berlin, 1848.

Hill, G.F., *A Corpus of Italian Medals of the Renaissance*, I-II, London, 1930.

Hill, G.F., *Dessins de Pisanello*, Paris-Bruxells, 1929.

Hill, G.F., *Pisanello*, London, 1905.

Marinelli, G., *Il Codice Vallardi e i disegni di Pisanello al Louvre*, Emporium CXXXIII, 1961.

Martinie, A.H., *Pisanello*, Paris, 1930.

Put, A. van de, *Pisanelliana, Old Master Drawings*, VI, 1931-32.

Venturi, A., *Pisanello*, Rome, 1939.

POLLAIUOLO, Antonio (1431/2-1498)

Antonio, together with his younger brother Piero (c. 1441-1498), worked as painter, sculptor and engraver. In addition, they were famous as goldsmiths and designers of embroidery. As scientists, they experimented with the new oil-painting techniques and demonstrated a high degree of knowledge of anatomy. Antonio was especially interested in realistically rendering muscles both in action and at rest. His execution of the *Hercules and Anteus* is particularly interesting. The subject matter is derived from classical mythology, but the execution does not follow the practice of ancient classical prototypes. The forceful muscles and the articulation of the faces reflect a keen interest in anatomy rather than studies of classical nudes.

1457	Silver crucifix for the Baptistery of Florence (with Betto di Francesco Betti).
1460	*Labors of Hercules* for the Palazzo Medici, Florence (with his brother Piero; lost).
1465	*Voyage of Tobias*, Gallery Sabauda, Torino.

c.1466 Or later; Design for the vestments of the Baptistery of Florence.

c.1466-68 Altarpiece and frescoes on the wall of the Chapel of the Cardinal of Portugal, S. Miniato al Monte, Florence.

1467 *SS. Eustache, James and Vincent,* Uffizi, Florence.

1469 Visited Rome where he studied classical sculpture.

c.1470 *Battle of Ten Nudes,* engraving, Fogg Art Museum, Cambridge, Mass.

c.1470 *Slaying of the Centaur Nessus While Carrying Off Dejanira,* Yale University Gallery, New Haven, Conn.

c.1470 *David,* Berlin.

c.1470 *Hercules and Anteus,* Uffizi, Florence.

c.1475 *Martyrdom of S. Sebastian* altarpiece, National Gallery, London (with Piero).

c.1475-80 *Hercules and Anteus,* bronze, Bargello, Florence.

1477-78 *Birth of John the Baptist* relief on the silver altar of the Baptistery, Florence.

1482-93 Tomb of Pope Sixtus IV, S. Peter's, Rome.

1483 Altarpiece for S. Agostino, S. Gimignano (with Pietro).

1491 Architectural project for the Cathedral of Florence.

1492-98 Tomb of Pope Innocent VIII, S. Peter's, Rome (with Pietro).

1495 Worked on the cupola of the Sacristy of S. Lorenzo, Florence.

c.1495 Worked as an architect on the building of S. Maria dell' Umilta, Pistoia.

1498 Died in Rome.

Selected Bibliography

Cruttwell, M., *Antonio Pollaiuolo,* N.Y., 1907.

Etlinger, L.D., Pollaiuolo's Tomb of Pope Sixtus IV, *Journal of the Warburg and Courtauld Institutes,* Vol. XVI, 1953.

Ortolani, S., *Il Pollaiuolo,* Milan, 1948.

Phillips, J.G., *Early Florentine Designers and Engravers,* Cambridge, Mass., 1955.

Sabatini, A., *Antonio e Piero Pollaiuolo,* 1944.

QUERCIA, Jacopo della (1374/5-1438)

A Sienese sculptor, he was a contemporary of Donatello. His early work showed some Burgundian traditions combined with Roman classicism. His mature style culminated in the work for the main portal of S. Petronio, Bologna. His robust figures influenced Michelangelo's formation of nudes. In the sculpture of Quercia, strength and frequently crude expression are balanced by the voluptuousness of female nudes and a Giottesque landscape setting is often used as background contrast.

1401	Participated in the competition for the bronze doors of the Baptistery of Florence.
c.1406	Tomb of Ilaria del Caretto, Cathedral of Lucca.
1408	*Madonna of Ferrara.*
1409	Commissioned for the Fonte Gaia, Pal. Pubblico, Siena (executed 1411-19).
1413-16	Polyptych of the Trenta Family, S. Frediano, Lucca.
1417-31	Reliefs for the Baptistery of Siena (Ghiberti and Donatello worked on portions).
1425-38	Reliefs for S. Petronio, Bologna.

Selected Bibliography

Bacci, P., *Jacopo della Quercia: Nuovi documenti e Commenti,* 1929.

Biagi, L., *Jacopo della Quercia,* 1946.

Nicco, G., *Jacopo della Quercia,* 1934.

RIZZO, Antonio (Active after 1465-1499/1500)

He was a Northern Italian sculptor. During his Certosan period, he was influenced by Amadeo's Lombard style and the Franco-Flemish naturalistic style. In his Venetian period, he developed his own style which derived to a certain extent from classicism.

c.1464-65	Tomb of Orsato Giustiniani, S. Eufemia, Venice.
1465	Carved the capitals for Certosa, Pavia.
c.1467	Tomb of Vittore Capello, S. Elena, Isola.
1467	Worked at S. Andrea della Certosa, Venice.
1476	Monument of the Doge Niccolo Tron, Frari.
1476	Executed a staircase for the Scuola di S. Marco (designed by Gentile Bellini; destroyed by fire).
1483-98	Courtyard of the Palace of the Doges, Venice.
1483	Protomagister of the Ducal Palace, Venice.
c.1483-91	*Adam and Eve,* courtyard of Palazzo Ducale, Venice.
c.1484	Tomb of Giovanni Emo, S. Maria dei Servi, Venice.
1491	Scala dei Giganti, constructed with classical victory reliefs, Venice.
1498	Moved to Ancona, Lesena and Foligno.

Selected Bibliography

Mariacher, G., "Aggiunte ad Antonio Rizzo," *Arte Veneta,* IV, 1950.

Pope-Hennessy, J., *Italian Renaissance Sculpture,* London, 1958.

ROBBIA, Lucca della (1399/1400-1482)

A Florentine sculptor and the inventor of glazed terracotta, he was well known as a master of bronze and marble. In his *Cantoria Cantata*, he recalled the charming child figures of antiquity and his bronze doors augmented his fame. His son, Giovanni, and nephew, Andrea, carried on the family business together with the sons of Lucca della Robbia throughout the 16th century.

1421	Or before; Worked on the *Assumption of the Virgin* over the Porta della Mandorla (with Nanni di Banco).
c.1431-38	*Cantoria Cantata*, Cathedral of Florence.
1432	Matriculated in the guild for sculptors.
1434	Modeled colossal heads for the "Gula" of the cupola of the Cathedral of Florence (with Donatello).
1437-39	Five marble reliefs of the Arts and Sciences for the Campanille, Florence.
1439	Marble altars for the Chapel of SS. Peter and Paul in the Cathedral of Florence.
1441	*Pietà*, Tabernacle of Peretola.
1439	Marble tabernacle for the Capella di S. Luca, S. Maria Nuova, Florence.
1442-45	*Resurrection* lunette for the Cathedral of Florence (first recorded enameled terracotta).
c.1445	*Visitation of S. Giovanni Fuorcivitas*, Pistoia.
1445	Model for the bronze doors for the sacristy at the Cathedral of Florence.
1446-69	Bronze doors for the sacristy of the Cathedral of Florence.
1446-48	*The Ascension*, Cathedral of Florence.
1447	Doors for the Capella de Crocifisso, S. Miniato al Monte, Florence.

1448-51	*Two Angels with Candlesticks,* Cathedral of Florence.
1450	Lunette for S. Domenico, Urbino.
1451-69	*Apostle* tondos, Pazzi Chapel, Florence.
1454-57	Tomb of Benozzo Federighi, S. Trinita, Florence.
1455-65	Stemma for the Arte dei Medici e Speziali, Florence (now in Orsanmichele, Florence).
1461-66	Ceiling decoration for the Chapel of the Cardinal of Portugal, S. Miniato al Monte, Florence.
1472	Or later; Altarpiece, Chapel of the Palazzo Vescovile, Prescia.

Selected Bibliography

Bode, W. von, *Florentine Sculpture of the Renaissance,* London, 1908.

Cruttwell, M., *Lucca and Andrea della Robbia and their Successors,* 1902.

Maclagau, E., *Italian Sculpture of the Renaissance,* Cambridge, Mass., 1935.

Marguand, *Andrea della Robbia,* I-II, 1922.

Marguand, *Giovanni da Robbia,* 1920.

Marguand, *Lucca della Robbia,* 1914.

Planiscig, *Lucca della Robbia,* 1948.

ROBERTI, Ercole dei (c. 1448/55-1496)

Roberti was an eclectic painter who was mainly active in Ferrara where he was a pupil of Cosimo Tura. From Donatello's sculpture through the Padua school and to Flemish art, one can find the various influences in his work.

1469-70	Partially painted the frescoes for the Palazzo Schifanoia, Ferrara.

1473-75	Worked on the Griffoni altarpiece, S. Petronio, Bologna (with Cossa).
1476-78	*Madonna Enthroned,* Kaiser Friedrich Museum, Berlin.
1479-86	Court painter in Ferrara.
1480/1	Altarpiece, Brera Gallery, Milan.
c.1485	*Christ Carrying the Cross,* Gemaldegalerie, Dresden.
c.1485	*S. John the Baptist,* Dahlem Museum, Berlin.
1486-90	*Studies of Riders and Soldiers,* Boymans-Van Beuningen Museum, Rotterdam; Gathorne-Hardy Collection, Donnington; and National Museum, Budapest.

Selected Bibliography

Filippini, F., *Ercole da Ferrara,* Florence, 1922.

Nicholson, B., *The Painters of Ferrara,* London, 1951.

Padovani, *La critica d'arte e la pittura Ferrarese,* Rovigo, 1955.

Ruhmer, E., *Erganzendes zur Zeichenkunst des Ercole de' Roberti,* Pantheon, XX, 1962, pp.241-47.

Salmi, M., *Ercole de' Roberti,* Milan, 1960.

ROMANO, Gian Cristoforo (c. 1465-1512)

As sculptor, medalist and architect, Romano was active in Certosa di Pavia, Mantua, Urbino and Naples. He was a Roman pupil of Andrea Bregno. When Romano moved to Northern Italy, Roman classicism entered with him into the Franco-Flemish dominated north. He invented the aedicular-type of tomb in Pavia.

1490/1	Bust of Isabella d'Este, Louvre, Paris.
1498	Bust of Isabella d'Este, Mantua.
1498	Bust of F. Gonzaga, Mantua.
1493-97	Collaborated on the tomb of Galeazzo Visconti, Certosa di Pavia.

Selected Bibliography

Giordemi, P., *Stuoii sulla scultura Romano del Rinascimento; Gian Cristoforo Romano a Roma,* L'Arte, X, 1907, pp.197-208.

Panofsky, E., *Tomb Sculpture,* London, 1964.

Pope-Hennessy, *Italian Renaissance Sculpture,* London, 1958.

ROSELLI, Cosimo (1439-1507)

A Florentine painter, Roselli was a pupil of Benozzo Gozzoli and Neri di Bicci. Despite his rather dull technique, he managed a very prosperous workshop. He was the master of Piero di Cosimo and Fra Bartolommeo. In his style, he combined the best of the Florentine traditions.

1476 Frescoes in the Annunnciata, Florence.

1482-83 *Last Supper* fresco, Sistine Chapel, Vatican.

1486 *Procession of the Miraculous Chalice,* Florence.

Selected Bibliography

Steinmann, E., *Die Sixtinische Kapelle,* I-II, Munich, 1901-05.

Vasari, G., *The Lives of the Painters, Sculptors, Architects,* v. II, N.Y., 1950, p.54.

ROSSELLINO, Antonio (1427-1479)

Antonio was a Florentine sculptor and the youngest of five Rossellino brothers. Although he follows Donatello's pattern in his tomb architectural sculptures, they exhibit a strong concentration of graceful line and delicacy. On bust portraits, he demonstrated a physical vigor and expressiveness.

1449 Carved the capitals for S. Lorenzo, Florence (with brother Tommaso).

1452 Worked on the Buggiano pulpit in S. Maria Novella, Florence.

1456	Bust of Giovanni Chellini, Victoria and Albert Museum, London.
1458	Tomb of Neri Capponi, S. Spirito, Florence.
1458	Tomb of Beato Marcolino, Forli (with Bernardo and Giovanni Rosellino).
c.1460	Or later; *S. Sebastian* altar, Collegiata, Empoli.
1461	Monument of Cardinal of Portugal, S. Miniato al Monte, Florence.
1464	Monument of Filippo Lazzari, Cathedral of Pistoia (commissioned from Bernardo Rossellino, 1462).
1468	Bust of Matteo Palmieri, Bargello, Florence.
1470-75	*Altar of the Nativity,* Church of S. Anna dei Lombardy, Naples.
1471	Worked on the Baptistery of Florence.
1472-3	Worked on the Matteo Civitali's Monument of Piero da Noceto, Cathedral of Lucca.
1473	Three reliefs for the internal pulpit of the Cathedral of Prato.
1476	Tomb of Lorenzo Roverella, S. Giorgio, Ferrara (designed and partly executed by Ambrogida Milano).
c.1477	*S. John the Baptist,* Bargello, Florence.
c.1478	*Madonna and Child,* on the Nori grave, S. Croce, Florence.
c.1479	Tomb of Mary of Aragon, Piccolomimi Chapel, S. Anna dei Lombardy, Naples (completed by B. da Maiano).

Selected Bibliography

Planiscig, L., *Bernardo und Antonio Rossellino,* Vienna, 1942.

Pope-Hennessy, J., *Italian Renaissance Sculpture,* London, 1958.

ROSSELLINO, Bernardo (1409-1464)

He was a Florentine sculptor and architect. His architectural work strongly reflects the tradition of Alberti and Brunelleschi. As a sculptor, he followed the Donatello style, especially on his tomb sculptures.

1433-36	*Madonna of Mercy with SS. Lorentino and Pergantino,* facade of the Misericordia, Arezzo.
1434	*SS. Donetus and Gregory* for the facade of the Misericordia, Arezzo.
1435	Tabernacles for the Badia di SS. Fiora e Lucilla, Arezzo and for the Badia in Florence.
1441-44	Worked on the Duomo in Florence.
1443	Served on the commission for the stained glass windows of the cupola of the Cathedral of Florence.
1444	Monument of Leonardo Bruni, S. Croce, Florence.
1446-51	Supervised the building of the Palazzo Rucellai, Florence.
1446	Carved a doorway for the Palazzo Publica, Siena.
1447	*Annunciation,* S. Agostino dei Scolopi, Empoli.
1449-50	Tabernacle for the Church of S. Egidio.
1451	Tomb of Beata Villana, S. Maria Novella, Florence.
1451-53	Ingegniere di Palazzo of Pope Nicolas V, designed the apse of S. Peter's and restored the church of S. Stefano Rotondo, all in Rome.
1455	Palazzo Venezia, Rome.
1456	Tomb of Orlando de' Medici, SS. Annunziata, Florence.
1458	Tomb of Neri Capponi (with Antonio and Giovanni Rossellino).
1460	Interior of the Palace Rucellai, Florence.

1460-63 Employed by Pope Pius II at Pienza in connection with the Cathedral and Palazzo Piccolomini.

1461-64 Capomaestro of the Cathedral of Florence.

1462 Tomb of Beato Marcolino da Forli.

1462 Tomb of Filippo Lazzari, Cathedral of Pistoia (Antonio and assistants worked with him).

1462-64 Tomb of Giovanni Chellini, S. Domenico at S. Miniato al Tedesco (with Antonio and Giovanni Rossellino).

Selected Bibliography

Fleming, J., Honour, H. and Pevsner, N., *The Penguin Dictionary of Architecture,* Middlesex, 1967.

Planiscig, L., *Bernardo and Antonio Rossellino,* Vienna, 1942.

Pope-Hennessy, J., *Italian Renaissance Sculpture,* London, 1958.

SANGALLO, Giuliano da (giuliano Giamberti) (1445-1516)

He was a Florentine sculptor, architect and military engineer. A follower of Brunellischi, he created the first central-type church on the Greek-cross plan—S. Maria dell Carceri, Prato. This church's decoration was based on Brunelleschi's Pazzi Chapel. Sangallo's Palazzo Gondi also follows Brunelleschi's rusticated facades.

1480-85 Villa del Poggio a Caiano.

1485 S. Maria della Carceri, Prato.

1490-94 Palazzo Gondi, Florence.

1514 S. Maria dell' Anima, Rome.

c.1514 Project for S. Peter's, Rome.

1515-16 Facade projects for S. Lorenzo, Florence.

Selected Bibliography

Clausse, G., *Les San Gallo,* Paris, 1900-02.

Fleming, J., Honour, H. and Pevsner, N., *The Penguin Dictionary of Architecture,* Middlesex, 1967.

Murray, P., *The Architecture of the Italian Renaissance,* N.Y., 1970.

SANTI, Giovanni (c. 1430/40-1494)

A mediocre painter, Santi was born in Colbordolo near Urbino and died in Urbino on August 1, 1494. He worked for the courts of Urbino and Mantova. He wrote *Cronaca Rimata* in which he mentioned some Quattrocento artists. His signed works include (dates unknown): *Madonna* of the Pinacotea of Fano; *Visitation* in S. Maria of Fano; and *S. Girolamo* in the Pinacotea Vaticana. We have information only about the last part of his life.

1484	*Pala,* now in the City Hall of Gradara.
1489	*Pala of Montefierentino* and *Madonna,* Urbino Gallery.
1490	*Annunciation,* Brera Gallery, Milan.
1491	*Ecce Homo.*

Selected Bibliography

Berenson, B., *Italian Pictures of the Renaissance,* 1932.

Campori, G., *Notizie e documenti per la vita di G. Santi e di Raffaello,* 1870.

Passavant, J.D., *Raffaello d'Urbino,* 1887.

Pungileoni, L., *Elogio storico di G. Santi,* 1822.

Schmarsow, A., G. *Santi der Vater Raphaels,* 1887.

SASETTA (Stefano di Giovanni) (c. 1400 or earlier -1450)

He was a Sienese painter and a follower of Paolo di Giovanni Fei's International style. His paintings retained a kind of naive mysticism and never developed to the level of realism and naturalism of his contemporaries.

1423-26	Altarpiece (dismembered and dispersed in various museums).
1430-32	*Madonna of the Snow,* Private Collection, Florence.
1430-32	*Journey of the Magi,* Metropolitan Museum, N.Y.
1436	Altarpiece, Chiesa dell' Oservanza, Siena.
1437-44	Altarpiece, S. Francesco, S. Sepolcro (dismembered and in Berenson Coll., Florence, Louvre, and National Gallery, London).
c.1440	*Life of S. Anthony Altarpiece* (dismembered and in Kress Coll. Wash., D.C., Yale University Gallery, Robert Lehman Coll., N.Y., and Berlin).

Selected Bibliography

Berenson, B., *Sassetta,* Florence, 1947.

Brandi, C., *Quattrocentisti sensi,* Milan, 1949.

Carli, E., *Sassetta e il Maestro dell'Osservanza,* Milan, 1957.

Pope-Hennessy, J., *Sassetta,* London, 1939.

SETTIGNANO, Desiderio da (c. 1430-1464)

He was a Florentine sculptor greatly influenced by Donatello's "rilievo schiacciato" (very low reliefs) but without adopting the Donatello heroic style. Most of his works are an overdose of softness and sentimentality fused with a luminous effect. However, with his refined and gracious elegance, he became popular with the new aristocracy of Florence.

1450-55	*S. Jerome before the Crucifix,* Wash., D.C.
1450-53	*Turin Madonna.*
1450-60	*The Young Christ with S. John the Baptist,* National Gallery, Wash., D.C.
1453	Matriculated in Paestri di Pietra e Legname.
1453	Assessor on the Buggiano pulpit, S. Maria Novella, Florence (with A. Rossellino).
1453-55	Marsuppini Monument, S. Croce, Florence.
1455-60	*Madonna and Child* relief for the Hospital of S. Maria Nuova, Florence (now in the Philadelphia Museum Collection).
1455-60	Bust of a Boy, National Gallery, Wash., D.C.
1458-61	*Altar of the Sacrament,* S. Lorenzo, Florence.
c.1460	Bust of a Lady, National Gallery, Wash., D.C.
c.1460-61	*S. Jerome before the Crucifix,* relief, National Gallery, Wash., D.C.
c.1460	Several portraits.
c.1461-64	*Panciatichi Madonna.*
c.1464	*Magdalen,* wood, S. Trinita, Florence (unfinished).

Selected Bibliography

Planiscig, L., *Desiderio da Settignano,* 1942.

Pope-Hennessy, J., *Italian Renaissance Sculpture,* London, 1958.

SIGNORELLI, Luca (Luca da Cortona, or Luca D'Egidio di Ventura de'Seignorelli) (c. 1441/50-1523)

Luca Signorelli was born in the Florentine subject town of Cortona. In Florence, he was influenced by the Pollaiuolo brothers and Botticelli's style. Considered a master of the nude, he reached a crescendo with his nudes in the frescoes he painted for the Cathedral of Orvieto.

c.1475 *Scourging of Christ,* Brera Gallery, Milan.

1479 Frescoes for the cloister of the Monastery of Monte Olivetto, Siena.

1480 Frescoes in the Casa Santa, Loreto.

1484 *Madonna and Saints,* Cathedral of Perugia.

1490 *Madonna and Child,* Uffizi, Florence.

1490 *School of Pan* (destroyed in 1945).

c.1495 *Holy Family,* tondo, Uffizi, Florence.

1499-1502 Frescoes in the Chapel of S. Brizio, Cathedral of Orvieto.

1515 Altarpiece, National Gallery, London.

1515-16 *Deposition,* S. Croce, Florence.

1519 *Assumption,* Museo Diocesano, Certona.

1521 *Immaculate Conception,* Museo Diocesano, Cortona.

Selected Bibliography

Carli, E., *Luca Signorelli: Gli affreschi nel Duomo di Orvieto,* Bergamo, 1946.

Crispatti, C., *Perugia augusta,* Perugia, 1648.

Cruttwell, M., *Luca Signorelli,* London, 1899, 3rd ed. 1907.

Dussler, L., *Signorelli: Des Meisters Gemalde,* Stuttgart, 1927.

Manni, D.M., *Vita di Luca Signorelli, in Raccolta milanese,* 1756.

Pungileoni, L., *Elogio storico di Giovanni Santi,* Urbino, 1822.

Ricci, A., *Memoria storiche delle arti e degli artisti della Marca di Ancona,* Macerata, 1834.

Salmi, M., *Luca Signorelli,* Novara, 1953.

Serra, L., *Il Palazzo Ducale ela Galleria Nazionale di Urbino,* Rome, 1930.

Sterling and Francine Clark Art Institute, *Luca Signorelli: the Martyrdom of S. Catherine and the Biehi Altar,* Williamstown, Mass., 1961.

Venturi, A., *Luca Signorelli,* Florence, 1929.

Vischer, P., *Luca Signorelli und die italienische Renaissance,* Leipzig, 1879.

SQUARCIONE, Francesco (1397-1468)

Squarcione was a Paduan painter. His most famous pupil, Mantegna, left him after a violent quarrel. A great admirer of the Greek and Roman statues, his dry composition and executions reflect his love for antiquities and a certain Donatello-like sensitivity.

1429 First recorded as a painter in Padua.

1449-52 Polyptych in the Museum of Padua.

1449-52 *Madonna,* Berlin.

c.1452-66 *Life of S. Francis* fresco cycle, exterior of S. Francesco, Padua.

Selected Bibliography

De Wald, E., *Italian Painting, 1200-1600,* N.J., 1961.

Hartt, F., *History of Italian Renaissance Art,* N.Y., 1970.

Muraro, M., "A Cycle of Frescoes by Squarcione in Padua," *Burlington Magazine,* 1959, pp.89-96.

TORRIGIANO, Pietro (1472-1528)

He was a Florentine sculptor who specialized in tomb sculptures. He studied with Michelangelo in the sculpture garden of the Medici. Later he worked in England, Netherlands and Italy. Torrigiano died in Spain after being imprisoned for heresy by the Inquisition.

c.1472 He broke the nose of Michelangelo.

1492 Worked in Rome. Stucco decoration of the Apartment of Borgia, Vatican.

1494 Bust of Stefano della Torre, terracotta, lost.

1494	Bust of Pope Alexander VI, terracotta, Vatican.
c.1495	Probably made the marble busts of Christ and S. Fina and a terracotta bust of S. Gregory for the Ospedale di S. Fina at S. Gimignano.
After 1498	Served in the army of Cesare Borgia.
1500	Altarpiece, SS. Annunziata dei Zoccolanti, Fossombrone.
1509-10	Visited the Netherlands and England where he sculpted the busts of Henry II, Henry VIII, and the Bishop of Rochester.
1511	Contracted for the tomb of Lady Margaret Beaufort in Westminster Abbey, England.
1512	Tomb of Henry VII and Elizabeth of York, Westminster Abbey.
c.1512	Altar, Henry VII Chapel, Westminster Abbey, London.
1516	Tomb of Dr. John Young, Rolls Chapel, London.
1518	*Portrait of Sir Thomas Lovell*, bronze relief.
1519	Project for the Monument of Henry VIII and Catherine of Aragon (abandoned).
1522	Moved to Spain. *S. Jerome*, terracotta statue for the Convent of Buena Vista, Seville.
1528	Died in the hands of the Inquisition.

Selected Bibliography

Bloomfield, R., *History of Renaissance Architecture in England,* 1897.

Pope-Hennessy, J., *Italian Renaissance Sculpture,* London, 1958.

TURA, Cosimo (1430-1495)

A Ferrarese painter, he had a strong Mantegna-like character, especially in the handling of drapery, landscape, and certain facial expressions. He inherited this approach from his master Galasso.

1451	Worked for the Court of Este.
c.1460-63	*Primavera*, National Gallery, London.
1468	Decoration of the organ, Cathedral of Ferrara.
1469	Frescoes for Palazzo Shifanoia, Ferrara (with others).
c.1473-74	*Pieta* from the Roverella Altarpiece, Louvre, Paris (other parts in Casa Colonna, Rome; Fogg Museum, Cambridge, Mass.; Gardner Museum, Boston; and Metropolitan Museum, N.Y.).
1475	Or earlier; *Pieta*, S. Giorgio, Ferrara (now dispersed).
1495	Died in Ferrara.

Selected Bibliography

Bianconi, P., *Cosme Tura,* Milan, 1963.

Campori, G., *I Pittori degli Estensi,* Modena, 1886.

Campori, G., *L'arazzeria Estense,* Modena, 1876.

Cittadella, L.N., *Ricordi e documenti intorne alla vita di Cosimo Tura,* Ferrara, 1866.

Neppi, A., *Cosme Tura,* Milan, 1952.

Ruhmer, E., *Cosmino Tura: Paintings and Drawings,* London, 1958; includes a full bibliography.

Salmi, M., *Cosme Tura,* Milan, 1957.

UCCELLO, Paolo (Paolo di Dono) (1396/7-1475)

A Florentine painter, he was considered the master of foreshortening. His work often shows very sculptural qualities. In Florence, Uccello worked with the sculptor Ghiberti and in Venice he worked

on mosaics. His style was quite diversified. On the frescoes of the Green Cloister of the S. Maria Novella, Ghiberti's presentation is echoed. On the *Battle of S. Romano,* a simplification of the forms is evident which is similarly found in the *Miracle of the Host,* Palazzo Ducale, Urbino. Uccello demonstrates some resemblance to the images of the International style. In his equestrian fresco of Giovanni Acuto (Sir John Hawkwood), he used as a model the Hellenistic horses on the summit of S. Marco in Venice which reveals his extreme sculptural quality as contrasted to other works.

1415	Entered the painters' guild in Florence.
1425	Departed for Venice.
1425-31	Mosaic of S. Mark.
1431	Returned to Florence.
c.1431-35	*Creation Scenes,* Green Cloister of S. Maria Novella, Florence.
1435-44	*Birth of the Virgin,* Prato Cathedral (attributed to him or the Prato Master).
1436	*Equestrian Portrait of Giovanni Acuto (Sir John Hawkwood),* Cathedral of Florence.
c.1440	*S. George and the Dragon,* Musee Jacquemart, Paris.
c.1440	*S. George and the Dragon,* Lanckoromski Collection, Vienna.
1443	*Four Prophets,* around the clock of the Cathedral of Florence.
1443-45	Cartoons for the stained glass windows for the Cathedral of Florence.
1445	*The Giants,* Padua (lost).
c.1444-45	*The Deluge,* Green Cloister, S. Maria Novella, Florence.
c.1446	*The Nativity,* Church of S. Martino alle Scale, Florence.

1454-57	*Battle of S. Romano,* Uffizi, Florence, National Gallery, London and Louvre, Paris.
1465-69	Predella for altarpiece for the confraternity of the Holy Sacrament, Urbino.
1466-69	*Miracle of the Host,* Urbino.
1475	Died in Florence on December 10.

Selected Bibliography

Boeck, W., *Paolo Uccello,* Berlin, 1934.

Carli, E., *All the Paintings of Paolo Uccello,* N.Y., 1963.

De Witt, A., *La Pieta di Paolo Ucello,* Florence, 1886.

Micheletti, E., *Paolo Uccello,* Novara, 1950.

Moltesen, E., *Paolo Uccello,* Copenhagen, 1924.

Parronchi, A., *Le Fonti di Paolo Uccello,* Paragone VIII, 1957.

Pope-Hennessy, J., *The Complete Works of Paolo Uccello,* London, 1950.

VECCHIETTA (Lorenzo di Pietro) (1412-1480)

A Sienese sculptor, he was a pupil of Sasetta and the teacher of Matteo di Giovanni. He worked mostly in Siena but his style in sculpture shows strong Florentine influence, especially during the period when he shared a studio in Siena with the visiting Florentine sculptor Donatello. However, his frescoes still basically followed the Sienese linear and decorative style. As a sculptor, he was famous for his wooden statues and also achieved fame in marble. Bronze was his other favorite medium.

1412	Born in Castiglione d'Orcia.
1428	Entered the painters' guild in Siena.
c.1428	Active as a painter in the choir of the Collegiata at Castiglione d'Olona in Lombardy.
1436	Frescoes in the sacristy of the Hospital in Siena.

1439	Painted a wooden *Annunciation* on the high altar of the Cathedral of Siena (with Sano di Pietro).
1441	Fresco in the Pellegrinaio of the Spedale della Scala, Siena.
1442	*Risen Christ,* wood, altar of the Cathedral of Siena.
1446-49	Fresco cycle in the sacristy of S. Maria delia Scala, Siena.
1459-62	Frescoes in the Baptistery on Siena.
1460-62	*SS. Peter and Paul,* marble, Loggia di S. Paolo, Siena.
1461	Fresco of S. Catherine of Siena, Palazzo Publico, Siena.
1461-62	Triptych for the Cathedral of Piacenza.
1463	*Foscari Effigy,* S. Maria del Popolo, Rome.
1467	*Mariano Sozzini,* bronze, Bargello, Florence.
1467-72	Bronze high altar of S. Maria della Scala, Siena.
1472-73	*SS. Catherine of Siena and Bernardino,* silver, Cathedral of Siena (lost).
1475	*S. Anthony, the Abbot at Narm and S. Bernadino,* wood, Bargello, Florence.
1475	*S. Paul,* Cathedral of Siena (lost).
1476-77	*The Resurrected Christ* altarpiece for the high altar of S. Maria della Scala, Siena.
1478	*S. Sebastian,* Cathedral of Siena (lost).
1480	*Burial and Assumption of the Virgin,* Museum of Lucca (unfinished; completed by Nerroccio).

Selected Bibliography

Berenson, B., *Italian Painters of the Renaissance,* London, 1968.

Murray, P. and L., *A Dictionary of Art and Artists,* Middlesex, 1968.

VENEZIANO, Domenico (Domenico di Bartolomeo da Venezia) (c. 1400-1461)

Although a Florentine painter, he probably came from Venice. His first record in Florence dates from 1438 where his assistant was Piero della Francesca. He retained many tendencies from his former education in the International style. His draperies remind us of the draperies of Donatello. He experimented with light but it was Piero della Francesca who developed the feeling of natural light and the use of color-intensity changes for the sensation of depth. Veneziano introduced the use of bird's-eye views for achieving depth in landscapes with their curving rivers. This became very fashionable in Florence.

c.1430-35 *Adoration of the Magi,* Berlin.

1439-45 Frescoes in S. Egidio, S. Maria Novella, Florence (lost).

c.1445-48 *S. Luci* altarpiece for the Church of S. Lucia de' Magnoli, Florence (dispersed: center section, Uffizi, Florence; *Martyrdom of S. Luci,* K.F. Museum, Berlin; *Miracle of S. Zenobius* and *Annunciation,* Cambridge, England; and *S. John in the Desert,* National Gallery, Wash., D.C.

1450 or 60 *Portrait of a Young Girl,* Berlin.

1454 Frescoes in Plazzo dei Priori, Perugia (with Fra Angelico and Fra Filippo Lippi).

1460 Frescoes in the S. Croce, Florence.

Selected Bibliography

Berenson, B., *Italian Painters of the Renaissance,* II, London, 1868.

Salmi, M., *Paolo Uccello, Andrea del Castagno e Domenico Veneziano,* 1937.

VERROCCHIO, Andrea del (c. 1435-1488)

Pomponius Guaricus considered him as a rival of Donatello although he was a Florentine painter and goldsmith. After the death of Donatello, he became the principle sculptor of Florence. His highly finished surfaces and grace of line were in direct contrast to the dramatic power of Donatello's style. As a painter, he employed Lorenzo di Credi as his principle assistant, who not only worked as a painter but as a sculptor as well. Verrocchio's fame attracted foreign Renaissance rulers also. Matthias Corvinus, King of Hungary (Matyas Kira'ly az igazsagos) commissioned a fountain from him. A reclining marble putto in the De Young Museum, San Francisco, California, is attributed to Verrocchio and it is suggested that this is one of the marble putti which were made for the fountain of Matthias Corvinus. The putto is very similar to the child on the lap of the Virgin in the painting of Durer (Kunsthistorisches Museum, Vienna). Several scholars seriously doubted that Verrocchio made this small marble statue. Verrocchio was also the teacher of the young Leonardo who is supposed to have painted the angel on the left of Verrocchio's *Baptism of Christ.*

1435	Born in Florence.
1452	Acquitted from a charge of manslaughter.
1465-66	Lavabo for the old sacristy of S. Lorenzo, Florence (some critics only attribute it to him).
1465	Model for the Chapel of the Madonna della Tavola, Cathedral of Orvieto, in competition with Desiderio da Settignano and Giuliano da Majano (not executed).
c.1465-67	Design for the tomb of Cosimo de'Medici, Crypt of S. Lorenzo, Florence.
c.1465-67	*Christ and S. Thomas,* Or San Michele, Florence.
1467	Bronze candlestick, Sala dell'Udienza, Palazzo della Signoria, Florence.
1467-71	A copper ball for the top of the lantern of the Cathedral of Florence.

After 1470 *Baptism of Christ,* S. Salvi, Florence.

c.1470 Putto with a Fish, Palazzo della Signoria, Florence.

c.1470-80 *Virgin and Child,* Bargello, Florence.

Before 1476 *David,* bronze, Bargello, Florence.

1472 Tomb of Piero and Giovanni de'Medici, S. Lorenzo, Florence.

1473 Assessor for the Prato pulpit of Antonio Rossellino.

1473 Forteguerri Monument, Cathedral of Pistoia (unfinished).

1477-80 *Decapitation of the Baptist* relief for the silver altar, Baptistery of Florence.

1479-88 Colleoni Monument, Campo SS. Giovanni e Paolo, Venice (unfinished; completed by Lorenzo di Credi and Alessandro Leopardi).

1478-85 *Madonna di Piazza,* Cathedral of Pistoia.

c.1480 *Alexander the Great and Darius* reliefs for the King of Hungary, Matthias Corvinus.

1488 Fountain ordered by Matthias Corvinus.

Selected Bibliography

Balogh, J., "Un capolavoro sconosciuto de Verrocchio," *Acta Historiae Artium Academiae Scientiarum Hungaricae,* VIII, 1962.

Busignani, A., *Verrocchio,* Florence, 1966.

Cruttwell, M., *Verrocchio,* London, 1904.

Passavant, G., *A. del Verrocchio als Maler,* Dusseldorf, 1959.

Planiscig, *Andrea del Verrocchio,* Vienna, 1941.

Reymond, M., *Verrocchio,* Paris, 1906.

VIVARINI, Alvise (1457-1503/5)
VIVARINI, Antonio (c. 1415-1476/84)
VIVARINI, Bartolommeo (active 1450-1499)

The Vivarini family was one of the famous dynasties of Venetian painters. They began with experimentation in the International style. Antonio was assisted by his brother-in-law, Giovanni d'Alemagna. His style changed under the direct contact of Donatello and his compositions adopted a slightly sculptural quality. Bartolommeo shows, in addition to the International style, influences from Giovanni Bellini. Alvise, the son of Antonio, finally developed the family style into the minutely-detailed image of the Flemish as a result of direct contact with Antonello da Messina.

1443-44 Altarpiece for the church of S. Tarasio in S. Zaccaria, Venice (Antonio in collaboration with Giovanni d'Alemagna).

1447-50 *Coronation of the Virgin,* S. Panteleone, Venice (Antonio with Giovanni d'Alemagna).

1459 Altarpiece, Louvre, Paris (Bartolommeo).

1464 Altarpiece, Vatican (Antonio).

1488 Alvise became court painter in Venice.

Selected Bibliography

Berenson, B., *Italian Pictures of the Renaissance: Venetian School,* 2 volumes, N.Y., 1957.

Marle, R. van, *The Development of the Italian School of Painting,* I-XIX, The Hague, 1923-1938.

Appendix

LIST OF POPES AFTER THE GREAT SCHISM (1378-1417)

1417-1431	Martin V (Oddone Colonna)
1431-1447	Eugenius IV (Gabriele Condulmaro)
1447-1455	Nicholas V (Thommaso Parentucelli)
1455-1458	Calixtus III (Alfonso de Borgia)
1458-1464	Pius II (Aenea Silvio Piccolomini)
1464-1471	Paul II (Pietro Barbo)
1471-1484	Sixtus IV (Francesco della Rovere)
1484-1492	Innocent VIII (Giovanni Battista Cibo)
1492-1503	Alexander VI (Rodrigo Borghia)

LIST OF THE RULING FAMILIES IN ITALY IN THE QUATTROCENTO

The Doges at Venice

1400-1413	Michele Steno
1414-1423	Tommaso Mocenigo
1423-1457	Francesco Foscari
1457-1462	Pasquale Malipiero
1462-1471	Cristoforo Moro
1471-1473	Niccolo Tron
1473-1474	Niccolo Marcello
1474-1476	Pietro Mocenigo
1476-1478	Andrea Vendramin
1478-1485	Giovanni Mocenigo
1485-1486	Mario Barbarigo
1486-1501	Agostino Barbarigo

The Medici of Florence

1429-1464	Cosimo (Pater Patriae) de' Medici
1464-1469	Piero (The Gouty) de' Medici
1469-1492	Lorenzo (The Magnificent) de' Medici
1492-1494	Piero (The Unfortunate) de' Medici

The Montefeltre of Urbino

1444-1482	Federigo I Montefeltre
1482-1508	Giudobaldo Montefeltre

The Visconti of Milan

1402-1412	Giovanni Maria Visconti
1412-1447	Filippo Maria Visconti

The Sforza of Milan

1450-1466	Francesco Sforza
1466-1476	Galeazzo Maria Sforza
1476-1480	Gian Galeazzo Maria Sforza
1480-1500	Ludovico Il Moro Sforza

The Este of Ferrara

1384-1441	Niccolo III d'Este
1441-1450	Lionello d'Este
1450-1471	Borso d'Este
1471-1505	Ercole I d'Este

Gonzaga of Mantua

1407-1444	Gian Francesco I Gonzaga
1444-1478	Ludovico Gonzaga
1478-1484	Federigo Gonzaga
1484-1519	Gian Francesco II Gonzaga

The Malatesta of Rimini

1385-1429	Carlo Malatesta
1429-1432	Galeatto Malatesta
1432-1468	Sigismondo Pandolfo Malatesta
1468-1469	Sallustio Malatesta
1469-1482	Roberto Malatesta
1482-1500	Pandolfo (Pandolfacio) Malatesta

House of Anjou of Naples

1386-1414	Ladislaus
1414-1435	Joanna II

House of Aragon of Naples

1435-1458	Alfonso I
1458-1494	Ferdinand I (Ferrante)
1494-1495	Alfonso II
1495-1496	Ferdinand II (Ferrandino)
1496-1501	Frederick

TREATISES AND LITERARY WORKS DURING THE QUATTROCENTO

Acciaivoli, Donato

> Translated and commented on:
>
> Aristotle, *Ethics, Politics, Physics*
>
> Plutarch, *Life of Alcibiades, Demetrius, Annibales,* 1467; *Life of Scipio,* 1478
>
> Translated:
>
> Leonardo Bruni, *Storia Fiorentina*

Accolti, Benedetto (Benedetto d'Arezzo)

> *De Bello a Christianis Contra Barbaros,* 1458
>
> *Dialogus de Praestantia Virorum sui Aevi,* 1459-1464

Alberti, Leon Battista

> (see Artists' Biographies)

Biondo, Flavio (Biondo da Forli)

> *De Verbis Romanae Locutionis,* 1435
>
> *Historiarum ab Inclinatione Romanorum,* I-X, 1435
>
> *Romae Instauratae,* I-III, 1444-1446
>
> *Historiae,* 1453
>
> *Italia Illustrata,* 1453

De Militia et Iurisprudentia, 1460

Roma Triumphalis, I-X, 1455-1463

Bisticci, Vespasiano

Le Vite. . . , 1482

Bruni, Leonardo

Historiarum Florentini Populi Libri, 1404

Colonna, Fra Francesco

Hypnerotomachia Doliphili, 1499

Dati, Leonardo

Trophaeum Anglarium

Facio, Bartolommeo

De Differentiis Verborum, 1444

De Rebus Gestis ab Alphonso Primo Neapolitanorum Rege, 1450

De Viris Illustribus, 1455

Filarete (Antonio Averlino)

Trattato dell' Architettura, c. 1451-1464

Filelfo, Francesco

Commentationes Florentinae de Exilio, 1440

Convivia Mediolanensia, 1443

Vita del Sanctissino I Baptista, I-V, 1448

De Iocis ac Seriis, I-X, 1458-1465

Francesca, Piero della

De Prospectiva Pingendi; Libellu- de V. Corporibus Regularibus

Francesco di Giorgio (Martini)

Trattato d'Architettura Civile e Militare, 1482

Ghiberti, Lorenzo

 I Commentarii, 1447-1455

Guardati, Tommaso

 Novellino, 1475

Guarino, Veronese

 Regulae, 1452

 Chrysolorina, 1452

 Commentariolo, 1452

Landino, Christoforo

 De Vera Nobilitate de Nobilitate Animae, 1472.

 Disputationes Camaldulenses, 1475

 Apologie, 1481

 Commentation on *Aeneide* and *Divina Comedia,* 1478

Lapacino, Francesco di

 Transcript in Latin of Ptolemy, *Cosmagraphia,* 1462

Lapo da Castiglianchio (The Elder)

 Allegationes of Jurisprudence, c.1380

 De Hospitalitate, c. 1380

 De Canonica Portione et de Quarta, c. 1380

Manetti, Antonio

 Vita di Filippo di Ser Brunellesco, 1462

 Novella del Grasso Legnaiuolo, 1465

Manetti, Giannozzo

 Historia Pistoriensium

 Vita Nicolai V

 De Dignitate et Excellentia Hominis

Manuzio, Aldo

> In his Aldina Press he printed the following:
>
> *Museo,* 1494; Nine comedies of Aristophanes; *Galeomyomacchia,* 1494; Works of Sophocles, 1495; *Greek Grammar; The Idilli; De Aetna; Diaria de Bello Carolino; Opere di Angelo Poliziano;* and five volumes of Aristotle (1495-1498).
>
> *Scrittori Astronomici et Dioscoride*
>
> Colonna's *Hypneromacchia Poliphili*

Marsuppini, Carlo

> Translated into Italian:
>
> *Batracomio Machia,* 1429

Niccolo da Cosa

> *De Concordantia Catholica,* 1433
>
> *De Docta Ignoranti,* 1440
>
> *De Coniecturis,* 1440
>
> *De Pace Fidei,* 1453
>
> *De Beryllo,* 1458
>
> *De Possest,* 1460
>
> *De Nonaliud,* 1462
>
> *De Ludo Globi,* 1462

Pacioli, Luca

> *Summa de Arithmetica et Geometria,* 1494
>
> *De Divina Proportione,* 1496
>
> *De Ludis,* 1497
>
> *De Viribus Quantitatis,* 1498

Palmieri, Matteo

> *De Temporibus,* 1449

Historia Florentina

Della Vita Civile, I-IV

La Citta di Vita, 1451-1465

Piccolomini, Aenea Silvius (Pope Pius II)

De Duobus Amantibus Eurialo et Lucresia, 1443

Chrysis, 1443

Execrabilis et in Pristinis Temporibus Inauditus (papal bull)

Pico della Mirandola

Heptaplus, 1489

De Ente et Uno, 1489

Disputationes Adversus Astrologiam Divinatricem, 1489

Poggio, Fiorentino

In Auaritiam Liber Unus Historia Populi Florentini de Miseria Conditione Humanae

De Varietate Fortunae

Translated:

Xenophon, *Cryopoedea*

Lucianus, *Asinus*

Poliziano, Agnolo Ambrogini

Detti Piaceuoli, 1473

Stanze per Giuliano de' Medici, 1475

Raccolta Aragonese, 1476

Favola D'Orfeo, 1480

Odae, 1480

Sylvai, 1480

Miscallaneorum Centuria Prima, 1489

Epistolae, 1494

Pontano, Giovanni

De Laudibus Divinis, 1458 (Essay)

Charon, Antonius, Asinus, Actius, Aegidus, 1467-1501 (essays dealing with religion, philosophy and literature)

Pulci, Luigi

Morgante, 1460-1483

Sannazzaro (Sannazaro), Jacopo

Rime; Arcadia, 1481-1486

Santi, Giovanni

Cronica Rimata, 1482-1494

Sanudo, Marino

Vite dei Dogi, 1490

La Spedizione di Carlo VIII, 1495

I Diarii, begun 1496

Savonarola, Girolamo

Triumphus Crocis, 1495

Compendium Reuelationum

Savonarola, Michele

Opus Medicinae seu Practica de Aegritudinibus de Capite uszue ad Pedes, 1479

Udibus Patavii, c. 1440

De Balneis et Thermis, 1450

Libellus de Magnificis Ornamentis Regie Civitatis Paduae, 1450

Spagnoli, Giovan Battista

 Alphonsus, 1465

 Parthenicae, 1478

Tortelli, Giovanni

 Orthographia, 1449

Toscanelli, Paolo dal Pozzo

 Immensi Labores et Graves Pauli de Puteo Toscanello Super Mensera Comete, 1472

Valla, Lorenzo

 De Voluptate, 1431

 Translated Homer's *Iliad,* 1431

Vergilio, Polidoro

 Liber Proverbiorum, 1498

 De Rerum Inventoribus, 1499

Vegio, Maffeo

 Astyanax, 1430

 Velleris Aurei Libry IV, 1430

 Regisol, 1430

 Convivium Deorum, 1430

 Carmen Heroicum, 1430

 Pompeiana, 1431

 Rusticalia, 1431

 Epigrammata, 1431

 De Verborum Significatione, 1455

 De Educatione Liberorum, 1455

Villani, Filippo

> *De Origine Civitatis Fiorentiae et Eiusdem Famosis Civibus*

Zembino of Pistoia

> *Chronicle*
>
> *History of the Assyrians*
>
> *History of the Medes*
>
> *History of the Romans*

Bibliographies

GENERAL BIBLIOGRAPHY

Antal, F., *Florentine Painting and its Social Background*, London, 1948.

Armstrong, E., *Italian Studies*, N.Y., 1934.

Barfucci, E., *Lorenzo de' Medici e la Societa artistica del suo Tempo*, Florence, 1964.

Barnes, M.F., *Renaissance Vistas*, Payson, 1930.

Baron, H., *Crisis of the Early Italian Renaissance*, Princeton Univ. Press, 1955.

Bayley, H., *A New Light on the Renaissance Displayed on Contemporary Emblems*, N.Y., 1967.

Berenson, B., *Aesthetics and History in the Visual Arts*, Pantheon, 1948.

Bistici, V. da, *Renaissance Princes, Popes and Prelates*, N.Y., 1963.

Blunt, A. (Sir), *Artistic Theory of Italy*, Oxford, 1940.

Bode, W. von, *Die Kunst der Frührenaissance in Italien*, Berlin, 1926.

Bolgar, R.R., *The Classical Heritage and its Beneficiaries: From the Carolingian to the End of the Renaissance*, N.Y., 1964.

Borsook, E., *The Mural Painters of Tuscany*, London, 1960.

Burckhardt, J., *The Civilization of the Renaissance*, London, 1950.

Burckhardt, J., *Der Cicerone*, 1855.

Burke, P., *The Renaissance*, London, 1964.

Carli, E., *Rinascimento Fiorentino*, Novara, 1963.

Carter, C.H., *From the Renaissance to the Counter-Reformation*, N.Y., 1965.

Cassierer, E., *The Individual and the Cosmos in Renaissance Philosophy*, N.Y., 1963.

Chastel, A., *The Flowering of the Italian Renaissance*, Jonathon Grinnin, 1966.

Chastel, A., "Fin du Moyen Age et Renaissance," *R. des Arts*, I, Dec., 1951, pp.251-256.

Chastel, A., *Italian Art*, N.Y., 1963.

Chastel, A., *Italie, 1460-1500*, Paris, 1965.

Chastel, A. and Klein, R., *The Age of Humanism in Europe, 1480-1530*, N.Y., 1963.

Checksfield, M.M., *Portraits of Renaissance Life and Thought*, N.Y., 1965.

Clements, R.J., "Michelangelo on Effort and Rapidity in Art," *Warburg and Courthauld Inst. J.*, XVII, July 1955, pp.301-10.

Cooper, M., *The Invention of Leonardo da Vinci*, N.Y., 1965.

Cosenza, M.E., *Biographical and Bibliographical Dictionary of the Italian Humanists and of the World Classical Scholarship, Italy, 1300-1800*, Boston, 1963.

Cox, T., *Renaissance in Europe, 1400-1600*, Methuen, 1933.

De Roover, A.A., *The Rise and Decline of the Medici Bank, 1397-1494*, Cambridge, 1963.

Eglinski, E., *The Art of the Italian Renaissance*, W.C. Brown, 1968.

Elton, G.R., *Renaissance and Reformation, 1300-1648*, N.Y., 1963.

Ergang, R., *The Renaissance*, N.J., 1967.

Ettlinger, L.D., "From Allegory to Diagram of the Renaissance Mind: A Study on the Significance of the Allegorical Tableau," *Burlington Magazine*, C, October 1958, p.264.

Fallico, A.B. and Shapiro, H., *Philosophy of the Renaissance*, Modern Library, 1967.

Fanning, R. and Myron, R., *Italian Renaissance*, London, 1965.

Faure, E., "Art Renaissance," *Histore de l'Arte*, Paris, 1965.

Faure, E., *Italian Renaissance*, Musson, 1930.

Faye, C.V. and Bond, W.H., *Supplement to the Census of Medieval and Renaissance Manuscripts in the United States and Canada*, N.Y., 1962.

Ferguson, W., *Europa in Transition*, 1300-1520, Boston, 1963.

Ferguson, W. et al., *The Renaissance: Six Essays*, N.Y., 1963.

Freud, S., *Leonardo da Vinci and a Memory of his Childhood*, N.Y., 1964.

Gebelin, F., *Tresors de la Renaissance,* Paris, 1947.

Geck, F.J., *Bibliographies of Italian Early, High and Late Renaissance,* Boulder, 1932-34.

Gilmore, M., *Humanist and Jurists: Six Studies in the Renaissance,* Cambridge, Mass., 1963.

Gilmore, M., *The World of Humanism, 1453-1517,* N.Y., 1963.

Godfrey, F.M., "Apotheosis of Childhood in the Renaissance," *Connoisseur,* January 1952, pp.152-159.

Gombrich, E.H., "Renaissance and the Golden Age," *Warburg and Courthauld Inst. J.,* XXIV, July 1962, pp.306-309.

Gombrich, E.H., "Renaissance Artistic Theory and the Development of Landscape Painting," *Gazette des Beaux Arts,* May 1953.

Gould, C., *Early Renaissance,* N.Y., 1965.

Greifenhagen, A., "Zum Saturnglauben der Renaissance," *Antike,* I, 1939, pp.67-84.

Gundersheimer, W.L., *The Italian Renaissance,* N.Y., 1967.

Haftmann, W., "Die Medici-ausstellung in Florenz; with English summary," *Pantheon,* XXIV, July 1939, pp.237-243.

Harms, E., "Identifying a Renaissance Motif in the Treatment of the Theme of the Pietà," *Connoisseur,* CXXXVIII, September 1956, p.78.

Hart, I.B., *The Mechanical Investigation of Leonardo da Vinci,* Berkeley, Calif., 1963.

Hartt, F. et al., *The Chapel of the Cardinal of Portugal, 1434-1459,* Philadelphia, 1964.

Hartt, F., "Florentine Art under Fire," *Apollo,* LI, May 1950, p.145 (review).

Hartt, F., *History of Italian Renaissance Art,* N.Y., 1970.

Hauser, A., *The Social History of Art,* II, N.Y., 1961.

Hay, D., *The Italian Renaissance,* Cambridge, 1966.

Hay, D., *The Italian Renaissance in its Historical Background,* Cambridge, 1961.

Herlihy, D., *Pisa in the Early Renaissance,* New Haven, 1958.

Hollings, M.A., *Europe in Renaissance and Reformation, 1453-1660,* Nethuen, 1934.

Holt, G., *A Documentary History of Art,* I-II, N.Y., 1957.

Huyghe, R. ed., *Larousse Encyclopedia of Renaissance and Baroque Art,* London, 1964.

Jacob, E. ed., *Italian Renaissance Studies,* N.Y., 1965.

Jebb, R.C., "Classical Renaissance," *Metropolitan Museum Bulletin,* V, November, 1946, p.73.

Kendrick, F. and Shipp, H., *Italian Masters; with a Chart of the Italian Artists of the Renaissance,* Low, 1929.

Kristeller, P., *The Classic Scholastic and Humanist Strains,* N.Y., 1963.

Kristeller, P., *Classical and Renaissance Thought,* Harvard Univ. Press, 1955.

Kristeller, P., *Eight Philosophers of the Italian Renaissance,* Palo Alto, Calif., 1964.

Kristeller, P., *Iter Italicum:A Finding List of Uncatalogued or Incompletely Catalogued Humanist Manuscripts of the Renaissance in Italian and Other Libraries,* London, 1963.

Kristeller, P., *Renaissance Thought,* Harper, 1965.

Lavin, M.A., "Giovannino Battista, A Study in Renaissance Religious Symbolism," *Art Bulletin,* XXXVII, June 1955, pp.85-101.

Leonardo da Vinci, *Notebooks* I-II, N.Y., 1938.

Longhi, R., *Frescoes,* Oxford, 1949.

Lucki, E., *History of the Renaissance, Economy and Society,* Salt Lake City, 1963.

Mariano, N., *La Roccolta Berenson,* Milan, 1962.

Marle, R. van, "Iconographie de l'art profane au moyen age et a la renaissance," *Burlington Magazine,* LIX, Aug. 1931, p.97-98.

Martin, A. von, *Sociology of the Renaissance,* N.Y., 1963.

Martines, L., *The Social World of the Florentine Humanists, 1390-1460,* New Haven, 1963.

Mates, J. and Cantelupe, E., *Renaissance Culture,* N.Y.

Matt, L. von, *Renaissance Art in Rome,* Universe Books, 1961.

Mayorr, A.H., "Renaissance Costume Books, Libro de Geometria and the Rucueil de la diversite de habits," *Metropolitan Museum Bulletin,* XXVII, June 1940.

Mazzeo, J.A., *Renaissance and Revolution,* Warburg, 1967.

Meiss, M., "French and Italian Variations on an Early Fifteenth Century Theme, S. Jerome and his Study," *Gazette des Beaux Arts,* LXII, 1962, p.147.

Morehouse, J., *Glimpses of Italian Art,* Mowbray, 1930.

Murray, P. and L., *The Art of the Renaissance,* London, 1963.

O'Malley, C.D. and Saunders, J.D., *Leonardo da Vinci on the Human Body,* Milano, 1965.

Paccagnini, G., "Mantegna e la Plastica dell Italia Settentrionale," *Boll. Arte.,* S4, XLVI, January 1961, pp.65-100.

Pacht, O., "Early Italian Nature Studies and the Early Calendar Landscape," *Warburg and Courthauld Inst. J.,* XIII, January 1950, pp.13-47.

Panofsky, E., *Renaissance and Renascences in Western Art,* Stockholm, 1960.

Panofsky, E., *Study in Iconology: Humanistic Themes in the Art of the Renaissance,* N.Y., 1963.

Parronchi, A., *Studi su la dolce prospettiva,* Milan, 1964.

Plochman, G.K., ed., *Resources of Leonardo da Vinci,* Southern Illinois Univ. Press, 1953.

Plumb, J.H., *The Italian Renaissance, A. Concise Survey of its History and Culture,* N.Y., 1965.

Plumb, J.H., *Renaissance Profiles,* Harper, 1965.

Portgliotto, G., *Some Fascinating Women of the Renaissance,* Coward-McCann, 1929.

Princeton University, "The Renaissance and Mannerism: Studies in Western Art," *Act of the XXth International Congress of the History of Art,* vol. II, 1964.

Ricci, S. and Wilson, W.J., *Census of the Medieval and Renaissance Manuscripts in the United States and Canada,* N.Y., 1935-40.

Rochon, A., *La Jeunesse de Laurent de Medicis, 1449-1478,* Paris, 1963.

Rowland, B., *The Classical Tradition in Western Art,* Cambridge, Mass., 1964.

Salmi, M., "Aggiunte al Tre e al Quattrocento Fiorentino," *Rivista d'Arte,* VII, October, 1935, pp.411-421.

Salmi, M., "Un Libro di Disegni Florentino del Sec. XV," *Rivista d'Arte,* II, January 1930, pp.87-95.

Sarton, G., *Appreciation of the Ancient and Medieval Sciences during the Renaissance, 1450-1600,* Univ. of Penn. Press, 1955.

Schevill, F., *Medieval and Renaissance Florence,* Harper, 1963.

Schmitaz, H., "Renaissance: aus der Werkstatt der Künstler Italiens," Heilbronn Am. Neckar, Gauss-Verlag, 1951.

Schwitzer, F.M., *Dictionary of the Renaissance,* N.Y., 1967.

Sellery, G.C., *Renaissance, its Nature and Origins,* Univ. of Wis. Press, 1950.

Seznae, J., "La Survivance des dieux antiques; essai sur la role de la tradition mythologique dans l'humanisme et dans l'art de la Renaissance," *Art Bulletin,* XXIV, March 1942, pp.97-99.

Shipp, H., *Italian Masters,* McBride, 1930.

Simpson, L., *Greek Spirit in Renaissance Art,* N.Y., 1953.

Spencer, J.R., "Spatial Imagery of the Annunciation in 15th century Florence," *Art Bulletin,* XXXVII, December 1955, pp.273-80.

Strong, M., *The Classical World,* N.Y., 1965.

Symonds, J.A., *Renaissance in Italy,* London, 1967.

Symonds, J.A., *The Revival of Learning: The Renaissance in Italy,* N.Y., 1960.

Sypher, F.W., *Four Stages of Renaissance Style,* Doubleday, 1955.

Taylor, R., *Aspects of Italian Renaissance,* Kennikat Press, 1968.

Taylor, R., *Invitation to Renaissance Italy,* Harper, 1930.

Tea, E., *Quattrocento e Cinquecento,* Torino, 1964.

Toesca, P., *Storia dell'Arte Italiana,* Torino, 1968.

Tolnay, C. de, *The Art and Thought of Michelangelo,* N.Y., 1964.

Vasari, G., *The Lives of the Painters, Sculptors and Architects,* I-IV, N.Y., 1927.

Vaughn, H.M., *Studies in the Italian Renaissance,* Dutton, 1939.

Wardrop, J., *The Script of Humanism: Some Aspects of the Humanistic Spirit,* 1460-1560, N.Y., 1963.

Wechsler, H., *Gods and Godesses in Art and Legend,* N.Y., 1961.

Weisinger, H., "Renaissance Theory of the Reaction Against the Middle Ages as a Cause of the Renaissance," *Speculum,* XX, October, 1945.

Westfall, J. et al., *Civilization of the Renaissance,* Chicago, 1929.

White, J., *The Birth and Rebirth of Pictorial Space,* N.Y., 1958.

White, J., "Developments in Renaissance Perspective," *Warburg and Courthauld Inst. J.,* XII, 1949, pp.78-79.

White, J., "Developments in Renaissance Perspective: the Problem of Donatello's Rklifs," *Warburg and Courthauld Inst. J.,* XIV, January 1951, pp.42-69.

Wickham, A.K., *Italian Renaissance,* MacMillan Press, 1939.

Wind, E., *Mysteries in the Renaissance,* New Haven, 1958.

Wolf, R.E. and Milen, R., *Renaissance and Mannerist Art,* N.Y., 1968.

Wolfflin, H., *The Art of the Italian Renaissance,* Schochen, 1963.

Wolfflin, H., *Classic Art,* London, 1953.

Wolfflin, H., "Classical Art, an Introduction to the Italian Renaissance," *Liturgical Arts,* XXII, August 1954, pp.126-127.

Zervos, C., "Notes sur Les Portraits et les Figures de la Renaissance Italienne," *Cahiers d'Art,* XXV, No.2, 1950-51, pp.365-382.

Zupnick, L.I., "Iconology of Style, or Wolfflin Reconsidered," *J. Aesthetics,* XIX, no. 3, Spring 1961, pp.163-173.

ARCHITECTURE BIBLIOGRAPHY

Ackerman, J.S., "Architectural Practice in the Italian Renaissance," *Society of Architectural Historians Journal,* XIII, October 1954, pp.3-11.

Alberti, L.B., *Ten Books on Architecture,* London, 1955.

Bottari, S., "I mensi della Catterale di S. Martino di Lucca," *Arti,* I, August 1939, pp.56-566.

Clark, K., "Humanism and Architecture," *Architectural Review,* XIV, February 1951, pp.65-69.

Frey, D., "Ein entwurf Giulianos da Sangallo für das gestuhl in der palazzo Medici-Riccardi," *Florence Kunsth. Inst. Mitt.,* V, July 1939, pp.197-202.

Gideon, S., "Space and the Elements of the Renaissance City," *Magazine of Art,* January 1952, pp.3-10.

Haupt, E.A., "Renaissance Palaces of Northern Italy and Tuscany," *Roy. Inst. of British Architects Journal,* XXXIX, June 1932, pp.662-663.

"Italian Renaissance Architecture in Terracotta," *Architectural Review,* LXX, October 1931, pp.117-120.

Krauteimer, R., "Ghiberti-Architetto, Gates of Paradise," *Oberlin College Bulletin,* XII, 1955, pp.48-67.

Lowery, B., *Renaissance Architecture,* N.Y., 1962.

Luporini, E., *Brunnelleschi, forma e ragione,* Milan, 1964.

Moscato, A., *Il Palazzo Pazzi e Firenze,* Rome, 1963.

Murray, P., *The Architecture of the Italian Renaissance,* N.Y., 1963.

Pergola, P della, "Aspetti del Primo Rinascimento dell'Architetecturra della Calabris," *Emporium,* CII, November 1945, pp.109-118.

Pretz, R.H., "Architecture of the Renaissance," *Ga. Inst. of Technology Bulletin,* 1950.

Rosenthal, E.E., "House of Andrea Mantegna in Mantua," *Gazette des Beaux Arts,* LX, no.6, September 1962, pp.327-348.

Scaglia, G., "Three Renaissance Drawings of Church Facades," *Arts Bulletin,* June 1965, pp.173-185.

Spencer, J., *Filarete's Treatise on Architecture,* New Haven, 1965.

Thompson, M.L., "Notes on the Pazzi Chapel," *Marsyas,* 1950-53, pp.70-71.

Tiegler, P., *Die Architecturtheorie des Filarete,* Berlin, 1963.

Venturi, R., "Edifici di un Umanista a Padova," *Arte,* May 1930, pp.165-279.

Wittkower, R., *Architectural Principles in the Age of Humanism,* N.Y., 1965.

Wittkower, R., "Brunelleschi and Proportion in Perspective," *Journal of the Warburg and Courthauld Institute,* July 1953, pp.285-286.

Wolfflin, H., *Architecture in the Renaissance,* Cornell Univ. Press, 1967.

PAINTING BIBLIOGRAPHY

Adams, P.R., "Fra Angelico's Virgin and Child," *Art News,* LXV, December 1966, pp.34-35.

Alberti, L.B., *On Painting,* New Haven, 1956.

Almedinge, M.E. von, *The Young Leonardo da Vinci,* N.Y., 1964.

Ansaldi, G.R., "Contributi alla Pittura del Rinascimento," *Arte,* VII, July 1936, pp.168-182.

Argan, G.E., *Fra Angelico,* N.Y., 1955.

Arslan, E., "Contributi a Ercole de Roberti, Parmigianino, Primatico," *Emporium,* CV, February 1947, pp.65-69.

Arti Grafiche Ricordi Series, Milano.

Battisti, M., *Giotto,* Milan, 1960.

Bazin, G., *Fra Angelico,* N.Y., 1949.

Bean, J., *Drawings from the New York Collection of the Italian Renaissance,* N.Y., 1966.

Berenson, B., "A New Masaccio," *Art in America*, XVIII, February 1930, p.44-53.

Berenson, B., *Drawings of the Florentine Painters*, Chicago, 1938.

Berenson, B., *Italian Painters of the Renaissance*, London, 1953.

Berenson, B., *Italian Pictures of the Renaissance: Florentine School*, London, 1963.

Berenson, B., "Missing Pictures of the Sienese Trecento," *Int. Studio*, XCVII, Oct.-Nov. 1930, pp.67-71.

Berenson, B., *Piero della Francesca*, London, 1954.

Bertram, A., *Piero della Francesca*, Studio, 1949.

Bianconi, P., *All the Paintings of Piero della Francesca*, N.Y., 1962.

Boeck, W., "Quattrocento Painting in the Kaiser Friedrich Museum," *Burlington Magazine*, LXIV, January 1934, pp.29-36.

Bongiorno, L.M., "Date of the Altar of the Madonna S. Maria de Soccorso, Aguila," *College Art Assoc. of American Art Bulletin*, XXVI, September, 1944, pp.188-192.

Borenius, T., "Among the Belliniani," *Burlington Magazine*, LXXIV, January 1939, pp.12-23.

Borenius, T., "Two Venetian Cinquecento Drawings," *Burlington Magazine*, LVI, February 1930, pp.104-107.

Brandi, C., "Quattrocentiati Senesi," *Burlington Magazine*, XCII, November 1950, p.331 (review).

Budapest, *Kozepitaliai Rajzok*, Hungarian National Museum of Fine Arts, Budapest, 1963.

Cantelupe, E.B., "Anonymous Triumph of Venus in the Louvre: an Early Italian Renaissance Example of Mythological disguise," *Art Bulletin*, XLIV, September 1962, pp.238-242.

Cardellini, I., *Desiderio da Settignano*, Milan, 1963.

Carli, E., *Florentine Painting*, London, 1963.

Carli, E., *Il Duomo di Orvieto*, Rome, 1965.

Carli, E., "Sassetta's Borgo San Sepolcro Altarpiece," *Burlington Magazine*, XCXXX, May 1951, pp.144-152.

Cartwright, I., *The Painters of Florence*, London, 1900.

Cipriani, R., *Piero della Francesca*, Milano, 1962.

Clark, K., "Architectural Backgrounds in Renaissance Pictures, with Discussion," *Royal Institute of British Architects Journal*, XLI, February, 1934, pp.325-343.

Clark, K., "Seven Sassettas for the National Gallery," *Burlington Magazine*, LXVI, April, 1936, pp.152-158.

Coletti, L., "Early Works of Simone Martini," *Arts Quarterly*, XII, November 1949, pp.290-308.

Comstock, H., "Florentine Annunciation Newly Brought to Light, Acquired under the Name of Pesellino," *Connoiseur*, XCVII, June 1936, pp.338-339.

Constable, W.G., "Abstract of Florentine Annunciation," *American Journal of Archaeology*, L, July 1946, p.416.

Constable, W.G., *Venetian Paintings*, London, 1949.

Coor-Achenbach, G., "Frescoe Fragment of a Nativity and Some Related Representations," *Boston Museum Bulletin*, February 1952, pp.11-15.

Crowe, (Sir) and Cavalcaselle, *A History of Painting in Italy*, N.Y., 1903-1914.

Crowe, (Sir) and Cavalcaselle, *A History of Painting in North Italy*, I-III, N.Y., 1912.

Davis, F., "Two Early Italian Painters," *London News*, CCVI, April 1955, p.606.

De Wald, E., *Italian Painting, 1200-1600*, N.Y., 1961.

Edgell, G.H., *A History of the Sienese Painting*, N.Y., 1932.

Edgell, G.H., "Six Unpublished Sienese Paintings in Boston," *Art in America*, XXVIII, July 1940, pp.92-99.

Eisenberg, M.J., "Partial Reconstruction of a Predella by Mariotto di Nardo," *Oberlin College Bulletin*, IX, December 1951, pp.9-16.

Emiliani, A., *Italian Painting, Perugino to Caravaggio*, N.Y., 1963.

Ettlinger, L.D., *The Sistine Chapel before Michelangelo*, N.Y., 1965.

Fairfield, O.P., *Italian Renaissance in Art*, N.Y., 1928.

Fastnedge, R., "Restored Works by Signorelli at Liverpool," *Burlington Magazine*, August 1953, pp.71-74.

Fenyo, I., *North Italian Drawings,* N.Y., 1965.

Fiocco, G., *Andrea Mantegna, Paintings,* N.Y., 1963.

Francis, H.S., "Sienese Madonna and Child by Lippo Memmi," *Cleveland Museum Bulletin,* April 1953, pp.59-61.

Frankfurter, A.M., "Giovanni Bellini, A Way of Art," *Art News,* XLVIII, October 1949, pp.22-25.

Frankfurter, A.M., "Italian Art, Great and Shabby: Fra Angelico Quincentenary Exhibition," *Art News,* LIV, October 1955, pp.44-45.

Gabrielli, M., *Giotto e l'origine del Realismo,* Rome, 1960.

Gamba, C., "Piero di Cosimo i suoi quadri mitologici," *Bol. Arte.,* XXX, August 1936, pp.45-57.

Garas, K., *Italian Renaissance Portraits in the Budapest Museum of Fine Arts,* Budapest, 1965.

Gilbert, C., "On Subject and Non-Subject in Italian Renaissance Pictures," *College Art Assoc. of America Art Bulletin,* Spring 1952, pp.202-216.

Gilbert, S., *Italian Painting,* critical studies by Lionello Venturi, historical surveys by Rosabianca Skira-Venturi, 3 vols, Geneva, 1950-51.

Godfrey, F.M., *Early Venetian Painters, 1415-1499,* Transatlantic, 1955.

Godfrey, F.M., *Students' Guide to Early Italian Painting, 1250-1500,* Burns and MacEachern, 1956.

Goering, M., *Italian Painting of the 16th Century,* Zwemmer, 1936.

Goldscheider, L., *Leonardo da Vinci, Painting and Drawings,* London, 1964.

Gould, C., *An Introduction to Italian Renaissance Painting,* London, 1957.

Gregory, P., *When Painting Was in Glory, 1280-1580,* Bruce Publishing Company, 1941.

Hart, I., *Leonardo da Vinci, Supreme Artist and Scientist,* London, 1964.

Hartt, F., "Mantegna's Madonna of the Rocks," *Gazette des Beaux Arts,* December, 1952, pp.329-342.

Heinemann, F., *Giovanni Bellini e i Belliani,* I-II, Venice, 1963.

Heydenreich, L.H., *Leonardo da Vinci,* N.Y., 1956.

Hill, G., *Drawings by Pisanello,* N.Y., 1965.

Kaftal, G., *Iconography of the Saints in Central and South Italian Painting,* Florence, 1965.

Karnaghan, A.W., "Virgin and Child by Andrea Mantegna," *Boston Museum Bulletin,* XXXII, April 1934, pp.19-24.

Lavagnino, E., "Origin of Sienese Landscape Painting," *Int. Studio,* XCVI, June 1930, pp.25-29.

Ledivelec, M., *Fra Angelico, Giovanni da Fiesole, 1387-1455,* Crown, 1963.

Lemaire-Le Monnier, M., "Le Negre dans la Peinture Italienne du Moyen Age et de la Renaissance a la'Epoque de la Coutre-Reform," *Musees de France,* October 1948, pp.209-211.

Leonardo da Vinci, *Drawings of Leonardo da Vinci,* N.Y., 1963.

Lipman, J., "Florentine Profile Portrait in the Quattrocento," *Art Bulletin,* XVIII, March 1936, pp.54-102.

Mantegna, A., *All the Paintings of Mantegna,* Oldbourne Press, 1964.

Mantegna: Painting, Drawing, Engraving, Complete Works, London, 1955.

Marchini, G., "Frescoes in the Choir of S. Maria Novella," *Burlington Magazine,* October 1953, pp.320-329.

Marle, R. van, *The Development of the Italian School of Painting,* I-XIX, The Hague, 1923-1939.

Mather, F.J., "Giotto's S. Francis Series at Assisi Historically Considered," *American Journal of Archaeology,* XLVIII, April, 1944, p.195.

Mather, F.J., *History of Italian Painting,* N.Y., 1938.

Mather, F.J., *Venetian Painters,* N.Y., 1936.

Meiss, M., "Early Altarpiece Painting from Cathedral of Florence: Intercession of Christ and the Virgin," *Metropolitan Museum Bulletin,* XII, June 1954, pp. 302-317.

Meiss, M., "Five Ferrarese Panels, Portrait of a Young Man in the Besancon Museum Attributed to Cossa, and an Altarpiece Vincino da Ferrara," *Burlington Magazine,* XCIII, March 1951, pp.69-72.

Meiss, M., "Giotto and Assisi," *Burlington Magazine,* CII, December 1960, pp.540-541.

Meiss, M., *Giovanni Bellini's S. Francis,* New Haven, 1964.

Meiss, M., *Painting in Florence and Siena After the Black Death,* Princeton University Press, 1951.

Meiss, M., "Problems of Francesco Traini," *Art Bulletin,* XV, June 1933, pp.96-173.

Mesnil, J., *Masaccio et les debuts de la Renaissance,* The Hague, 1927.

Mommsen, T.E., "Petrarch and the Decoration of the Sala Virorum Illustrium in Padua," *College Art Assoc. of American Art Bulletin,* Spring, 1952, pp.95-116.

Morrison, R.C., "Elusive Minor Sienese Master of the 15th Century," *Art in America,* XVIII, October 1930, pp.305-309.

Oberschall, M., "Un Elev Inconnu de Fra Filippo Lippi," *Gazette des Beaux Arts,* IV, October 1930, Supp. no. 2, pp.216-222.

Offner, R., "Carpaccio's S. Eustace Secured by Baron H. Thyssen," *Art News,* XXXIII, March 1935, pp.33-34.

Offner, R., "Critical and Historical Corpus of Florentine Painting," *Burlington Magazine,* LXVIII, March 1936, pp.152-153.

Orlandi, S., *Beato Angelico: Monographia storica della vita e della opere con un'appendice di nuovi documenti inediti,* Florence, 1964.

Parks, R.O., "Duccesque and Ghirlandairsque Panel Paintings: Madonna and Child with Saints Just and Justina," *John Herron Art Inst. Bull.,* October 1952, pp.22-27.

Pattillo, N.A., Jr., "Botticelli as a Colorist," *Art Bulletin,* XXXVI, September 1954, pp.203-222.

Pedretti, C. ed., *Leonardo da Vinci on Painting: A Lost Book,* University of Calif. Press, 1964.

Peixotto, E., "Some Panels for a Quattrocento Villa near Florence: Villa Razzolini, T.M. Spelman Home," *Arts and Decoration,* XLIII, January 1936, pp.14-16.

Pittagula, M., *Fra Filippo Lippi,* Florence, 1949.

Polluchini, R., *Giovanni Bellini,* London, 1963.

Pope-Hennessy, J., *The Complete Work of Paulo Uccello,* London, 1950.

Pope-Hennessy, J., *The Paintings of Fra Angelico,* London, 1952.

Pope-Hennessy, J., "Sienese Art in the Pinacoteca, Siena," *Burlington Magazine,* LXXXVIII, March 1946, p.71.

Pope-Hennessy, J., *Sienese Quattrocento Painting,* London, 1947.

Pope-Hennessy, J., "Virgin and Child by Agostino di Duccio," *Burlington Magazine,* XCVI, June 1954, p.187.

Popham, A.E., "Two Fifteenth Century Florentine Decorative Drawings of Angels Holding Candelabra," *British Museum Quarterly,* X, March 1936, p.85.

Previtali, G., *Early Italian Painting,* N.Y., 1964.

Procacci, R., *All the Paintings of Massaccio,* Oldbourne Press, 1962.

Pudelko, G., "Two Portraits of Unidentified Members of the Medici Family Ascribed to Andrea del Castagno," *Burlington Magazine,* LXVIII, May 1936, pp.235-242.

Pudelko, G., "Unknown Holy Virgin Panel by Paolo Uccello, now in the National Gallery of Ireland, Dublin," *Art in America,* XXIV, July 1936, pp.127-134.

Puppi, L., *Bartolommeo Montagna,* Venice, 1962.

Ragghianti, C.L., "La Giovenezza e lo Svolgimento Artistico di Domenico Ghirlandaio," *Arte,* VI, May 1939, pp.166-198.

Rey, J.D., *Giotto: Frescoes in the Upper Church, Assisi,* N.Y., 1955.

Ripley, E.G., *Botticelli,* Lippincott, 1960.

Ross, D.J.A., "Unrecorded Follower of Piero della Francesca," *Warburg and Courthauld Inst. J.,* XVII, January 1954, pp.174-181.

Salmi, M., *Paolo Uccello, Andrea del Castagno, Domenico Venetiano,* Milan, 1938.

Salvini, R., *All the Paintings of Botticelli,* London, 1965.

Scharf, A., "Eine Pinselzeichnung Filippino Lippis im Berliner Kupferstich Kabinett," *Berliner Museum,* LI, no.6, 1930, pp.145-147.

Scharf, A., "Study of a Young Warrior by L. Signorelli," *Old Master Drawings,* September 1939, pp.14-50.

Schmeckebier, L., *Handbook of Italian Renaissance Painting,* Putnam, 1938.

Smart, A., "Reflections of the Art of Giotto," *Apollo,* April 1965, pp.257-263.

Stampfle, F. and Bean, J., *Drawings from the New York Collection,* vol. I, The Italian Renaissance, Greenwich, Conn.

Tatlock, R.R., "Sassetta at the National Gallery," *Apollo,* XXI, April 1935, pp.223-224.

Taylor, R., *Leonardo the Florentine,* Harper, 1927.

Thiem, G. and Thiem, C., *Toskanische Fassadendecoration in Sgraffito und Fresco 14 bis 17 Jahrhundert,* Munchen, 1964.

Thompson, J.W., *Italian Painting,* London, 1954.

Tietze, C.E., *Mantegna,* London, 1955.

Tietze, H., "Mantegna and His Companions in Squarcione's Shop," *Art in America,* XXX, January 1942, pp.54-60.

Tietze, H. and C.R., "Drawings of the Venetian Painters in the Fifteenth Century," *Art Bulletin,* XXVII, June 1945, pp.152-156; also *Gazette des Beaux Arts,* S.6, XXVII, February 1945, pp.125-127.

Tintori, L. and Borsook, E., *Giotto: the Peruzzi Chapel,* N.Y., 1965.

Tintorri, L., *The Painting of the Life of S. Francis Assisi,* N.Y., 1961.

Valentiner, W.R., "On Leonardo's Relation to Verrocchio," *Art Quarterly,* IV, no. 1, 1941, pp.2-31.

Valentiner, W.R., "Verrocchio or Leonardo: Profile Portrait of a Young Woman," *Art News,* XXXV, December 1936, p.21.

Valery, P., *Introduction a la methode le Leonardo de Vinci,* Paris, 1964.

Vavala, E.S., "Sienese Studies," *Burlington Magazine,* XCVI, January 1954, pp.27-28.

Venturi, L., *Botticelli,* London, 1949.

Venturi, L., *Italian Painting,* I-II, N.Y., 1950-1951.

Venturi, *Nativity,* Harper, 1949.

Wehle, H.B., "S. Lawrence Altarpiece by Fra Filippo Lippi," *Art News,* XXXIV, December 1935, p.31.

Yashiro, Y., *Sandro Botticelli and the Florentine Renaissance,* Hale, 1929.

Zeri, F., "Towards a Reconstruction of Sassetta's Arte Della Lana Triptych," *Burlington Magazine,* XCVIII, February 1956, pp.36-39.

Ziff, J., "Reconstruction of the Altarpiece by Andrea Vanni," *Art Bulletin,* XXXIX, June 1957, pp.138-142.

SCULPTURE BIBLIOGRAPHY

Aubert, Marcel, *Sculpture de la Renaissance italienne au Musee du Louvre,* Paris, 1952.

Bacchelli, M., "Le Statue Quattrocenteache dei Profeti nel Campanile nell'Antica Facciata di Santa Maria del Fiore," *Revista d'Arte,* S2, VII, April-June 1935, pp.121-159.

Bacci, P., *Jacopo della Quercia,* Siena, 1929.

Beaulieu, M., *Sculpture Florentine du XV Siecle,* Paris, 1951.

Bertini, A., "L'arte del Verrocchio," *Arte,* no.6, November 1935, pp.433-473.

Bertram, A., *Michelangelo,* Seudio, 1949.

Biadego, G., *Il Pisanello,* Verona, 1892.

Bode, W. von, *Florentine sculptors of the Renaissance,* Methuen, 1928.

Bode, W. von, *Italienischen bronzestatuetien der Renaissance,* Berlin, 1922.

Bongiorno, L.M., "15th Century Stucco and the Style of Verrocchio," *Oberlin College Bulletin,* no.3, Spring 1962, pp.115-141.

Bouchaud, P. de, *Sculpture a Sienna,* 1901.

Bourgeois, S., "Italian Renaissance Sculpture," *Parnassus,* VII, March 1935, pp. 7-8.

Brizio, A.M., "Per il Quinto Centenario Verrocchiesco, 1435-1935," *Emporium,* vol.82, December 1935, pp.292-303.

Brunetti, G., "Jacopo della Quercia and the Porta della Mandorla," *Art Quarterly,* vol.15, no. 2, 1952, pp.119-131.

Buck, R.D., "Report on Technical Examination: Follower of Verrocchio, Madonna and Child," *Oberlin College Bulletin,* vol.19, no.3, Spring 1962, pp.115-141.

Busch, H. and Lohse, B., editors, *Renaissance Sculpture; European Sculpture,* N.Y., 1963.

Calabi, A. and Cornaggia, G., *Pisanello,* Milano, 1928.

Carli, E., "Nicola da Guardiagrele e il Ghiberti," *Art News,* X, October 1939, pp.222-238.

Carli, E., "Per lo stile tardo di Giovanni Pisano. . ." *Arte,* no. 7, July 1936, pp.141-167.

Carli, E., "Problema di Nino Pisano," *Arte,* no. 5, May 1934, pp.189-222.

Carli, E., "Recovered Francesco di Giorgio: S. John the Baptist from Fogliano," *Burlington Magazine,* vol.91, February 1949, pp.32-37+.

Castelfranco, G., *Donatello,* Milan, 1963.

Cecchi, E., *Scultura fiorentina del Quattrocento,* Milano, 1956.

Colasanti, A., "Donatelliana," *Rivista d'Arte,* S.2, vol.6, January 1934, pp.45-63.

Comstock, H., "Bronzes of the Italian Renaissance Acquired by the Minneapolis Institute of Arts," *Connoisseur,* CXLIX, January 1962, p.64.

Comstock, H., "Quattrocento Portrait Sculpture in the National Gallery, Washington," *Connoisseur,* CXXII, September 1948, pp.45-49.

Comstock, H., "Renaissance Sculpture: A S. Drey Exhibition," *Connoisseur,* XCV, June 1935, pp.348-349.

Cook, T.A., *Leonardo da Vinci, Sculptor,* Humphreys, 1923.

Cotton, A.G. and Walker, R.M., "Minor Arts of the Renaissance in the Museo Cristiano," *Art Bulletin,* XVII, June 1935, pp.118-162.

Cotton, A.G. and Walker, R.M., "Minor Arts of the Renaissance in the Museo Cristiano: Plaquettes," *Art Bulletin,* XVII, June 1935, pp.140-146.

Crichton, G.H., *Nicola Pisano and the Revival of Sculpture in Italy,* Cambridge, 1938.

Cruttwell, M., *Donatello,* Classics of Art, 1911.

D'Ancona, M.L., "Baptism of Constantine by Girolamo da Cremona," *Marsyas Suppl.,* I, 1964, pp.74-86.

Davies, G.S., *Michelangelo Buonarroti,* Methuen, 1924.

Day, R.E., *Historical Catalogue of Italian Sculpture, 1200-1500,* Ann Arbor, 1959.

Driscoll, E.R., "Isaia da Pisa; Alfonso of Aragon as a Patron of Art; Some Reflections on the Sculpture and Design of the Triumphal Arch of the Castel Nuovo in Naples," *Marsyas Suppl.,* I, 1964, p.88.

Foule, E., *Italienische Renaissanceplastiken aus der Sammlung,* Pantheon, 1929.

Freeman, L.J., *Italian Sculpture of the Renaissance,* N.Y., 1927.

Gengaro, M.L., "Precisazioni su Ghiberti architetto," *Arte,* no. 9, July 1938, pp.280-296.

Ghiberti, L., *Ghiberti,* London, 1949.

Gielly, L., *Jacopo della Quercia,* Paris, 1930.

Goldscheider, "Michelangelo's Sculptures," *Connoisseur,* January 1953, pp.73-75.

Goldscheider, "Sculptures of Donatello," *College Art Journal,* I, March 1942, pp. 79-80.

Goldscheider, L., *Donatello,* Unwin, 1941.

Goldscheider, L., *Ghiberti,* London, 1949.

Goldscheider, L., *Sculptures of Michelangelo,* Allen & Unwin, 1940.

Goldscheider, L., *A Survey of Michelangelo's Models in Wax and Clay,* London, 1962.

Goldscheider, L., *Unknown Renaissance Portraits*, N.Y., 1952.

Gore, W.G.A.O., *Florentine Sculptors of the 15th Century*, N.Y., 1930.

Grassi, L., *All the Sculpture of Donatello*, Oldbourne Press, 1965.

Grotemeyer, P., "Andrea del Verrocchio," *Pantheon*, XVII, April 1936, pp.109-115.

Haftmann, W., "Della Quercia and Sienese Sculpture," *Mag. Art*, XXXII, 1939, pp.508-511.

Hanson, A.C., *Jacopo della Quercia's Fonte Gaia*, N.Y., 1965.

Harms, E., "Identifying a Renaissance Motif in the Treatment of the Theme of the Pieta," *Connoisseur*, vol.138, September 1956, p.78.

Heil, W., "Unearthing a Renaissance Clue: Reclining Putto by Verrocchio," *Art News*, XLVIII, March 1949, p.16.

Hildburgh, W.L., "Marble Relief Attributable to Donatello and Some Associable Stuccos," *Art Bulletin*, XXX, March 1948, pp.11-19.

Hirsch, E.S., "Bust of S. John the Baptist, Italian 15th Century Work," *Baltimore Museum of Art News*, November 1949, pp.1-4.

Janson, H.W., "Hildburgh Relief: Original or Copy?" *Art Bulletin*, XXX, June 1948, pp.143-145 (reply by Hildburgh, XXX, September 1948, pp.244-246.)

Janson, H.W., *The Sculptures of Donatello*, New Haven, 1965.

Janson, H.W., "Two Problems in Florentine Renaissance Sculpture: Pagno di Lapo Portigiani and the Beginnings of Agostino di Duccio," *Art Bulletin*, XXIV, December 1942, pp.326-334.

Krautheimer, R., "Ghibertiana," *Burlington Magazine*, CXXI, August 1937, pp.68-80.

Krautheimer, R., "Ghiberti-architetto: Gates of Paradise for the Florence Baptistery," *Oberlin College Bulletin*, XII, no. 2, 1955, pp.48-67.

Krautheimer, R. and Krautheimer-Hess, T., *Lorenzo Ghiberti*, New Haven, 1956.

Kruger, H., "Architectural Ornament, Italian Renaissance Style," *Beaux Arts Inst. des Bul.*, VII, July 1931, p.12.

Landais, H., *Bronzes italiens de la Renaissance*, Paris, 1958.

Lanyi, J., "Tre relievi di Donatello," *Arte,* no. 6, July 1935, pp.284-297.

Lees, D.N., "Bronze Doors of the Florence Baptistery," *Apollo,* XLVIII, August 1948, p.41.

Lightbrown, R.W., "Three Genoese Doorways," *Burlington Magazine,* CIII, October 1961, pp.412-415.

Lopez-Rey y Arroyo, J., "Escultures de Antonio del Pollaiuolo," *Soc. Espan. Excurs. Bol.,* XLIII, June 1935, pp.81-88.

Maclagen, E.R.D., *Italian Sculpture of the Renaissance,* Harvard University Press, 1946.

Marceau, G., "Italian Sculpture of the 15th Century," *Penn. Mus. Bul.,* XXV, February 1930, pp.11-23.

Marcussi, L., *David di Michelangiolo Buonarroti,* Milano, 1963.

Mariacher, G., "Matteo Riverti nell'arte veneziana del primo quattrocento," *Revista d'arte,* XI, s.2, January 1939, pp.23-40.

Mariacher, G., "New Light on Antonio Bregno: the Foscari Tomb in the Presbytery of the Frari," *Burlington Magazine,* XCII, May 1950, pp.122-129.

Marle, R. van, "Ferrarese Sculptures of the 15th Century," *Apollo,* XXII, August 1935, p.108.

Marle, R. van, "Two Ferrarese Wood Carvings of the 15th Century," *Apollo,* XXI, January 1935, pp.9-13.

Marquand, A., *Andrea della Robbia and His Atelier,* Princeton Monographs in Art and Archaeology, no. 11.

Marquand, A., *Brothers of Giovanni della Robbia: Fra Mattia, Luca, Girolamo, Fra Ambroglio,* Princeton, 1928.

Marquand, A., *Della Robbia in America,* Princeton Monographs in Art and Archaeology, no.1, 1912.

Marquand, A., *Luca della Robbia,* Princeton monographs in Art and Archaeology, no.1, 1914.

Mather, R.G., "Documents Mostly New Relating to Florentine painters and sculptors of the 15th Century," *Art Bulletin,* XXX, March 1948, pp.20-65.

McGraw, P., "Terracotta bust, Attributed to Girolamo della Robbia, Maitland F. Griggs Collection," *Yale Associates Bulletin*, XXI, July 1955, pp.4-7.

Metropolitan Museum of Art, *Italian Renaissance Sculpture*, N.Y., 1933.

Milliken, W.M., "Head of a Singing Boy by Luca della Robbia," *Cleveland Museum Bulletin*, IX, February 1932, pp.19-21; and *Art News*, XXX, February 1932, p.5+.

Milliken, W.M., "Italian Renaissance Bronzes," *Cleveland Museum Bulletin*, XXXIV, April 1947, pp.64-68.

Milliken, W.M., "Paduan Bronzes by Riccio," *Cleveland Museum Bulletin*, XXXVI, March 1949, pp.33-35.

Milliken, W.M., "Renaissance Bronze from Siena," *Cleveland Museum Bulletin*, XXXV, November 1948, pp.207-209.

Milliken, M., "Two Renaissance Bronzes: Statuette of Venus by D. Cattaneo and Inkstand by A. Briosco," *Cleveland Museum Bulletin*, XXXVIII, February 1951, pp.42-44.

Molinier, E., *Bronzes de la Renaissance*, Paris, 1886.

National Gallery of Art, Wash., D.C., *Kress Collection: Renaissance Bronzes*, Wash., D.C., 1951.

Nicholson, A., "Donatello: Six Portrait Statues for the Campanile," *Art in America*, XXX, April 1942, pp.76-104.

Nocodemi, G., *Bronzi minori del Rinascimento italiano*, Milano, 1933.

Oman, C., "Base-Metal Goldsmith's Work of the Italian Renaissance," *Connoisseur*, CXLIV, January 1960, pp.218-221.

Ormsby, G.W., *Florentine Sculptors of the 15th Century*, N.Y., 1930.

Paoletti, P., *Architecture et la sculpture de la Renaissance a Venise*, Venise, 1897.

Planiscig, L., "Bronzes of the Italian Renaissance," *Burlington Magazine*, LXVI, March 1935, pp.126-129.

Planiscig, L., "Desiderio da Firenze, dokumente und hypothesen," *Z. Bild. K.*, LXIV, June 1930, pp.71-78.

Planiscig, L., "Di Alcune Opere Falsamente Attribuite a Donatello," *Phoebus,* II, November 1949, pp.55-59.

Planiscig, L., *Venezianische bildhauer der Renaissance,* Wien, 1921.

Polzer, J., "Lucca Reliefs and Nicola Pisano," *Art Bulletin,* XLVI, June 1964, pp.211-216.

Pope-Hennessy, J., *An Introduction of Italian Sculpture,* I-III, London, 1955-1963.

Pope-Hennessy, J., "Exhibition of Sienese Wooden Sculpture in Siena," *Burlington Magazine,* XCI, November 1949, pp.323-324.

Pope-Hennessy, J., *Italian Renaissance Sculpture,* London, 1958.

Pope-Hennessy, J., "Notes on a Florentine Tomb Front from the Florentine Convent of Monticelli. . ." *Burlington Magazine,* XCI, April 1949, pp.94-97.

Pope-Hennessy, J., "Two Paduan Bronzes Representing the Mountain of Hell," *Burlington Magazine,* XCVI, January 1954, pp.7-11+.

Reeder, H., "Borders of Filarete's Bronze Doors to S. Peter's," *Warburg and Courthauld Inst. J.,* X, 1947, pp.150-153.

Remington, P., "Adam by Tullio Lombardo, From the Monument of Doge Andrea Vendramin, Venetian, about 1490-95," *Metropolitan Museum Bulletin,* XXXII, March 1937, pp.58-62.

Reymond, M., *Sculpture Florentine,* Florence, 1897.

Richardson, E.P., "Profile Portrait of a Young Woman by Desiderio," *Detroit Institute Bulletin,* XXVIII, 1948, no.1, pp.1-4, and *Art Quarterly,* XI, 1948, no.3, pp.280-281+.

Rorimer, J.J., "Reliquary Bust Made for Poggio Bracciolini," *Metropolitan Museum Bulletin,* no.14, pp.246-251.

Rose, E.A., "Meaning of the Reliefs on the Second Pier of the Orvieto Facade," *Art Bulletin,* XIV, September 1932, pp.258-276.

Schubring, P., *Itanienische plastik des Quattrocento,* Potsdam, 1924.

Schubring, P., *Plastick Sienas im Quattrocento,* Berlin, 1907.

Sewter, A.C., "Small Italian Bronzes at the Barber Institute," *Connoisseur,* CXXIV, September 1949, pp.24-29+.

Seymour, C., "Attribution to Riccio and Other Recent Acquisitions

of Italian Renaissance Bronzes," *Yale University Art Gallery Bulletin,* XXVII, April 1962, pp.4-21.

Seymour, C., "Madonna and Child: Terracotta Relief," *Yale Associates Bulletin,* XXI, July 1955, pp.1-4.

Seymour, C., "Pisanello Medal of Lodovico Gonzaga," *Yale Associates Bulletin,* IX, June 1952, p.3.

Seymour, C., *Sculpture in Italy, 1400-1500,* London, 1966.

Seymour, C., "Younger Masters of the First Campaign of the Porta della Mandorla, 1391-1397," *Art Bulletin,* XLI, March 1959, pp.1-17.

Seymour, C. and Swarzenski, H., "Madonna of Humility and Quercia's Early Style," *Gazette Beaux Arts,* S.6, vol.30, September 1946, pp.129-152.

Sitwell, S., "Early Renaissance in Stone and Marble," *Arch. R.,* LXXII, July 1932, p.22.

Squilbeck, J., "Bronzes italiens de la Renaissance," *Brussels. Mus. Roy. Bul.,* S.3, vol.16, January 1944, pp.1-12.

Steingraber, E., "Madonna Relief by Michele da Firenze," *Connoisseur,* CXL, December 1957, pp.166-167.

Stites, R.S., "Bronzes of Leonardo da Vinci," *Art Bulletin,* XII, September 1930, pp.254-269.

Stokes, A., *Stones of Rimini,* Faber, 1934.

Supino, I.B., *Jacopo della Quercia,* Bologna, 1926.

Swarzenski, G., "Bronze Statuette of S. Christopher," *Boston Museum Bulletin,* XLIX, December 1951, pp.84-95.

Swarzenski, G., "Donatello's Madonna in the Clouds and Fra Bartolommeo," *Boston Museum Bulletin,* XL, August 1942, pp.64-77.

Swarzenski, G., *Nicolo Pisano,* Frankfort, 1926.

Swarzenski, G., "Some Aspects of Italian Quattrocento Sculpture in the National Gallery," *American Journal of Archaeology,* XLVIII, July 1944, pp.292-293.

Tolnay, C. de, *Michelangelo,* I-V, New Haven, 1953-1960.

Tolnay, C. de, "Michelangelo's Bust of Brutus," *Burlington Magazine,* LXVII, July 1934, pp.22-29.

Valentiner, W.R., "Coat of Arms of the Minerbetti by Donatello," *Detroit Institute Bulletin,* XXI, January 1942, pp.26-27.

Valentiner, W.R., "Italian Renaissance Sculpture: the Tomb of Roberto Malatesta," *Art in America,* XXXV, October 1947, pp.300-312.

Valentiner, W.R., "Mino de Fiesole," *Art Quarterly,* VII, no.3, October 1944, p.150.

Valentiner, W.R., "Notes on the Early Works of Donatello," *Art Quarterly,* XIV, no.4, 1951, pp.307-325.

Valentiner, W.R., "Portrait Bust of King Alphonso I of Naples," *Art Quarterly,* I, no.2, 1938, pp.61-89.

Valentiner, W.R., *Studies of Italian Renaissance Sculpture,* London, 1950.

Valentiner, W.R., "Terracotta Relief by Pietro Lombardo," *Detroit Institute Bulletin,* XVI, November 1936, pp.21-24.

Valentiner, W.R., "Two Lombard Sculptures of the Renaissance: Head of an Angel by Benedetto Briosco and Madonna and Child by Antonio Lombardo," *Detroit Institute Bulletin,* IX, 1939, pp.3-70.

Vigezzi, S., *Scultura in Milano,* Milano, 1934.

Weigert, et al., *Renaissance Sculpture,* N.Y., 1965.

Weinberger, M., "Giovanni Pisano, a New Discovery and the Technique of the Master's Workshop," *Burlington Magazine,* LXX, February 1937, pp.54-60.

Weiss, R., "Medals of Pope Sixtus IV, 1471-1484," *Burlington Magazine,* CIV, January 1962, p.40 (review).

Weller, A.S., *Francesco di Giorgio, 1439-1501,* Chicago, 1943.

White, J., "Developments in Renaissance Perspective, the Problem of Donatello's Reliefs," *Warburg and Courthauld Inst. J.,* XIV, January 1951, pp.42-69.

White, J., "Reliefs on the Facade of the Duomo at Orvieto," *Warburg and Courthauld Inst. J.,* XXII, July 1959, pp.254-302.

Whittet, G.S., "Italian bronze statuettes at the Victoria and Albert Museum," *Studio,* CLXII, November 1961, pp.195-196.

Wiles, B.H., "Fountains of Florentine Sculptors and their Followers` from Donatello to Bernini," *Art Digest,* VIII, February 1934, p.22.

Wiles, B.H., *Fountains of Florentine Sculptors and their Followers from Donatello to Bernini,* Harvard Univ. Press., 1933.

Ybl, E., "Zwei alteren Pisani und Brunelleschi," *Phoebus,* I, no.3-4, 1946, pp.156-160.

Young, W.J. and Edgell, G.H., "Modified Tomb Monument of the Italian Renaissance," *Boston Museum Bulletin,* XXXV, December 1937, pp.83-90; and *Art News,* XXXVI, December 11, 1937, p.12+.

Yriarte, C., *Sculpture italienne, XVe siecle,* Paris, 1886.

MEDALS AND COINS BIBLIOGRAPHY

Boerger, H., *Medaillen der italienischen Renaissance,* Hamburg, 1921.

British Museum, Department of Coins and Medals, *Select Italian Medals of the Renaissance,* 1915.

"Corpus of Italian Medals of the Renaissance before Cellini," *British Museum, Department of Coins and Medals Bulletin,* II, 1930, p.77.

Goldscheider, L., "Unknown Renaissance Portraits: Medals of Famous Men and Women of the 15th and 16th Centuries," *Numismatist,* December 1952, pp.1212-1213.

Greene, T.W., *Notes on Some Italian Medals,* 1913.

Habich, G., *Medaillen der italienis Renaissance,* Stuttgart, 1924.

Heiss, H., *Medailleurs italiens de la Renaissance,* Paris, 1881.

Hill, G.F., *Corpus of Italian Medals of the Renaissance before Cellini,* British Museum, 1930.

Hill, G.F., *Medals of Paul II,* 1910.

Hill, G.F. *Portrait Medals of Italian Artists of the Renaissance,* Lee Warner, 1912.

Ives, H.E., "Design of Florentine Florins as an Aid to Their Dating," *American Numismatic Soc. Mus. Notes,* 1952, pp.103-112.

Lincoln, W.S., *Catalogue of Papal Medals,* London, 1898.

Phillips, J.G., "Medals of the Renaissance," *Metropolitan Museum Bulletin,* IX, November 1950, pp.77-82.

Spencer, J.R., "Segismundue hic ego sum: a Bronze Medal of the Italian Renaissance," *Oberlin College Bulletin,* XXI, Spring 1964, pp.126-133.

Weiss, R., "Medals of Pope Sixtus IV, 1471-1484," *Burlington Magazine,* CIV, January 1962, p.40 (review).

OTHER BIBLIOGRAPHIES

Carli, E., "Archivistica e Critica d'Arte," *Rivista Mensile d'Arte e di Culture,* XCIX, April 1944, pp.50-71.

Comstock, H., "Florentine Processional Cross of the Fifteenth Century," *Connoisseur,* CXVI, December 1945, p.105.

Cotton, A.G. and Walker, R.M., "Minor Arts of the Renaissance in Museo Cristiano," *Art Bulletin,* June 1935, pp.118-62.

D'Otrange, M.L., "Collection of Renaissance Jewels at the Art Institute of Chicago," *Connoisseur,* September 1952, pp.66-74.

Francis, H.S., "Fifteenth Century Florentine Procession Cross," *Cleveland Museum Bulletin,* XXXII, January 1945, pp.3-4.

Goldschmidt, E.P., *Printed Book of the Renaissance,* Cambridge, 1950.

Hackenbroch, T., "Goldsmiths' Work from Milan," *Metropolitan Museum Bulletin,* March 1965, pp.258-264.

Hassall, W.O., "Fifteenth Century Ferrarese Illumination at Holkham Hall, Norfolk: Boccaccio's Decameron," *Connoisseur,* CXXXIII, March 1954, pp.18-24.

Michelesi, A., "Venetian Miniatures," *Apollo,* XLIV, November 1946, pp.129-130.

Middeldorf, U., "Zur Goldschmiedekunst der Toskanischen Frührenaissance," *Pantheon,* XVI, August, 1953, pp.279-282.

Milliken, W.M., "Niello Bookcover of the 15th Century," *Cleveland Museum Bulletin*, June 1952, pp.119-131.

Milliken, W.M., "Venetian Illuminated Miniature," *Cleveland Museum Bulletin*, XXXVIII, December 1951, pp.230-232.

Raggio, C., "Light and Line in Renaissance Crystal Engravings," *Metropolitan Museum Bulletin*, March 1952, pp.193-202.

Richardson, E.P., "Coat of Arms of the Minerbetti Family by Donatello," *Detroit Institute Bulletin*, no.1, XXVI, 1947, p.21.

Swarzewski, G., "Sienese Metal Bookcover of 1364," *Boston Museum Bulletin*, XLVIII, October 1950, pp.43-46.

Van de Put, A., "Renaissance Chest," *Burlington Magazine*, LX, February 1933, pp.83-85.

Wixom, W.D., "Twelve Masterpieces of Medieval and Renaissance Book Illumination: a Catalogue to the Exhibition, March 17-May 17, 1944," *Cleveland Museum Bulletin*, XLI, March 1964, pp.41-64.

Index